Manchester

THEN AND NOW

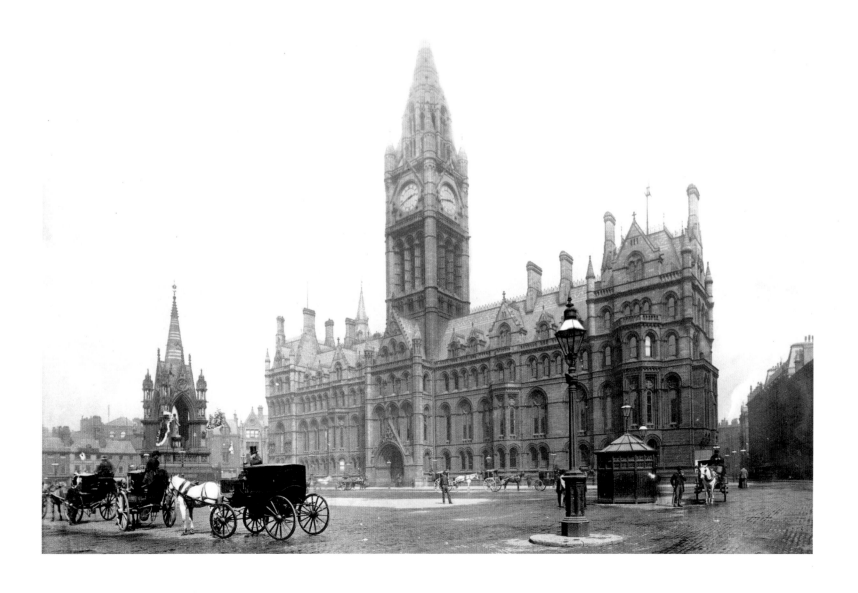

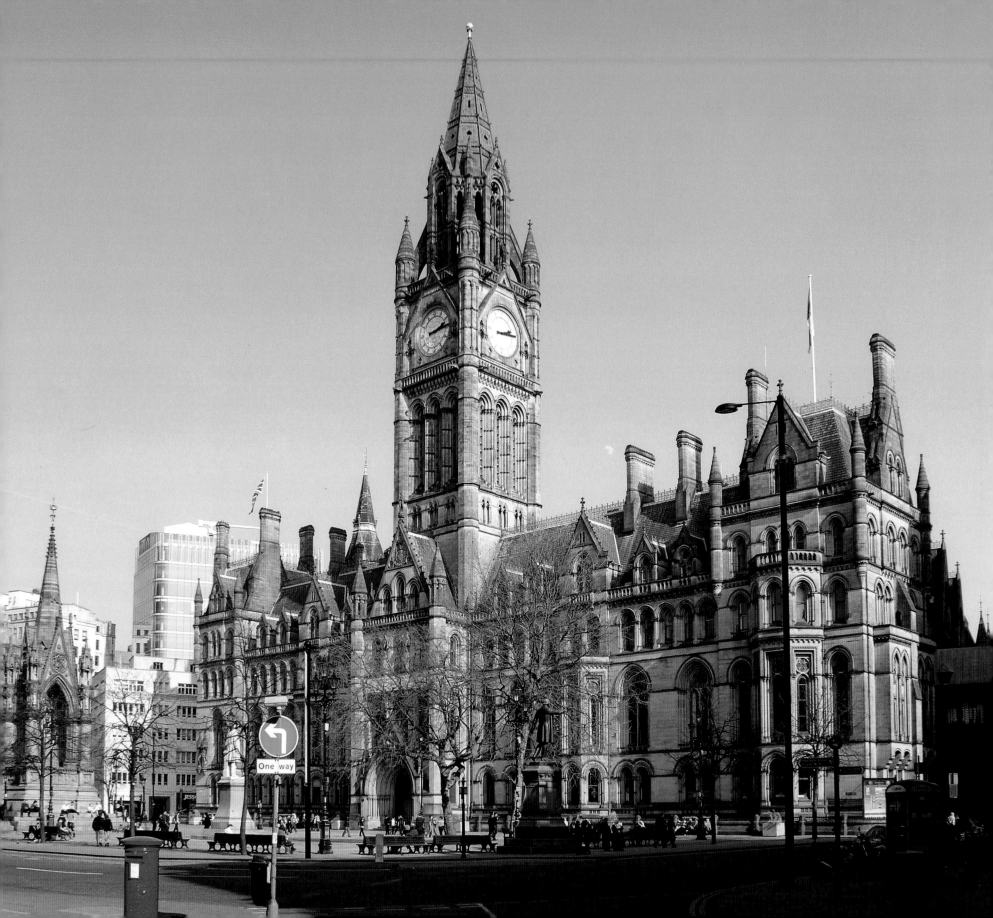

Manchester

THEN AND NOW

Jonathan Schofield

BATSFORD

First published in the United Kingdom in 2009 by
Batsford, an imprint of Pavilion Books Company Ltd
1 Gower Street
London
WC1E 6HD
www.pavilionbooks.com

ISBN 978-1-906388-36-2

A CIP catalogue record for this book is available from the British Library.

20 19 18 17 16 15
10 9 8 7 6 5 4

Reproduction by Rival Colour Limited, U.K.
Printed and bound by 1010 Printing International Limited, China

This book can be ordered direct from the publisher at the website: www.pavilionbooks.com

PHOTO CREDITS

The publisher wishes to thank Manchester Archives and Local Studies at Manchester Central Library for kindly providing 'then' photographs for the following pages: 8, 10, 18, 20, 22, 26, 28, 30, 32, 34, 36, 38, 44, 48, 50, 52, 54, 56, 58, 60, 62, 80, 84, 86, 88, 90, 92, 94, 98, 100, 102, 104, 106, 108, 110, 112, 114, 116, 118, 120, 126, 128, 130, 132, 134, 136, 138, 140, 142.

All other 'then' photographs are courtesy of Pavilion Image Library, with the exception of:
English Heritage/National Monuments Record: 6 (AFL03/Aerofilms/45987), 122 (AFL03/Aerofilms/45983), 124 (RAF/G3/TUD/UK/184/5213).
Reuters/Corbis: 24.

Thanks to Aidan O'Rourke for taking 'now' photographs for the following pages: 13, 25, 27, 29, 35, 37, 45, 49, 55, 59, 65, 71, 77, 87, 95, 99, 111, 113, 137. All other 'now' photographs are by David Watts, with the exception of pages 7, 123 and 125 (Pavilion Image Library).

Pages 1 and 3 show: Manchester Town Hall, then (photo: Pavilion Image Library) and now (photo: Aidan O'Rourke).

Front and back covers show: High Street, then (photo: Manchester Archives and Local Studies at Manchester Central Library) and now (photo: David Watts).

Introduction

It falls to few cities to become a concept. Manchester represents a way of thought pioneered more than 150 years ago and still with us today. One of the city's great buildings is the Free Trade Hall, the only building in Britain named after a principle: the idea of nations and individuals trading without tariff barriers. This was known as the Manchester School. It delivered, according to Detmar Doering writing in 2004, 'a far freer internal market in Europe than the Eurocrats in Brussels have achieved today'.

It falls to few cities to be a model of a commercial system. The story of Cottonopolis, the rise and rise of the textile industry centred on Manchester and its rapid fall and disappearance, is taught at schools and universities across the world. One thousand tonnes of raw cotton were imported in 1751, 45,000 tonnes by 1816, 205,000 tonnes by 1841 and, at its peak, in 1914, almost a billion tonnes. After World War II, the growth of the industry in countries that produced the raw material and a lack of investment in Lancashire led to its utter demise – signalling Britain's industrial decline.

It falls to few cities to be a model of urban development. Manchester has been recognised as the first industrial city for a long time. Friedrich Engels worked on the *Communist Manifesto* with Karl Marx here. He used the expansion of the city in a negative way, in both his works and through his research for Marx, as a model for the proletariat/bourgeois division of society. Manchester was the first city, as many commented, where the chimneys were taller than palaces and churches. It spoke of a new way of doing things; Disraeli called it 'as great a human exploit as Athens' in this respect.

Grand words, but then achievement is a big part of the Manchester story. In science and technology figures such as John Dalton, J.P Joule, William Fairbairn, Eaton Hodgkinson, Joseph Whitworth and James Nasmyth are globally famous for the first atomic theory, the first law of thermodynamics, boiler making, the H profile girder (used everywhere today), precision engineering and the steam hammer. In later years, A.V. Roe would be the first Briton to fly, Ernest Rutherford would split the atom here, Kilburn and Williams would develop the first true computer (one with an electronic memory) and today the city leads the world in future computing such as Reliable Systems.

In politics and society Manchester and Salford are the home of the first anti-slavery petition of 1788; the vegetarian movement, still based in Altrincham; the Peterloo Massacre, the fight for representation; the Anti-Corn Law League and the Free Trade Movement; the Trades Union Congress; the Suffragettes, through the Pankhursts; and the city was a centre for the gay rights movement in the 1960s. It is also the birthplace of *The Guardian*, formerly *The Manchester Guardian*.

In the arts, Manchester had the first and still largest temporary art exhibition, The Manchester Art Treasures Exhibition of 1857; the first permanent, professional UK orchestra, with the Hallé; the first repertory theatre, with the Gaiety Theatre; and a wealth of innovative rock and pop acts, including a whole period of music called Madchester. Today, Manchester International Festival is unique, dedicated to new and original work. In the world of sport, Manchester United, Manchester City, Lancashire Cricket Club, as well as the Commonwealth Games of 2002, are all part of Manchester's significant sporting legacy.

Transport has been another catalogue of 'firsts' for the city. The Bridgewater Canal, which opened in the 1760s, was the first fully artificial industrial navigation. In 1830 the Liverpool and Manchester rail system opened; it was also the first efficient goods railway. Later, the Manchester Ship Canal would open in 1894; the largest UK civil engineering project. Manchester Airport opened in 1930 and is the only major airport still owned by its own citizens. In 1991 Manchester would be a UK pioneer for the return of the trams.

All of this has happened in what has been, historically, a remarkably short time. Manchester with Salford went from 20,000 or so in the 1780s, to 80,000 in 1800, to almost half a million – including the townships – by the middle of the nineteenth century. The twin cities then ate up their suburbs. Thus, Heaton Park to the north became part of the city in 1903. Wythenshawe, as a vast Manchester slum clearance council estate, became part of the city in 1931. The inner urban areas reached their greatest population at the same time, with over a million in Manchester, Salford and Stretford.

The shape of the city was defined by this time: commercial centre; inner ring of poor, in Ancoats for example; outer ring of better-off, in Didsbury and other areas. There were key zones of heavy industry along the River Irk in the North, along the River Medlock and the Ashton and Rochdale Canals to the east, and around Manchester Ship Canal and Trafford Park.

Then came the decline, as economic tides washed away the heavy industry in the last four decades of the twentieth century. The population of Manchester and Salford is just over half of what it was in the 1930s. This sounds worse than it is because, with greater mobility, the population of the ten boroughs of Greater Manchester has collectively remained the same at around 2.5 million for three decades; a figure slightly up on the 1930s figure, as people moved to the fringes to commute.

Throughout the city's very significant history its character, according to historian A.J.P. Taylor as 'the least aristocratic city in the UK', has remained constant. That spirit of openness, of accepting anybody and making them part of the whole may have been diluted occasionally but it's never gone away. Indeed, for two hundred years the city has been a magnet for immigrants, all of whom have carved a niche for themselves in the city story.

The dynamism of the history has made Manchester the British barometer city. As Jim McClellan wrote in the late 1990s: 'Manchester makes the social processes more visible. You can see how things are developing. Where they might end up is another matter. Perhaps it'll be the first city to show us whether our new cities work.' He could have been writing that in the late 1820s – as others did. McClellan finishes with: 'Manchester, as Mancs love to tell you, has been ahead of the game.' Let's finish on that note.

Manchester, more than any other UK provincial city, has always been a little bit in love with itself. Stuart Maconie in his 2007 bestseller, *Pies and Prejudice*, commented that 'Manchester has fancied itself rotten for as long as anyone can remember'. Whether based on the city's incredible achievement over the centuries or merely on *braggadocio*, that's a basic fact that all visitors eventually learn: then or now.

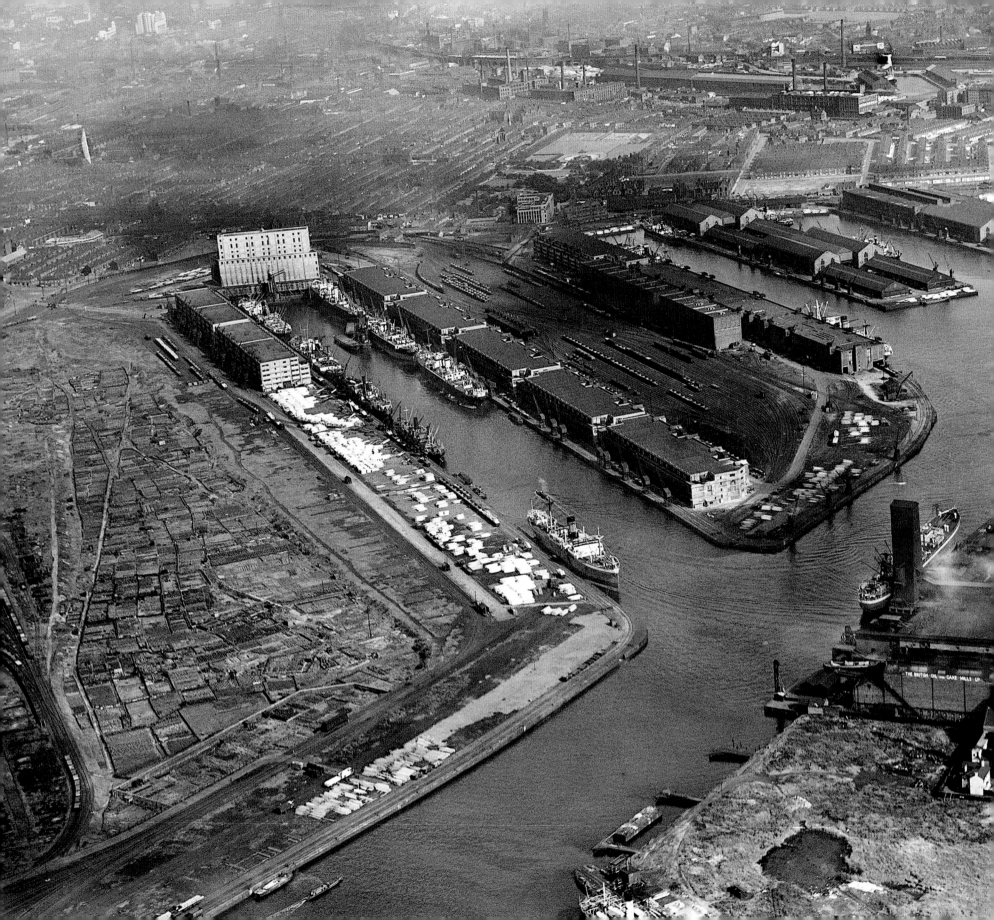

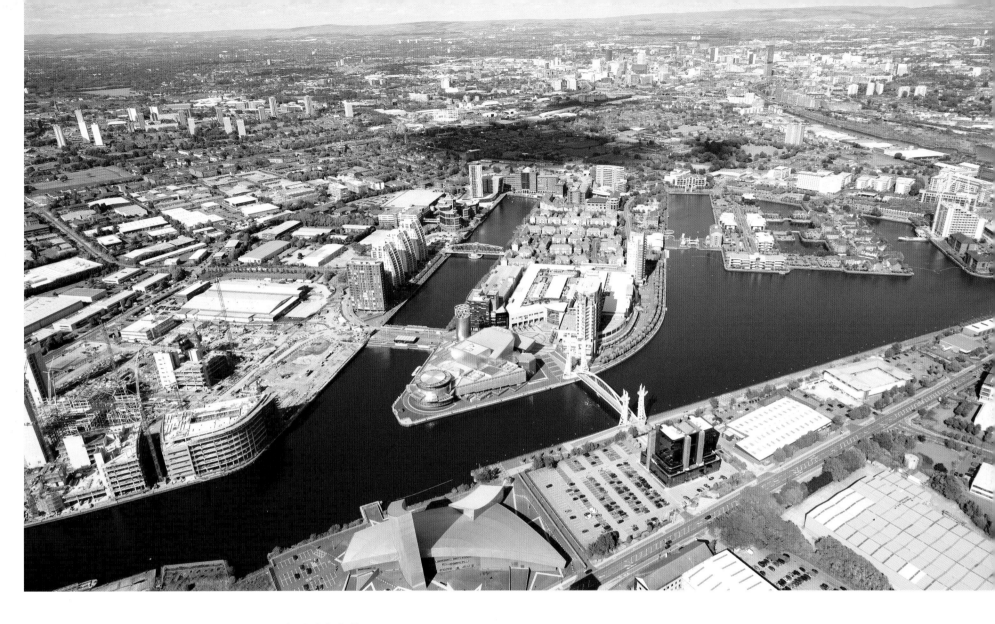

MANCHESTER SHIP CANAL

The single largest engineering project in the nation's history

Left: This 1950s view looks from east to west and shows Manchester as an industrial city. By the time this photograph was taken the Port of Manchester was the third largest port by tonnage in the United Kingdom. The Manchester Ship Canal, which linked ocean and city, opened in 1894 and remains the single largest engineering project in the nation's history. Built with the aid of up to 18,000 labourers, the motivating factor behind the construction of this 35-mile long canal was trade. The port of Liverpool and the railway companies were charging Manchester businesses excessive amounts in shipping tariffs and this was Manchester's fight-back. Dominating the picture is Dock Nine, with smokey Salford and Manchester behind.

Above: This is post-industrial Manchester: clear, smoke-free and defined by service industries as much as manufacturing. The last commercial ship to reach the head waters of Manchester Ship Canal arrived in 1982. Container vessels had killed the canal in its upper reaches because they had simply become too large. When the site was cleared, white-collar workers, apartment dwellers and shoppers arrived. So did culture. The silver-grey building in the immediate foreground is the Imperial War Museum North, designed by Daniel Libeskind and opened in 2002. Its design reflects the museum's theme of a world defined by war: air, water and land shards represent the three theatres of conflict. Catching the light on the opposite side of the canal is the Lowry, an arts complex built in 2000 and dedicated to the Greater Manchester artist, L.S. Lowry (1887–1976), well-known for his industrial images and 'matchstick men'. On the left is the construction site of MediaCityUK, a 200-acre development to accommodate 2,000 BBC employees. In the distance on the right is the 47-storey Beetham Tower, Manchester's tallest building. Behind lie the hills of the Peak District National Park.

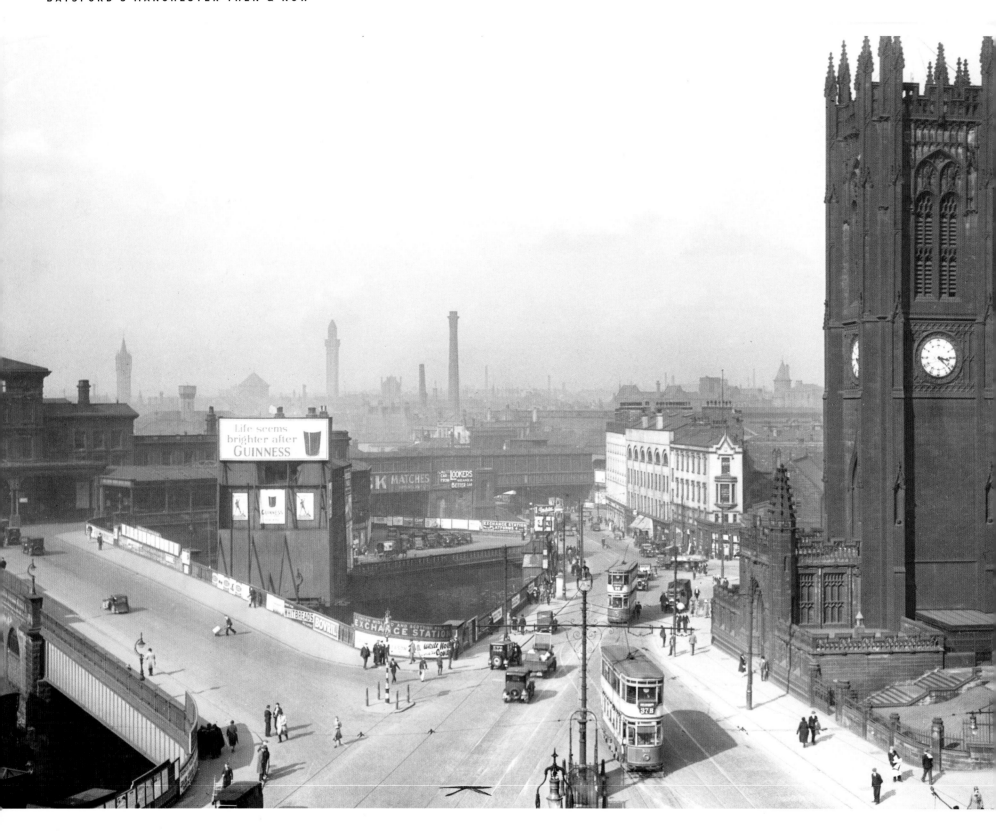

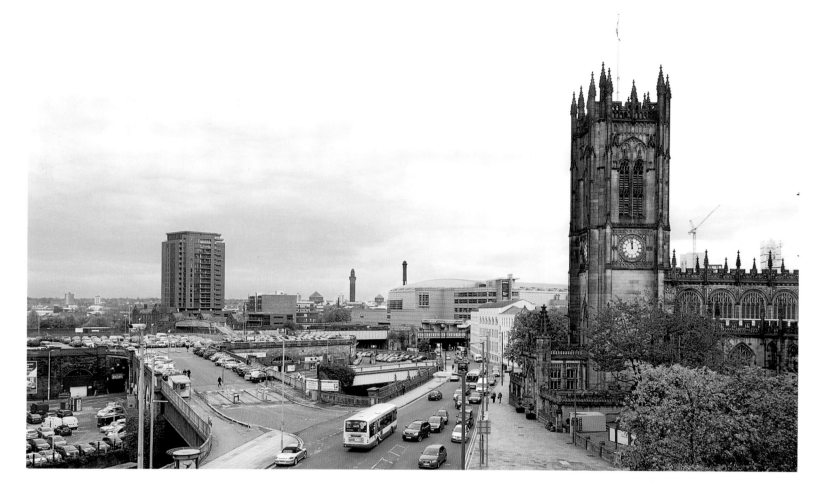

MANCHESTER CATHEDRAL AND EXCHANGE STATION

The first church to be built on this site dates back to the eighth century

Left: This is Manchester shortly after World War II. The industry-blackened tower of Manchester Cathedral is on the extreme right and Exchange Station on the extreme left. Manchester and Liverpool had the first inter-city link on the planet from 1830 and for the next few decades different companies opened different termini. Exchange Station was opened in 1884 by the London and North Western Rail Company after a plan to share the nearby Victoria Station fell through. An unusual result of this was that one platform between the two stations on the main Leeds-to-Liverpool line was the longest in the world at 669m (2,195ft). Behind the station is the tower of the Assize Court, to the immediate right of the Guinness advertisement is the tower of Strangeways Prison and further right is the tall chimney of Boddington's Brewery.

Above: Exchange Station closed in 1969 and is now used as a car park. Strangeways Prison is still there as is Boddington's Brewery chimney, although the brewery itself has been demolished. Fortunately, Greater Manchester still has four major independent breweries. The clumpy building in front of the chimney is the Manchester Evening News Arena with a capacity of 20,000 people: it is principally used as a gig venue for major touring performers, but was built for sport and was used in the 2002 Commonwealth Games. The cathedral tower has been cleaned since the 1940s. This is the constant in the view. The small parish church was enlarged in the 1420s as a collegiate church with a chantry function – singing the souls of those who could afford it to heaven. In 1847 it became a cathedral and despite plans to demolish and build a bigger one, the city has retained this building with its beautiful medieval woodwork.

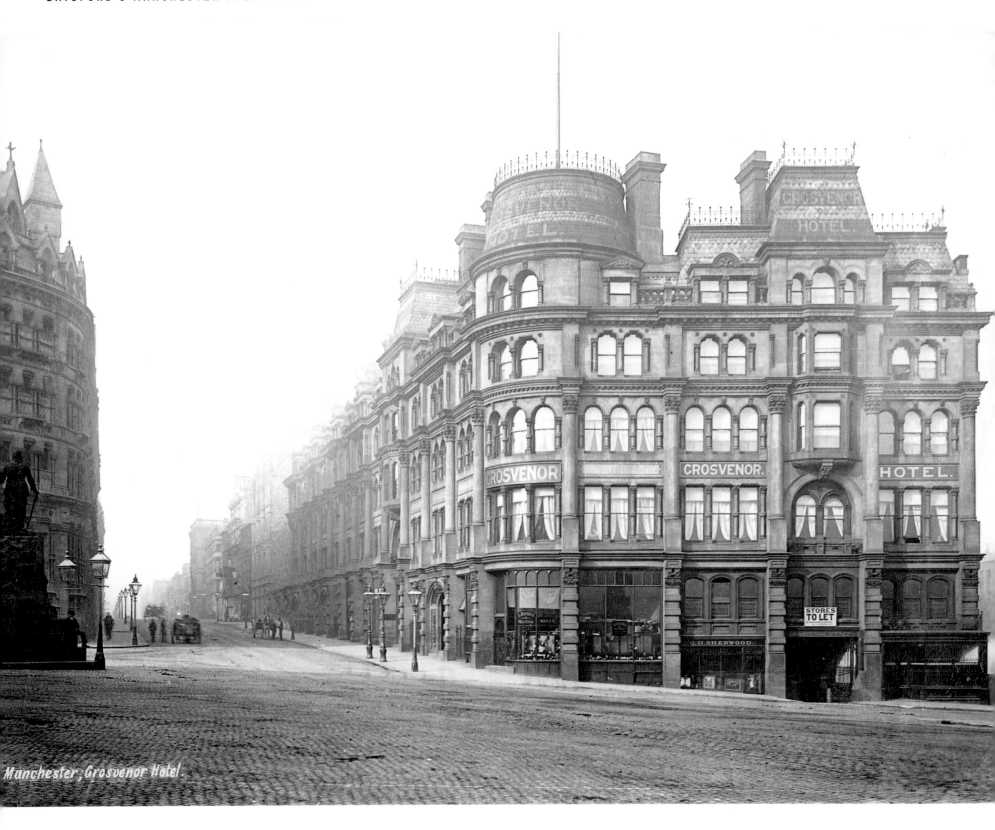

Manchester; Grosvenor Hotel.

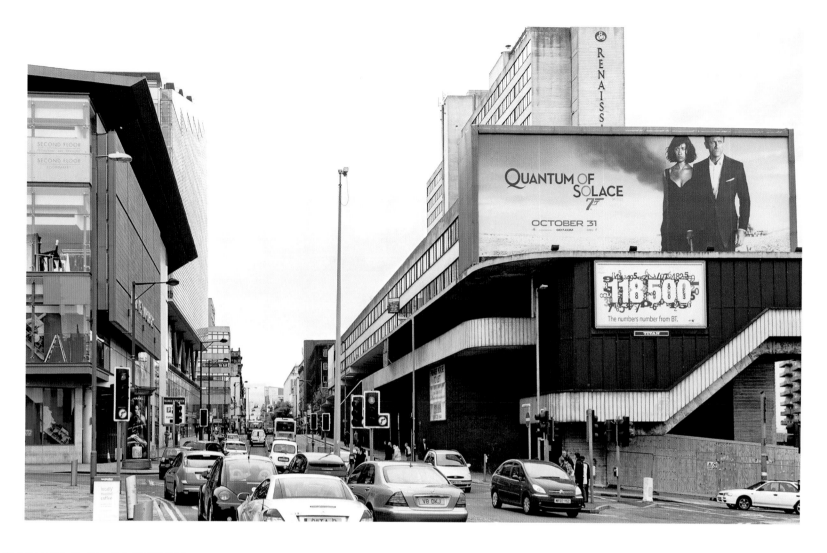

GROSVENOR HOTEL

This end of Deansgate is now home to smart department stores such as Harvey Nichols

Left: This circa-1904 picture is dominated by the Grosvenor Hotel. The hotel was built on land bought by the Walker Property Company in 1876. The street level had a row of elegant shops and the hotel was famous for its quirky functions. The hotel sits on the site of Ben Lang's music hall, where a stampede killed 23 people in 1868. The street stretching into the distance is Deansgate. This street is at least 1,900 years old, a Roman road in origin. When the Saxons settled Manchester they came a mile north of the Roman fort to this more easily defensible area, fifteen metres above the River Irwell. Victoria Bridge Street, to the right, leads to the separate administrative area of Salford. It was over an earlier bridge on this site that Royalists attacked Manchester in 1842. They were repulsed and Manchester became the headquarters for the Parliamentarians in the North West.

Above: Today the area is in transition. Manchester was bombed in 1940 and the Victoria Buildings (see page 12) were damaged. In a major redevelopment in the 1970s by architects Cruikshank and Seward that site and the Grosvenor Hotel site were cleared. In 1954 a famous science fiction convention – the Supermancon – had taken place at the Grosvenor. The large Brutalist concrete shopping centre and office scheme by architects Cruikshank and Seward that eventually swamped the site must have seemed like science fiction at the time. On one side of Deansgate this too has gone, replaced by smart department stores such as Harvey Nichols, glimpsed on the far left here.

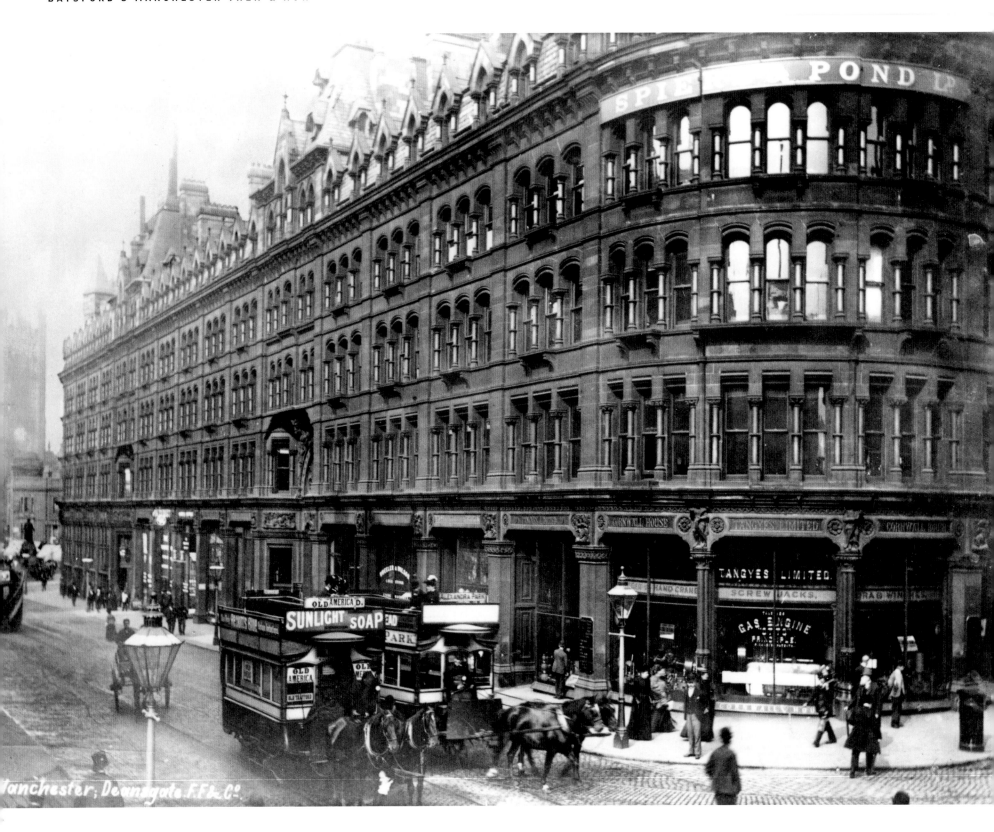

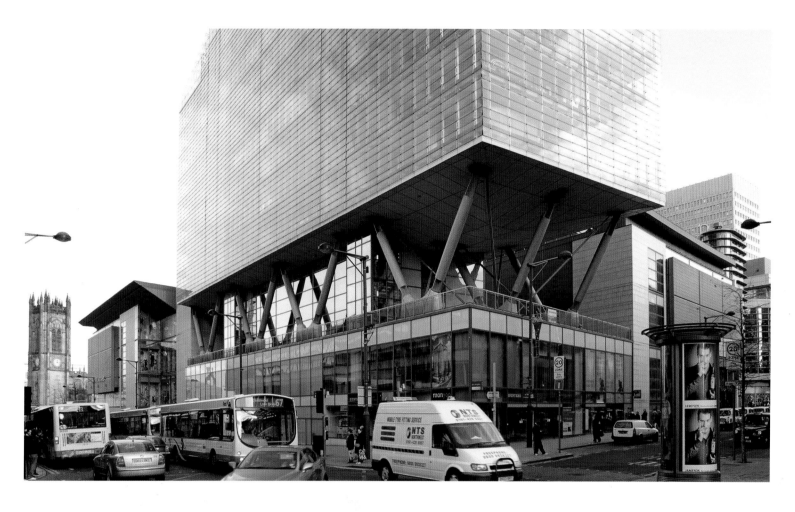

VICTORIA BUILDINGS / NO. 1 DEANSGATE

No. 1 Deansgate was designed by Ian Simpson and completed in 2002

Left: For much of its history Deansgate, the street with the horse-drawn omnibuses here, was a den of flagrant iniquity. Lined with drinking dens and dangerously narrow it was a byword for alcohol-driven violence. From the mid-part of the nineteenth century Deansgate was progressively widened and elevated with new buildings. By 1884, when this photograph was taken, Deansgate and nearby St Ann's Square had become a very distinguished retail area of the city. The elaborate building dominating the picture is Victoria Buildings, a well-known and desirable address for offices and shops. Note the buses here, one advertising Sunlight Soap from Merseyside and both with middle-class destinations to the south and west of the city, Old Trafford and Alexandria Park—suitable addresses for the core clientele of Deansgate's upmarket shops.

Above: Victoria Buildings was demolished in the 1940s after suffering severe wartime damage and a concrete shopping centre was built in its place. After another bomb, this time the IRA's of 1996, the area was developed again. For the first time in around 180 years residential properties returned. But whereas those early nineteenth-century buildings had been rickety and rundown, the twenty-first century gave the city its first million-pound apartments. No. 1 Deansgate, on the corner of Deansgate and St Mary's Gate, sits on a podium filled with offices and shops. Above is an exposed steel cradle and then the tall glass wedge of its residential apartments. After it opened in 2002, No. 1 Deansgate became the status address of central Manchester, attracting footballers and soap stars. The top apartment was occupied by its architect Ian Simpson, who also designed the Beetham Tower, or Hilton Tower as it is also known. The building on the left, in front of the cathedral, is Harvey Nichols, indicating that though the scenes are different the shops remain upmarket.

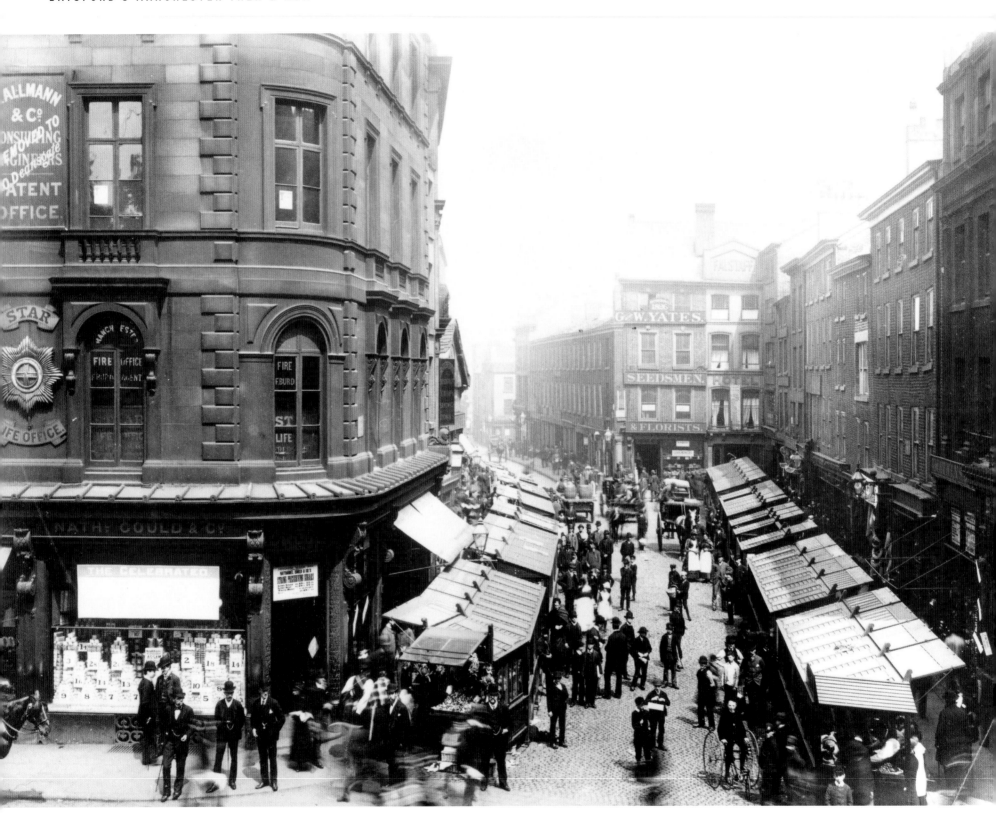

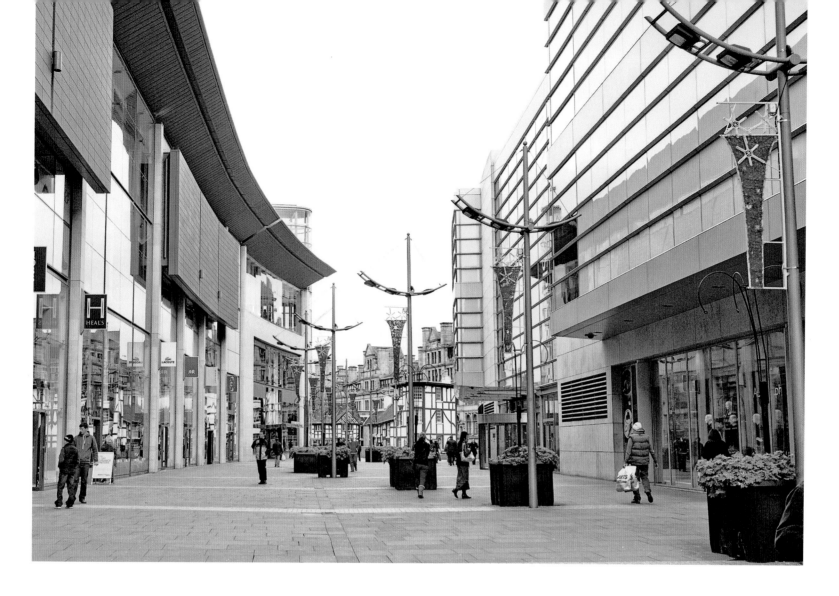

MARKET PLACE

Generations of Mancunians traded stories and goods here

Left: Manchester grew up around the Collegiate Church, Chetham's College and the area known as Market Place. This picture from the 1880s shows Smithy Door Market (later known as Victoria Market) on Victoria Street. Traditionally a place where fruit and vegetables were traded, the building closing off the view here, G.W. Yates ('Seedsmen and Florists'), shows that these businesses were still flourishing. A colourful area, the Market Place has seen a lot of history. Here the conduit ran with claret on the occasion of Charles II's return from exile in 1660, here Bonnie Prince Charlie halted on his abortive 1745 campaign to gain the throne, here Captain Mouncey was killed in a duel with Cornet Hamilton, here the heads of traitors were displayed. More importantly, here, away from great events, generations of countless Mancunians traded stories and goods and measured out their lives.

Above: Today the old and charming Market Place has gone. It was destroyed in World War II and a couple of re-buildings later the area (this isn't an exact duplicate position to the older picture; that is now impossible) has become a sharp and sassy retail zone. The only foodstuffs sold today are in the upmarket foodhalls of Harvey Nichols on the left and Marks and Spencer and Selfridges on the right. Both sides of the pedestrianised New Cathedral Street were designed by Building Design Partnership following the 1996 IRA bombing. In the distance the two black and white timbered pubs of Sinclairs Oyster Bar, the taller of the two, and the Old Wellington can be seen. The latter dates from the 1530s. The pubs were lifted to match the level of the newly developed Shambles Square in the 1970s and then shifted 50 metres after redevelopment in the 1990s.

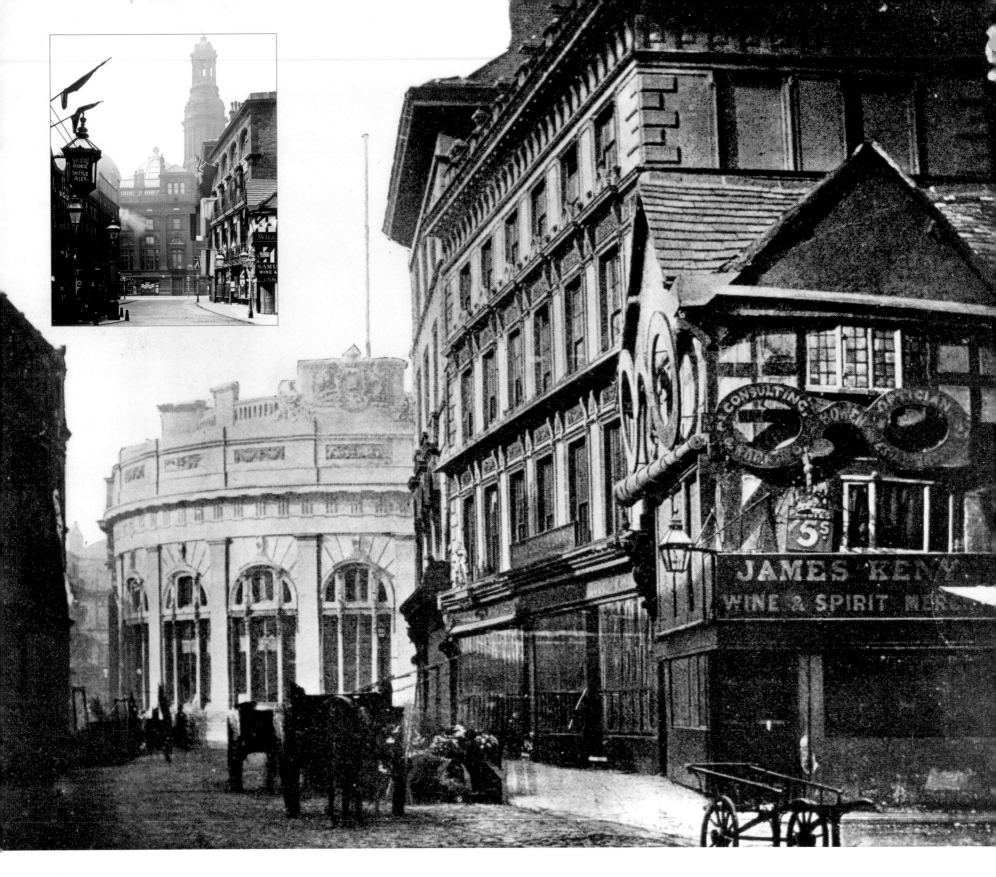

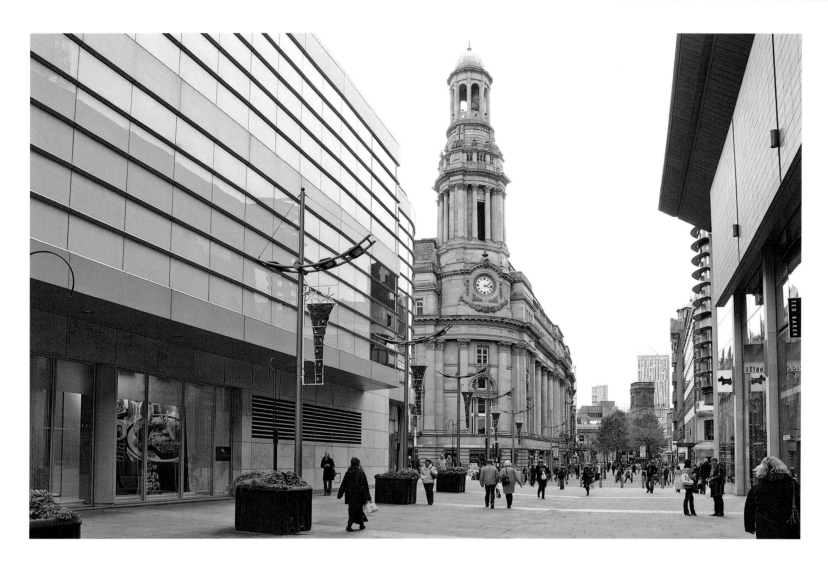

ROYAL EXCHANGE

By 1809 Manchester was becoming the centre of UK cotton production

Left: The main picture from 1859 shows on the left the handsome curve of Thomas Harrison's Exchange building, completed in 1809. This classical building was praised for the light that flooded in from its tall windows. The Exchange was proof positive that Manchester was becoming the centre of UK cotton production. This wasn't the first Exchange; the original had been completed 90 years earlier and was a much simpler affair in a position closer to the foreground in this photograph. The half-timbered building wears a pair of spectacles. In an interesting symbiosis it was a pub downstairs and an opticians upstairs. The pub, the Old Wellington, can be glimpsed on page 15, seen from the opposite end of New Cathedral Street. The inset was taken in the late 1890s and shows a larger 1874 remodelling of the Royal Exchange.

Above: The 1874 Exchange wasn't the last rebuilding, but some elements remain. Today the tower bears a clock and looks fancy but it also has a practical use as a flue. This view is looking south down New Cathedral Street and into St Ann's Square, and was taken from the area reconstructed after the IRA bomb of 1996. The tower of St Ann's church is in the middle distance, while closing off the view behind the church is Beetham Tower, home to the Hilton Hotel. At 171 metres, Beetham Tower is the tallest building in Manchester. Beetham Tower was completed in 2006 by Ian Simpson Architects. The architect lives in a duplex on the top two floors.

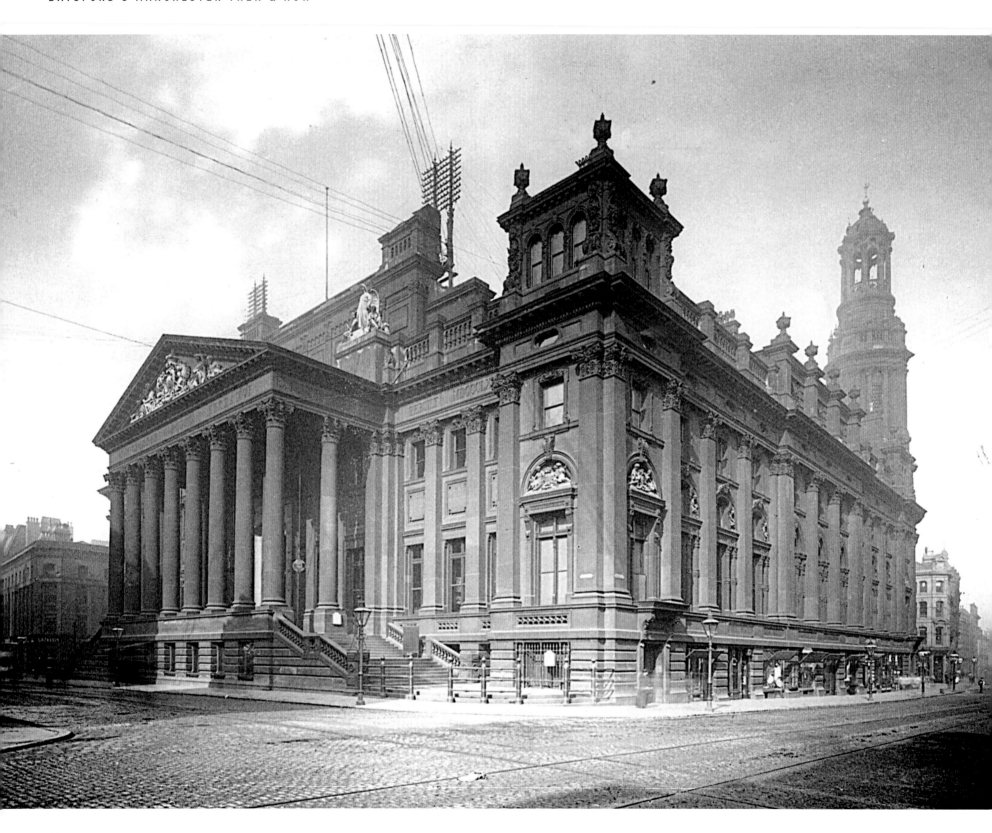

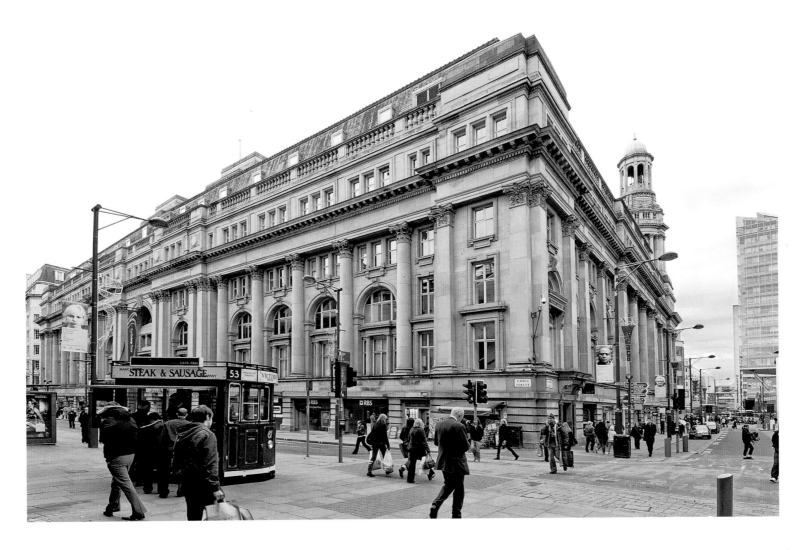

ROYAL EXCHANGE

After 240 years the Exchange closed on 31 December 1968

Left: This photo from 1905 shows the mighty Royal Exchange in its heyday. At this time Manchester, through the private Royal Exchange Company, controlled up to 80 per cent of the world's trade in finished cotton. The room behind the entrance was claimed to be the largest commercial room anywhere and was almost the size of a football pitch. Exchange days were Tuesdays and Fridays when as many as 15,000 international traders would gather in Manchester. The building shown here had been erected by a local practice, Mills and Murgatroyd, between 1869 and 1874. It was well-known for its imposing portico on Cross Street. This was a favourite place for traders to informally discuss prices (and probably which pub to go to for lunch). Given the quietness of the scene over one of the busiest junctions in the city, the picture was presumably taken on a Sunday morning, very early, or during summer holidays. Note also the telegraph communication system on the roof – as unsightly as mobile phone towers.

Above: The Mills and Murgatroyd building was deemed too small and the decision was taken to expand. The architects, Bradshaw, Gass and Hope, pushed the Exchange up to the building line on the pavement and further south over an adjacent building plot. Still boldly Classical in inspiration the expansion resulted in the loss of the landmark portico. With hindsight the decision to expand was a poor one. It started in 1914 and was completed in 1921, delayed by World War I. After a brief boom in the early 1920s, the cotton industry began to decline. In 1969, cheaper foreign competition and poor business practice meant that after 240 years the Exchange closed on 31 December 1968. The main trading room, halved in size after World War II bombing, is now home to the Royal Exchange Theatre. Constructed in 1976, it is the largest theatre in the round in Britain. No. 1 Deansgate (see page 13) can be glimpsed on the right.

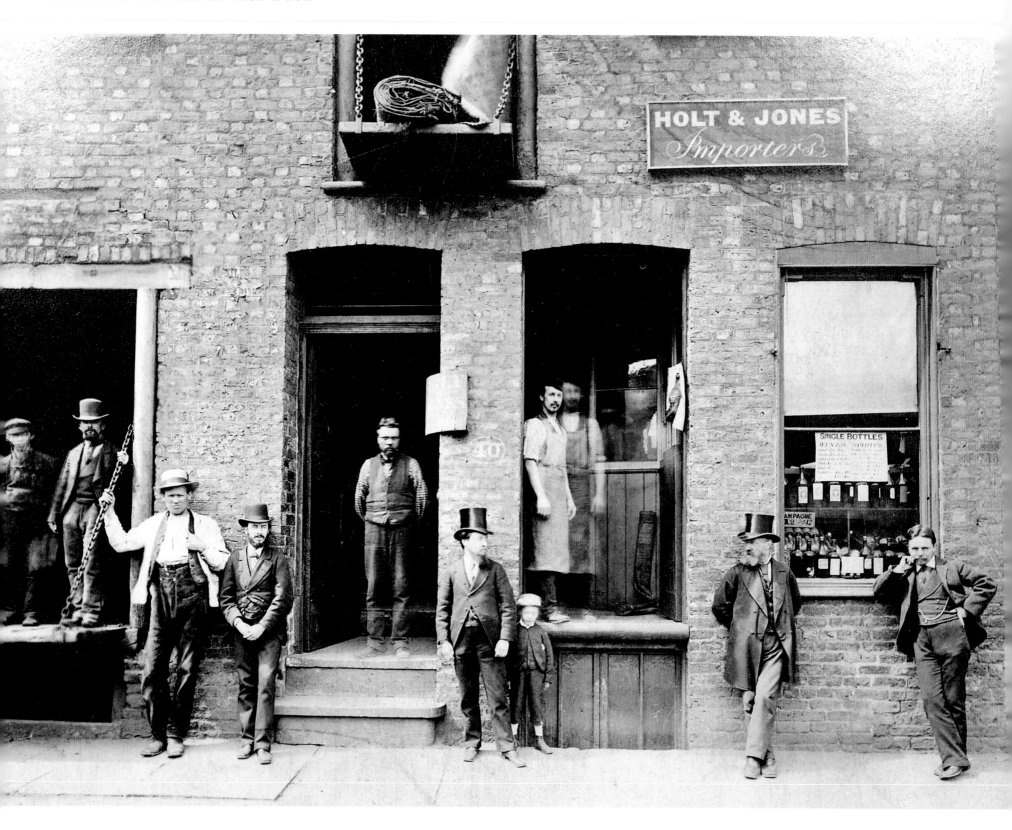

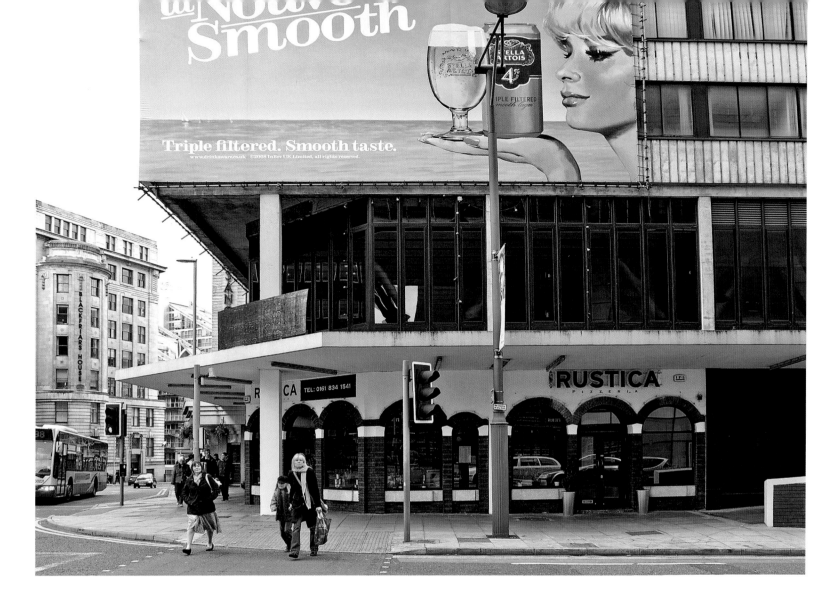

WEST OF DEANSGATE

There were more than 46 unofficial brothels scattered around this area

Left: This remarkable 1870s picture of one of the drinking dens off Deansgate includes a role call of Victorian types: the rather natty gent curling his moustache, the faded older man in his top hat and the Oliver Twist-like urchin. The barman (or warehouseman) standing on the elevated entrance, is clearly proud of himself, with his finely crafted beard and moustache. The drinks on offer in the window include wine, spirits and champagne. Despite the latter, the west side of Deansgate at this time was notorious for its 'rough' life. There were more than 46 unofficial brothels scattered around the area. Weekends were bedlam, with fights breaking out frequently and police officers walking around in packs. There were also plenty of pawn-shops where people would leave valuables in exchange for ready cash to enjoy the weekend.

Above: The street has been widened but it seems drab in comparison to its 1870s counterpart. The 1970s concrete building by Cruikshank and Seward (see page 11), now dominates the scene. Only the advertisement for beer reminds the viewer of the chief preoccupation of the denizens of this area in former times (although on a Friday and Saturday night Deansgate can still play host to some serious party-going). Down Blackfriars Street on the left of the picture is a white building in Portland stone. Called Blackfriars House, this 1925 building designed by Manchester architect, Harry S. Fairhurst backs onto the River Irwell. Originally the headquarters for the Bleacher's Association – another link to Manchester's textiles past – Blackfriars House is now a general office block.

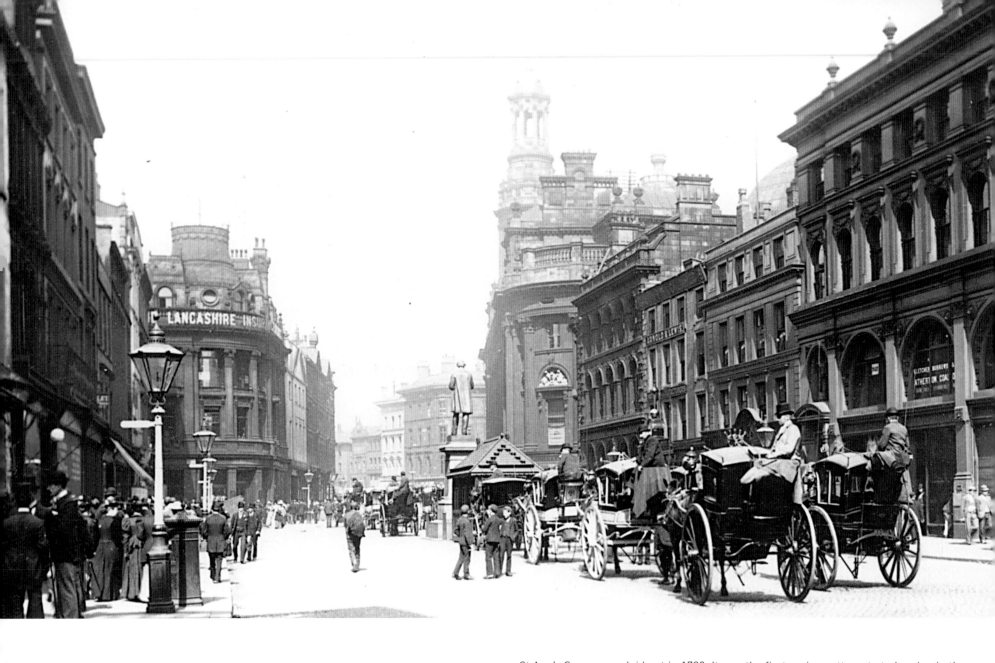

ST ANN'S SQUARE

Manchester's residential 'West End' had become an upmarket retail centre by 1895

St Ann's Square was laid out in 1720. It was the first serious attempt at planning in the early town. Rather than a civic, publically funded gesture by the local administration, this was a private speculation by the Mosley family, headed up by the remarkable Lady Ann Bland (née Mosley). The square was built on land that had hosted the main annual market and fair of Manchester since its first charter in the 1200s. The square was residential in character for many decades – Manchester's 'West End' – with a 'civilising' Assembly Rooms close to where the buildings on the right are located. By the time of this photograph in 1895 the area had become the upmarket retail centre of Manchester. In the right middle distance is the high bulk of the Royal Exchange with its tower. Cabbies wait in the sunshine down the centre of the square on each side of the statue of Richard Cobden, erected in 1867.

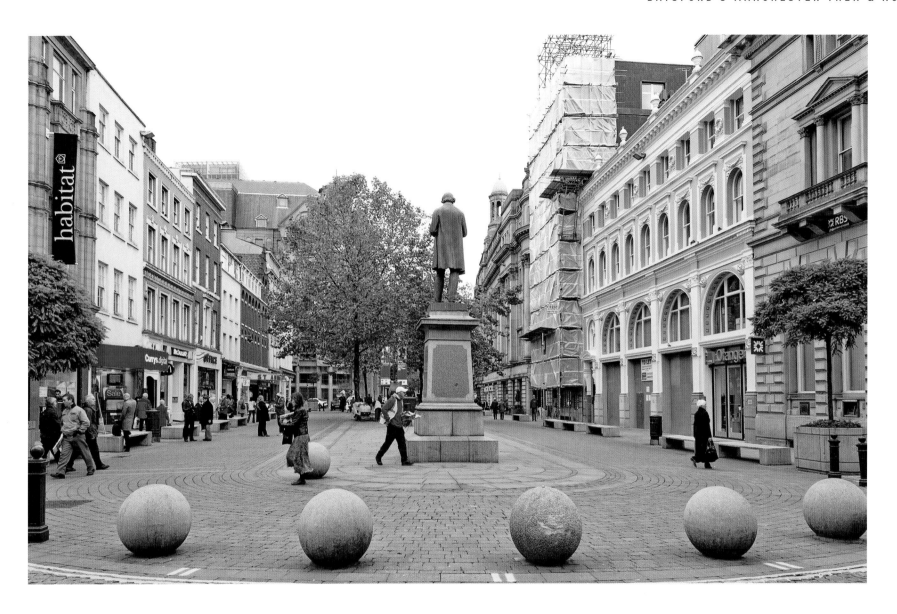

Free trade advocate Richard Cobden still stands facing the Royal Exchange, once the trading epicentre for the largest industry in the British Empire. The cabs are gone though, even in their internal combustion form, as St Ann's Square was pedestrianised in the 1980s. A decade later a new street decoration and furniture scheme was introduced, incorporating the concrete balls shown here. On the left of the square are two four-storey buildings, three bays wide; these probably date from the original setting out of the square almost 300 years earlier. Today St Ann's Square is in transition; its retail crown stolen by recent re-development to the north. A century ago, the characters and cobblers in Harold Brighouse's play *Hobson's Choice* were in awe of the status of St Ann's Square as the premier retail address in the North of England.

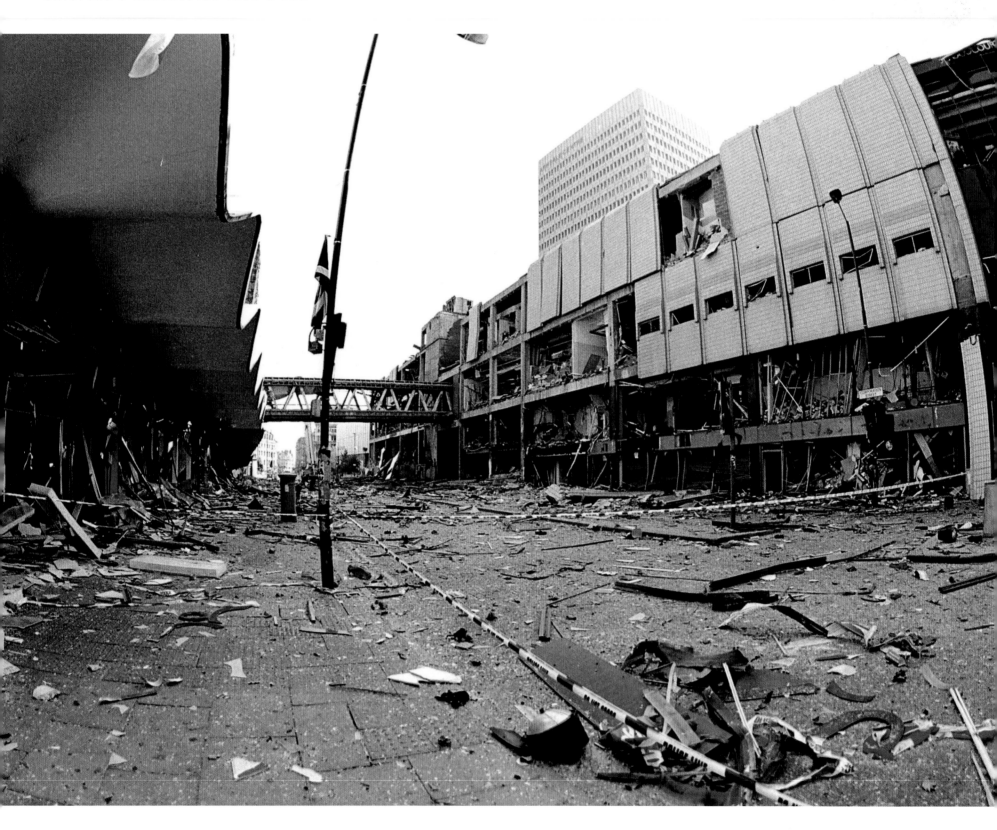

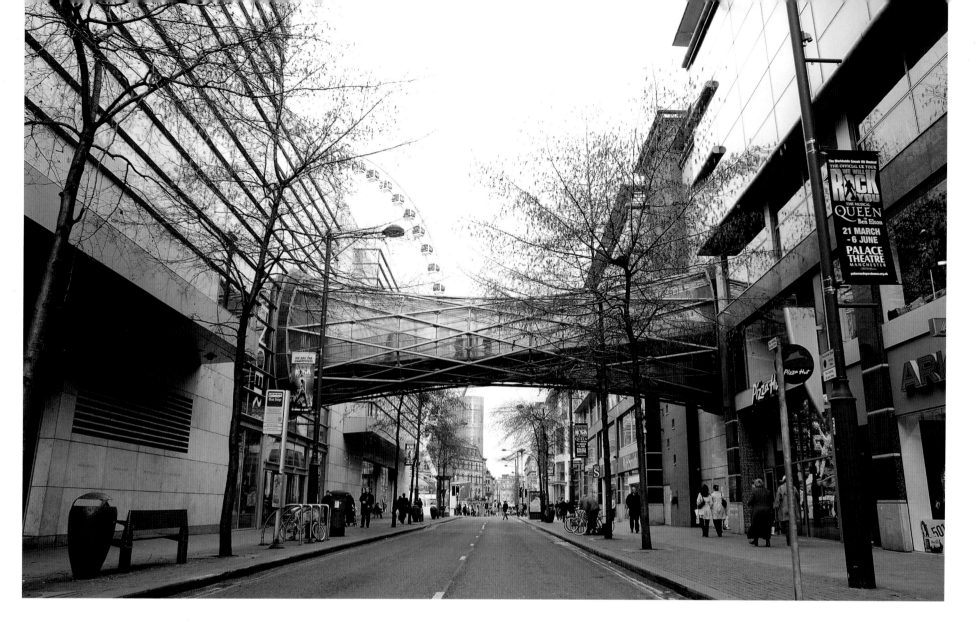

IRA BOMB OF 1996

The explosion ripped out the prime retail heart of the city

Left: On 15 June 1996 the IRA placed a van containing a 1,500kg (3,300lb) bomb on Corporation Street. They gave 45 minutes' warning and the bomb was detonated at 11.16 a.m. Eighty thousand lives were placed at risk but by some miracle nobody was killed, although several hundred were injured. The explosion ripped out the prime retail heart of the city, with 670 businesses having to relocate and damage amounting to around £500 million. This is the classic post-bomb shot of Corporation Street showing buildings torn open, with the Arndale Centre's curtain wall torn off on the right, and the old Marks and Spencer and connecting bridge shattered on the left. The only unscathed feature is the bright red post box from Queen Victoria's reign.

Above: Today the Arndale Centre has been refaced and redesigned. The bridge over Corporation Street has been rebuilt to a better design by Stephen Hodder Associates. On the left, Marks and Spencer shares a BDP-designed building with Selfridges. The post box remains and is the oldest structure in the area. With a brass plaque that records its place in history, it is the only reminder of what happened in 1996. The letters inside survived to be delivered in June 1996 and even today some people post their letters here to ensure their safe delivery. Manchester's central retail sector, although taken out of commission for several years, has regained its place as the premier northern shopping location.

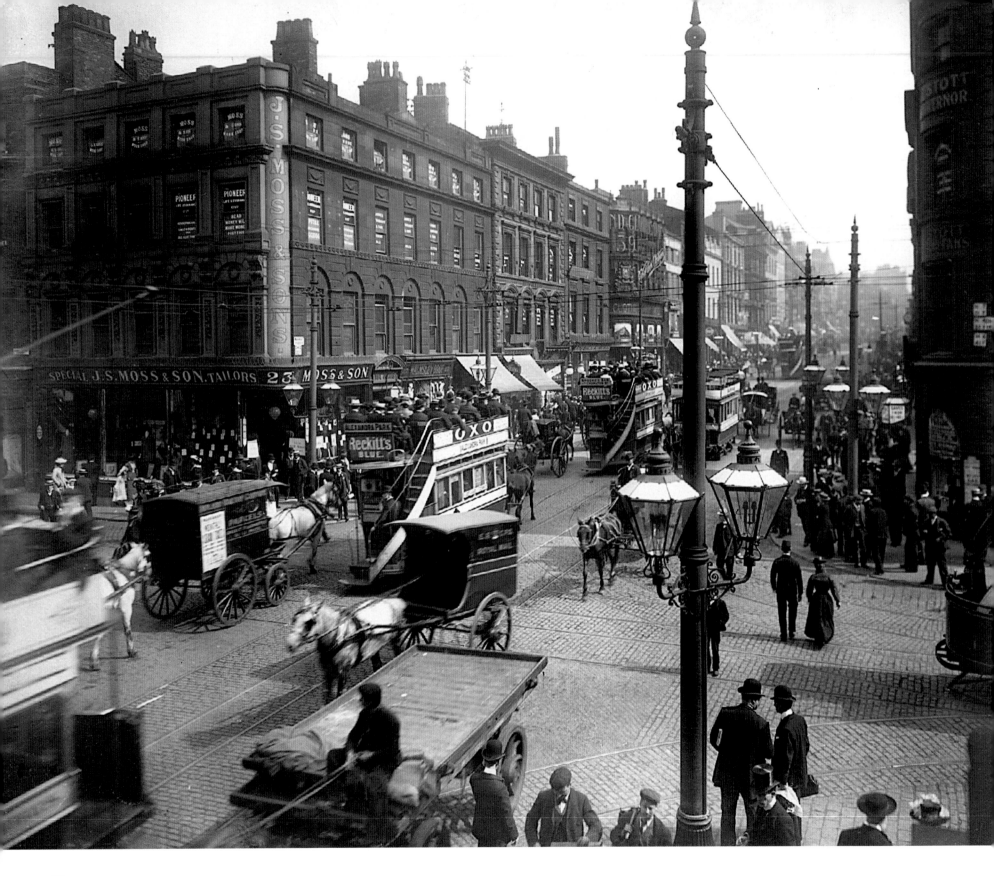

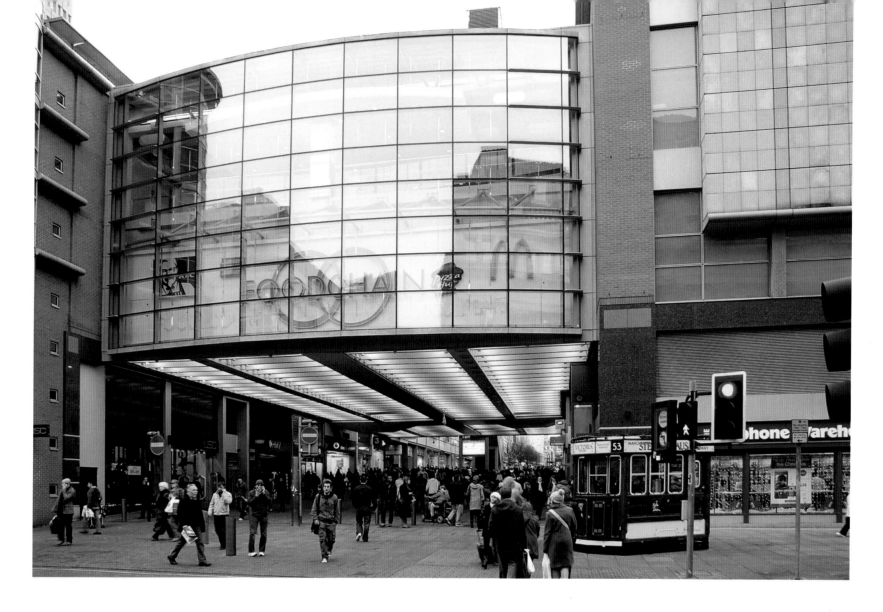

CROSS AND MARKET STREETS

One of Manchester's busiest junctions by 1900

Left: When this photograph was taken in 1902 it showed perhaps the busiest junction in Manchester. Taken from the Royal Exchange, the picture is looking up Market Street towards Piccadilly. It shows a confident Manchester controlling, as it did, key parts of global manufacturing, as well as the textile world with its finished-cotton pre-eminence. There are taxis, omnibuses and trams in the picture and in the foreground the proto-HGV, a cart consisting of a simple platform for piling bales of raw cotton or finished cotton on board. The building on the left-hand corner was home to Manchester's high-class tailors, J.S. Moss and Sons, whose luxurious premises included parquet flooring in oak and walnut.

Above: Market Street is now bridged by a heavy extension carrying an 800-seat food court, which is part of Manchester Arndale's shopping centre. The Arndale Centre, as it was first known, was originally built in the 1970s. In the 1902 picture all the businesses pictured were Mancunian owned, but here we have the globalised world that Manchester did so much to create (see Free Trade Hall on page 80). Pedestrianisation, in vogue since the 1970s, has closed Market Street to traffic. To the right of the pedestrian crossing is a fast-food outlet painted in burgundy and cream, a design that resembles the Manchester Corporation trams shown in the 'then' photograph.

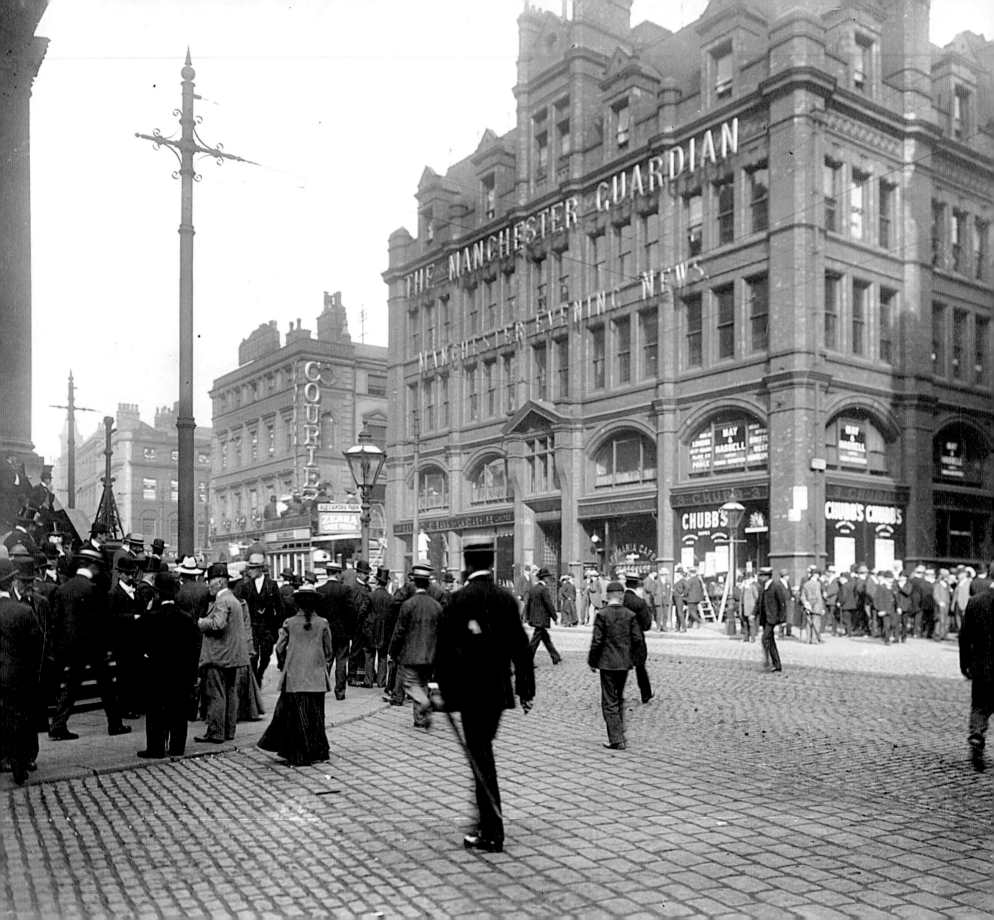

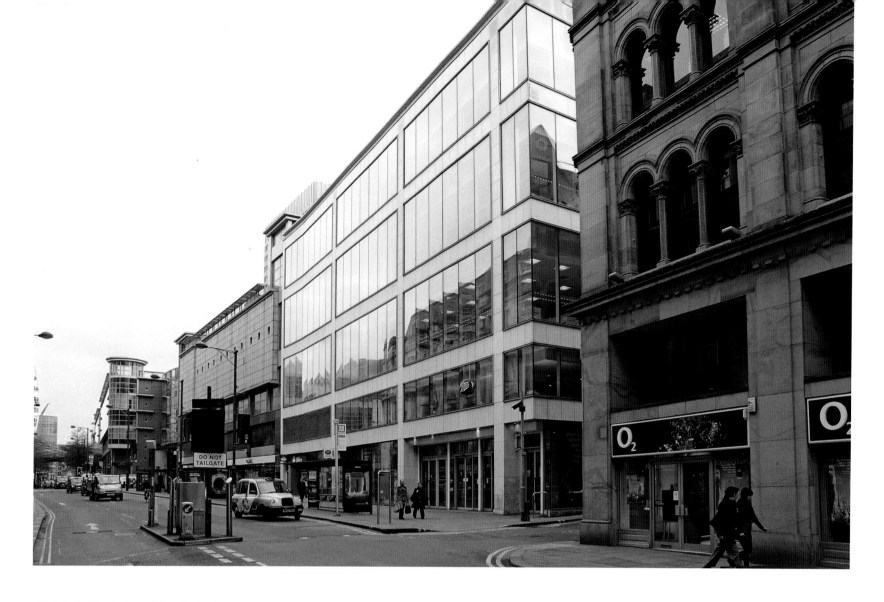

GUARDIAN BUILDING

The Manchester Guardian was founded in 1821

Left: This picture was taken from the south side of the Royal Exchange on the same sunny day in 1902 as the picture of Market and Cross streets (page 26). It's looking across Cross Street towards the Manchester Guardian building. The stairs at far left in the photo lead up to the Royal Exchange, where traders can be seen gathering. *The Manchester Guardian* was founded in 1821 to, 'zealously enforce the principles of civil and religious Liberty' and 'advocate the cause of Reform'. The editor in 1902 was C.P. Scott, who held the post for 57 years from 1872. Scott made *The Manchester Guardian* the English-speaking world's liberal paper. He wrote: 'Comment is free, but facts are sacred... The voice of opponents no less than that of friends has a right to be heard.'

Above: The construction of the Manchester Arndale shopping centre (1972–1980) obliterated 15 acres (6 hectares) of city centre Manchester. All the buildings shown on the older picture were swept away and, in this view, the Arndale extends as far as the eye can see down the east side of Cross Street. The white-framed building centre right, where a Boots store can be seen, occupies the site of the Guardian building. Cross Street itself is now closed to traffic (with the exception of buses) during trading hours. By the time the first concrete was poured for the Arndale *The Manchester Guardian* had changed its name to *The Guardian* and fled to London.

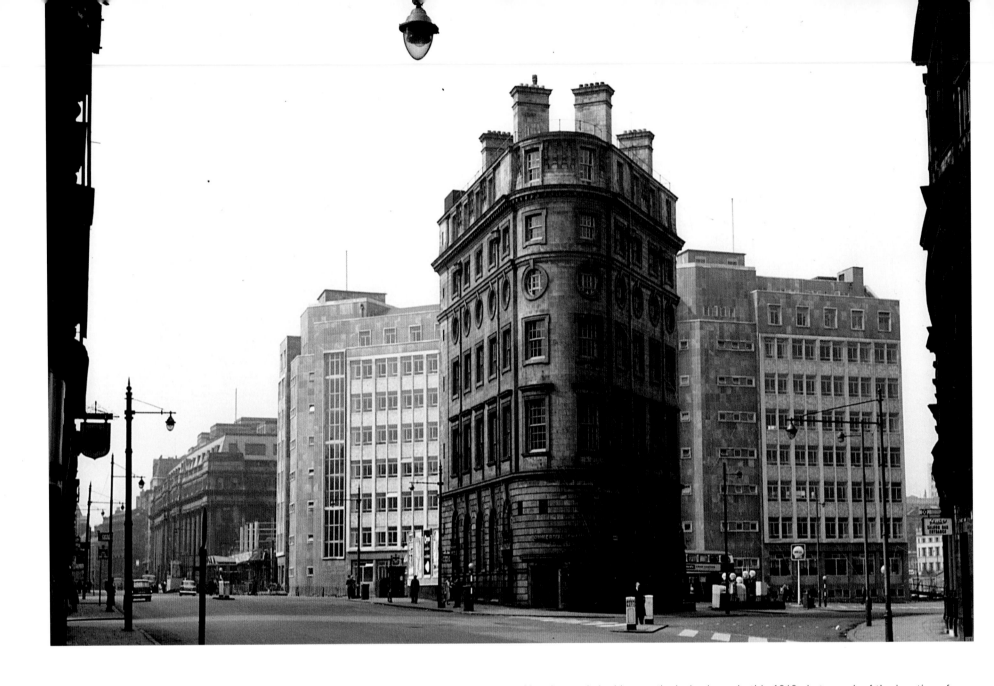

Manchester is looking particularly sleepy in this 1960 photograph of the junction of Corporation Street and Hanging Ditch. The most prominent building, Manchester's flat-iron building of the twentieth century, is Commercial Chambers built a little before World War I. It was a handsome set of offices with gardens behind. The bigger building behind is Longridge House, from 1959, by Harry S. Fairhurst architects. The Westmorland slate with which it was clad fell off after a heavy frost two years later, and cost £25,000 to replace. After the blitz the 1945 Manchester Plan envisaged an inner ring road and Longridge House was set back in anticipation of this.

EXCHANGE SQUARE

The IRA bomb of 1996 led to major reconstruction in this area

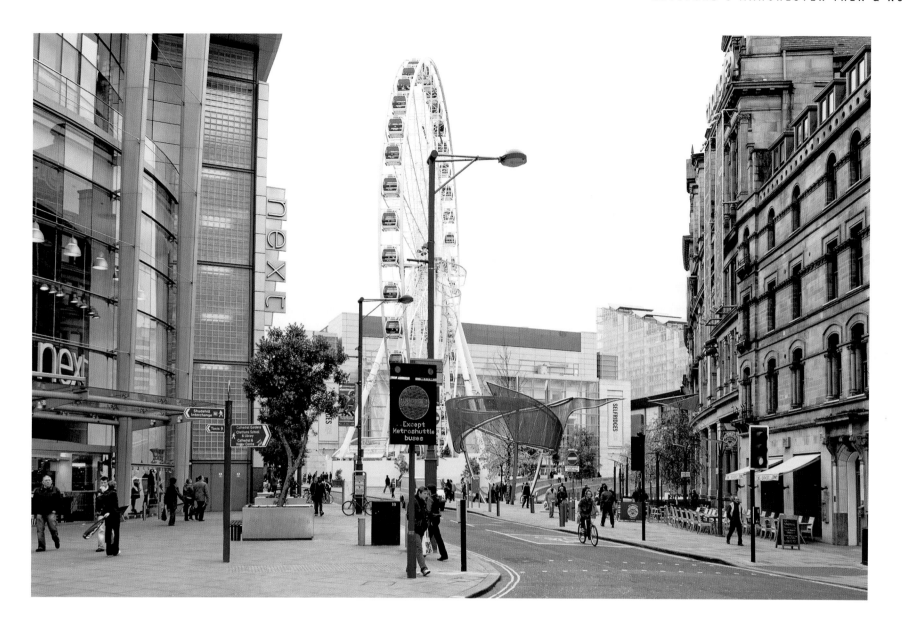

The inner ring road was never built – most of the fantastical 1945 Manchester Plan
was never realised, including the idea of demolishing the Town Hall. The IRA bomb
of 1996 caused the major reconstruction and re-think here, although Commercial
Chambers had already been demolished in the 1980s. Selfridges now occupies the
Longridge House site. Most of the view is taken up by Exchange Square. Designed by
New Yorker Martha Schwartz, this was the first public space to open in Manchester
following the 1996 IRA attack. The square is currently occupied by the Wheel of
Manchester, which was installed in 2004. To the left is the reconstructed Arndale
Centre, to the right the repaired Corn Exchange, now the Triangle Shopping Centre.
In the distance at right is the sloping roof of No. 1 Deansgate apartments.

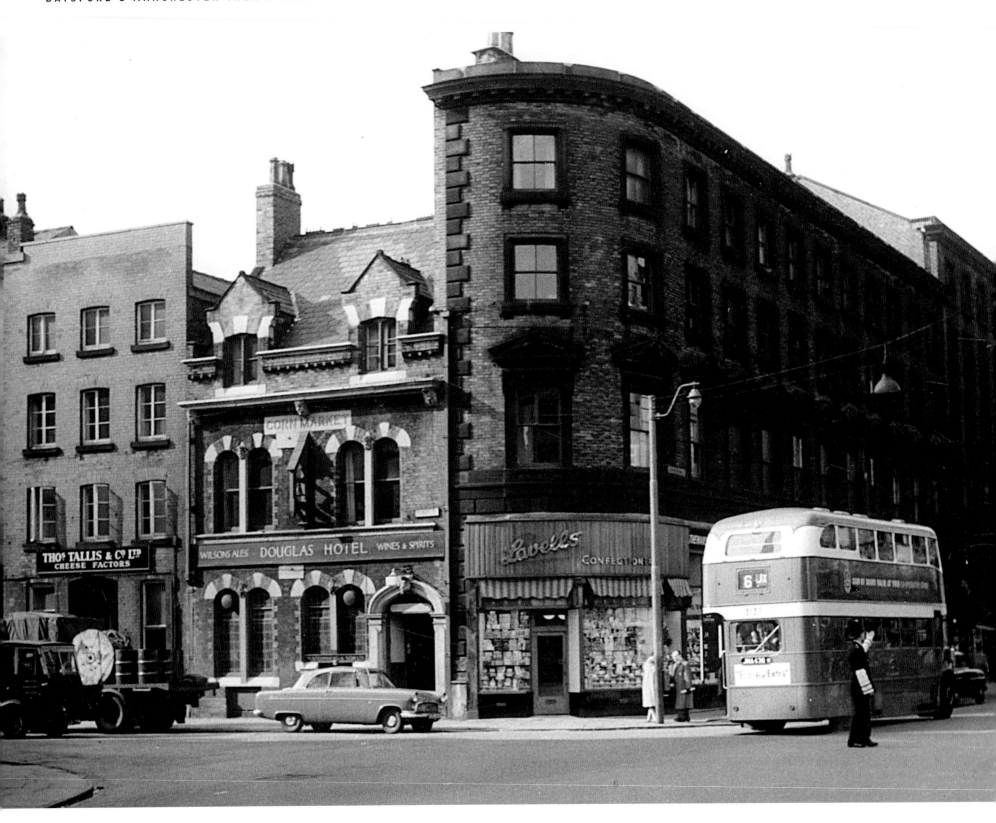

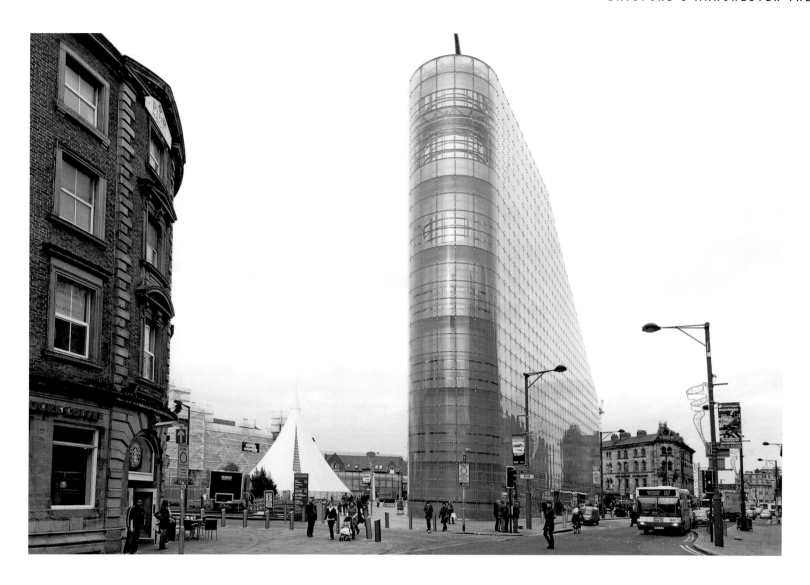

URBIS SITE

Urbis (Latin for 'of the city') is a gallery and attraction that examines modern urban life

Left: This 1958 scene – complete with a policeman directing the traffic – shows buildings desperately looking for a new life. Still suffering from the effects of the Great Depression, cotton and all the attendant office and warehouse functions were in decline. The smoke-blackened warehouse, behind the bus, is empty. Only the Douglas Hotel shows rude health: pubs were thriving in the 1950s. The junction of Fennel Street (left) and Corporation Street (right) is a key one, formerly known as Hyde's Cross. Fennel Street is Saxon in origin and was once known as Oak Apple Market. It was the focus of an informal grocery and provisions market: from 1837 the Corn Exchange was located nearby.

Above: The Douglas Hotel has vanished. Today the glass prow of Urbis stands proud in its stead, looking forward to a different age. Urbis (Latin for 'of the city') houses the National Football Museum; appropriate in the city where the world's first professional football league was created in 1888, and where the giants of Manchester City and United are located. The building is by Ian Simpson Associates and exemplifies Manchester's claim to be the first industrial society; the 'shock city of the age', in historian Asa Briggs memorable words. The pointed tent-like structure is the Manchester International Festival pavilion. Both the pavilion and Urbis put on gigs and club nights. Fennel Street, which enters from the left behind the corner of the former Corn Exchange, hosted Pips back in the 1970s and 80s: possibly the best known club in the North West.

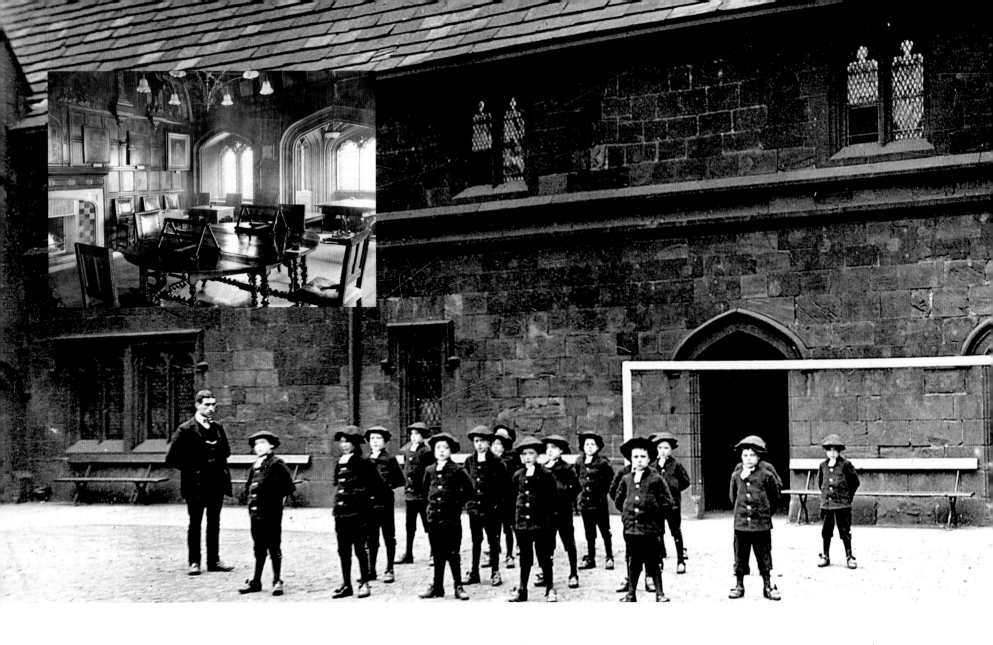

CHETHAM'S SCHOOL AND LIBRARY

Chetham's celebrated buildings date back to 1421

This 1870s photograph shows the charity school boys of Chetham's (pronounced Cheetham's) lined up in front of the school's ancient buildings on Long Millgate in the city centre. The school dates from 1421 and was once the priests' quarters of the Collegiate Church. After the Reformation it was acquired by the Mosley family, the Lords of the Manor of Manchester. From the mid-1650s, the buildings became a free public library and a school for poor boys, under the will of Humphrey Chetham, a prominent local merchant who'd backed both sides during the English Civil War and somehow come out smelling of roses. The inset shows the library reading room; the table in the bay window is the one where Friedrich Engels and Karl Marx studied in the 1840s and where they wrote, or planned, much of *The Communist Manifesto*. Engels had spent time in Manchester working for the textile firm of Ermen and Engels, in which his father was a shareholder.

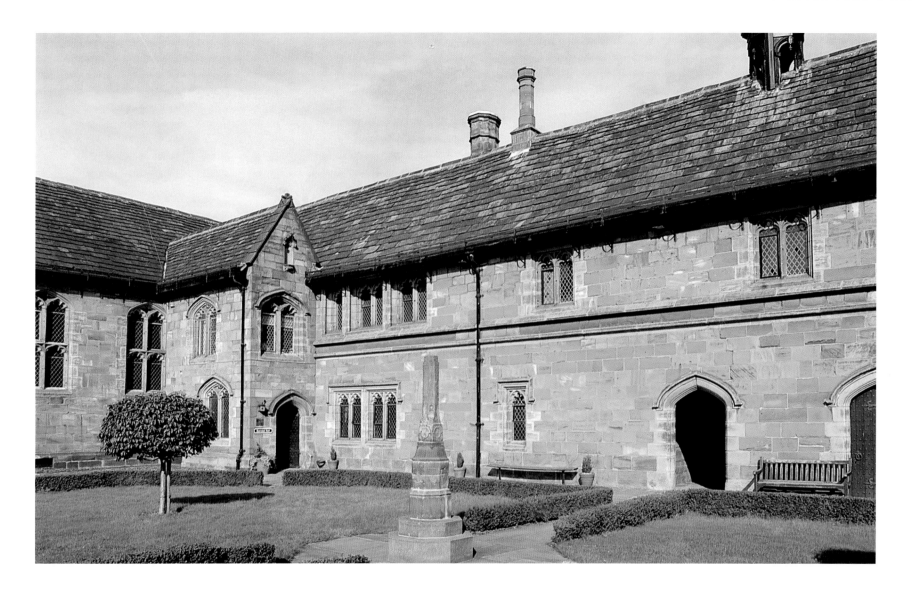

Seen in sunshine, the soft pinky red of Manchester's bedrock building stone (Collyhurst Sandstone) comes out to best advantage. These buildings are a rare survival in more ways than one. The local stone couldn't cope with the acid rain produced by the city's factories and usually eroded away quickly – it was in Manchester that scientist Robert Angus Smith coined the term 'acid rain' in 1852. The poor boys have gone from Chetham's School, replaced since the 1960s by over 300 music students aged 8–18, many of them boarders. The library is still going strong after 360 years. The gardens in front of the buildings were designed to resemble a formal garden from the 1600s. The wing on the left of the picture contains the Baronial Hall where student concerts are held.

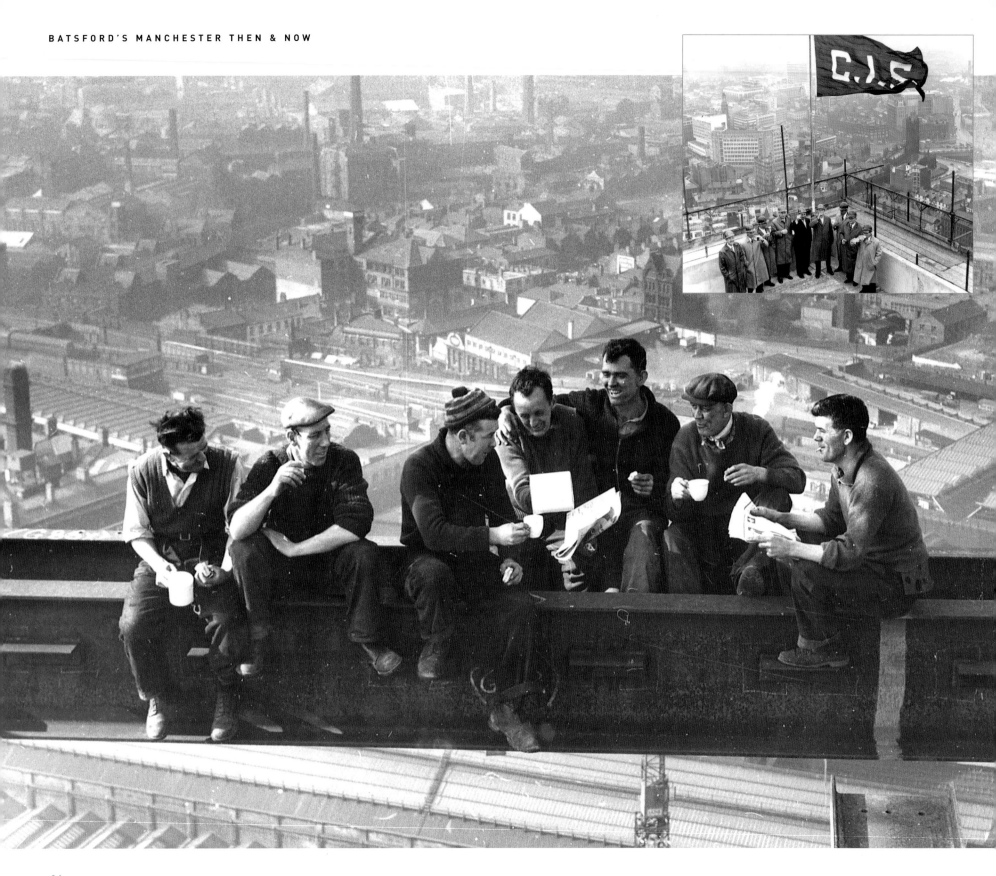

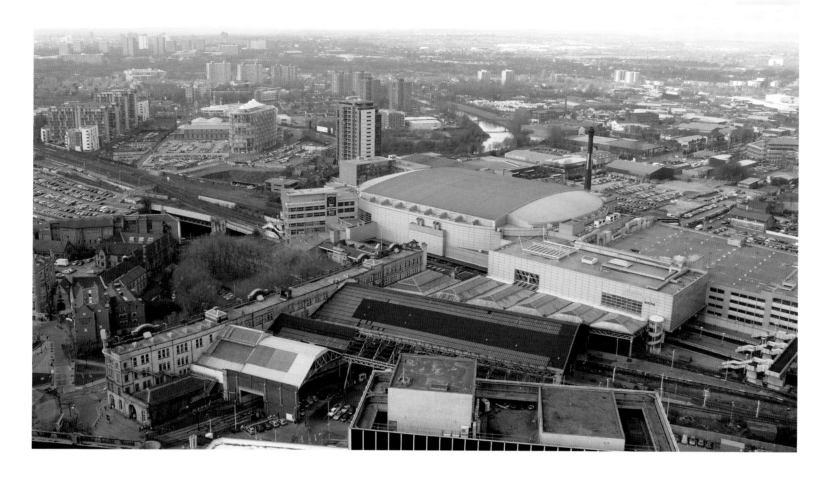

VIEW FROM THE CIS TOWER

A state-of-the-art blast of Americana in central Manchester

Left: The first successful Co-operative venture began in Rochdale in 1844, 12 miles north east of Manchester. In an area defined by its well-organised working-class groups the idea took hold quickly. By the late 1950s the Co-operative Insurance Society was looking to show off. To achieve this it decided to build itself a state-of-the-art blast of Americana in central Manchester. The result was a 25-storey International Modern-style tower block. Completed in 1962, the CIS Tower reared like an impossible vision of New York over the older brick buildings of the area. During construction the workers took their breaks 300ft up on steel girders, as shown in the main picture, with the industrial area of Cheetham Hill Road and the Irk Valley as a backdrop. The inset shows CIS directors 387ft up on the roof at the opening, the smoke blackened tower of Manchester Cathedral beneath them.

Above: The CIS Tower has changed since the 1960s but the basic shape remains the same, a sharp sleek building gripping on to a concrete service tower. Originally the service tower was decorated with 14 million one-inch mosaic tiles but these have been overlain with photovoltaic panels, which convert daylight into electricity. The move away from the smoke and pollution in Manchester to the new mixed economy, heavy-manufacturing-free twenty-first century is underlined best with the CIS Tower and its guests. These guests are a pair of breeding peregrine falcons that nest on the roof, feasting on the city's pigeons. The CIS is part of the Co-operative, the city's biggest home-grown business worth more than £8 billion. The foreground of this bird's eye view shows Victoria Station, with Manchester Evening News Arena behind and the Boddington's Brewery chimney at right.

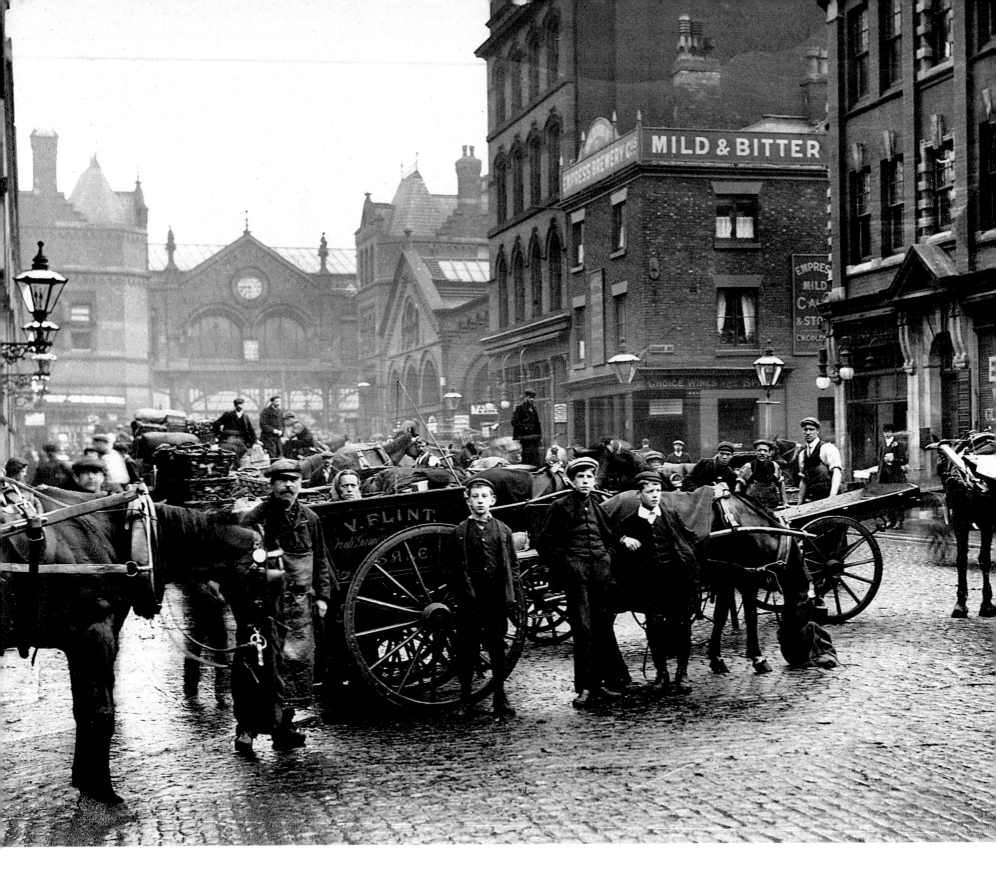

HIGH STREET

By 1897 Manchester's wholesale markets covered four and a half acres

Left: By the nineteenth century the chaos, smell and upheaval of the markets around Fennel Street and the cathedral needed to be addressed. They were moved lock, stock and barrel to the Shude Hill end of town with access from the High Street, pictured here. Purchased by the city in 1846, by 1897 the wholesale markets covered four and a half acres. They were the largest in the UK: a noisy, crazy, occasionally tatty tourist attraction for visitors and famous as a place to get good deals (especially Saturday afternoon when produce was sold off cheap before Sunday's day of rest). The markets were also notorious for their conmen. This picture from 1907 shows the extended market buildings in the background with a group of runners, ragamuffins and barrow boys in the foreground: a vivid moment from a lively area.

Above: The markets were relocated in 1973 when Smithfield Wholesale Market was pushed out to a soulless purpose-built complex in Openshaw. This area of the city centre fell into decline. Many of the market halls were demolished. Then in the 1990s a resurgence took place; flats occupied the shell of the old wholesale fish market from 1873 on the left of this picture. The area was rediscovered as a smart place to go out as bars such as Socio Rehab moved into the old market agents' buildings on the right, and restaurants such as the Northern Quarter Bar and Restaurant appeared further up the street. The 'Mild & Bitter' Empress Brewery public house on the corner of Edge Street (right in the 'then' photo) is still providing alcoholic refreshments, now under the name of The Market Restaurant. As new apartment blocks continue to fill in the gaps, the old markets area, now called the Northern Quarter, is once again starting to buzz with life.

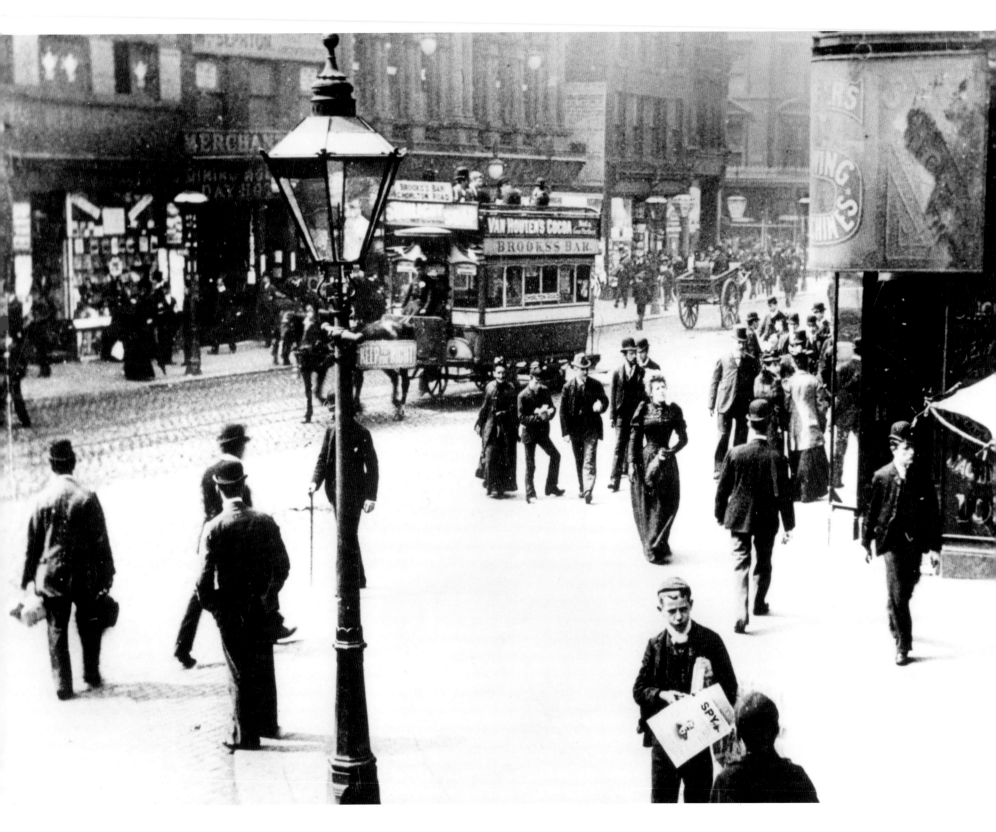

MARKET STREET JUNCTION

Looking north along the High Street

Left: This view from 1894 shows the junction of Market Street with High Street, looking north along the latter. There's some Manchester irreverence in the picture; the boy in the foreground is selling *Spy*, a short-lived Manchester satirical magazine. There is a horse-drawn tram in the middle distance leading its passengers back two miles to the placid suburb of Brooks' Bar (see page 117). Trams were not electrified until 1900; a report in 1893 had shown that the 385 tramcars of Manchester Carriage Company had required 3,583 horses. You had to mind your step when walking the streets.

Above: In the modern view High Street has lost its row of individual buildings along its west side, replaced by the monolithic Manchester Arndale. This shopping centre, constructed between 1972 and 1980, was derided from the start as the 'biggest public toilet in Europe'. This was on account of the urinal-like yellow tiles bought cheaply and in bulk from Germany. This part of the Manchester Arndale is the only remaining area – aside from a central tower block – that still sports its original look; the rest has been much improved. After World War II the tram lines were removed but this view shows them back in place. They returned in 1992. The corner building on the right, now a Debenhams department store, was originally the Rylands textile company warehouse finished in 1932 by Harry S. Fairhurst in white Portland stone.

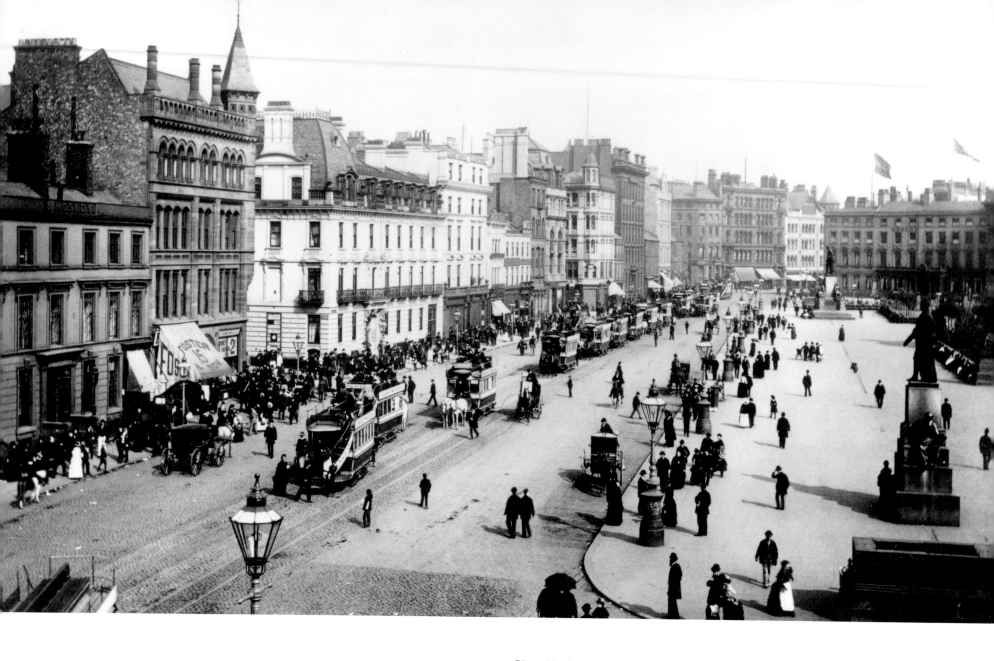

PICCADILLY GARDENS

The main esplanade of Piccadilly in the 1890s

Piccadilly Gardens has had several titles. By the time of this 1890s picture it had settled on its present name after a brief period as Portland Place. It is an area of the city where planning and public space have clearly been taken into consideration. The view here shows the main esplanade of Piccadilly, alive with horse-drawn trams. The statue of free trader and Bury-born Prime Minister, Robert Peel (1788–1850) is prominent at right. In the distance, beneath the flying flags, is the 1845 Queen's Hotel. The buildings on the left have varying heights and a range of uses that include inns and hotels. An early nineteenth-century plan for Piccadilly was never realised. This would have created lines of regular and very upmarket stucco buildings like those designed by John Nash for Regent's Park in London.

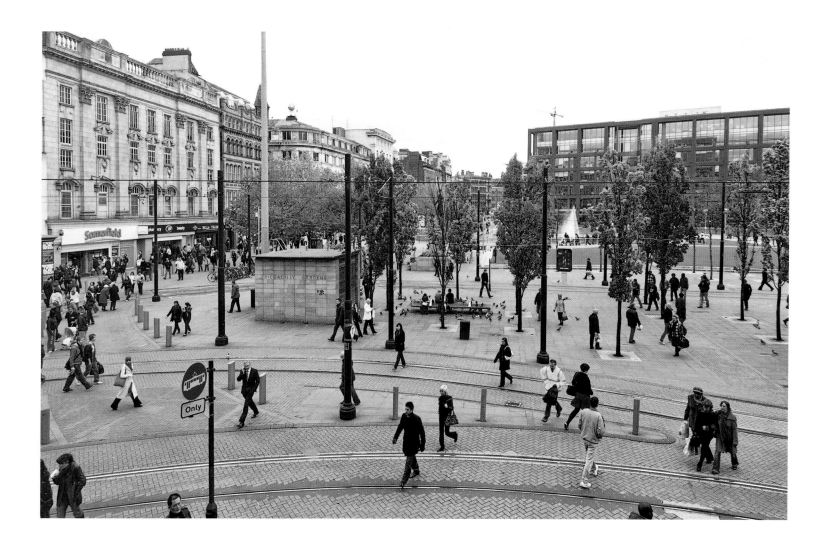

Today the scene has changed but the importance of the area as a focus for the city hasn't. There's been large-scale pedestrianisation but the statue of Robert Peel is still visible between the trees. The landscaping, complete with fountains on the right side of the picture, was intended to prettify the area for the Commonwealth Games of 2002. New tramlines cross in the foreground from ten years prior to that date. The sale of the land for One Piccadilly, the red brick and glass building in the right distance (on the site of the old Queen's Hotel), paid for the improvement of the gardens. The older picture was taken from the Royal Hotel where the Football League had been founded in 1888. The modern photo was taken from its successor, Royal Buildings, now offices and a bank. The buildings on the left are largely made up of bombastic Edwardian or 1920s structures.

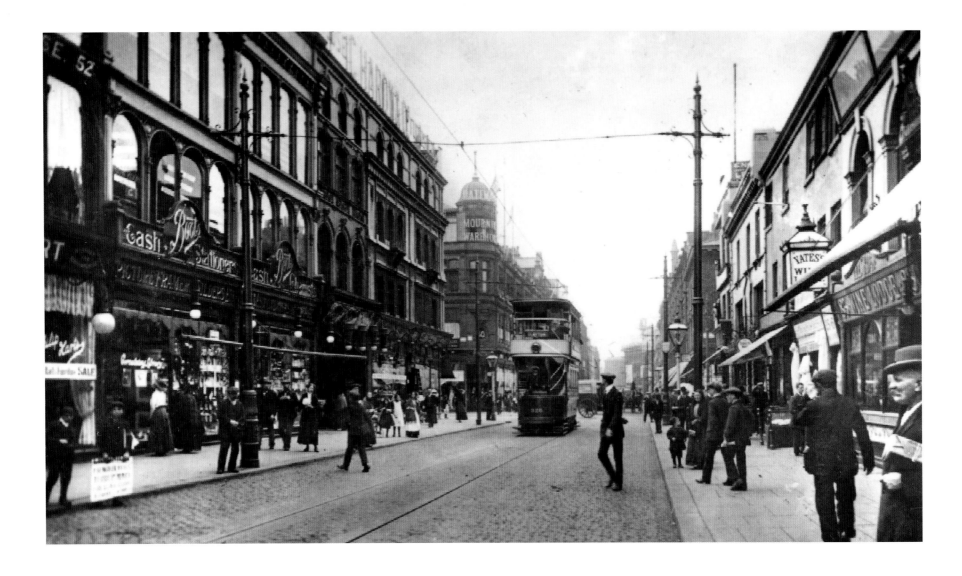

OLDHAM STREET

Named after the eighteenth-century developer Hugh Oldham

This view shows Oldham Street looking south to Piccadilly Gardens in 1900, when it was *the* place to come for women's and men's fashions. The street, which by coincidence runs in the direction of the town of Oldham, was in fact named after Hugh Oldham who developed this stretch of land in the eighteenth century. Smart home-grown stores such as Afflecks and Brown – the dark building with the awnings on the right of the street in the distance – catered for all a lady might require. On the near right in this picture is a Yates's Wine Lodge, a representative of a company born in Oldham in 1884. This became a legendary pub chain in the North, introducing exotic drinks such as 'the blob' – a mix of fortified white wine, hot water, sugar and lemon.

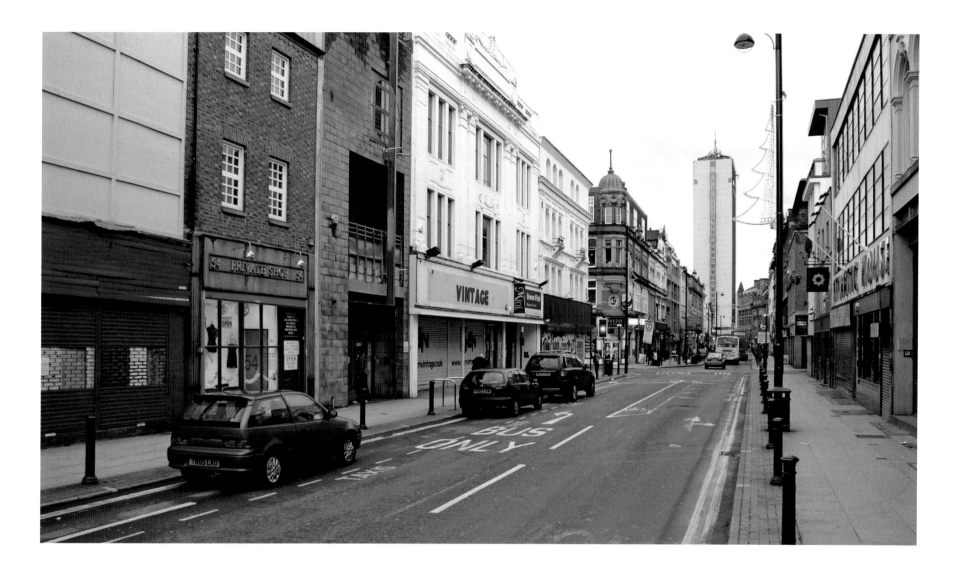

Oldham Street collapsed commercially when the Manchester Arndale Centre opened in the 1970s. Throughout the Eighties and Nineties it slid into decay, although it remained a famous drinking area. Rag trade and sex shops moved in, with a representative of the latter on the left, approximately where Boots stood in the 1900 photo. In the last 15 years the area has been rechristened the Northern Quarter and been revitalised with a series of independent clothes and record shops, apartments and bars, often aimed at students and the younger end of the market. Vintage, on the left, is a store that recycles second-hand clothes for resale. The new businesses were attracted by the low rentals of the area. The 107m (350ft) 1965 office block City Tower dominates this view at the end of the street.

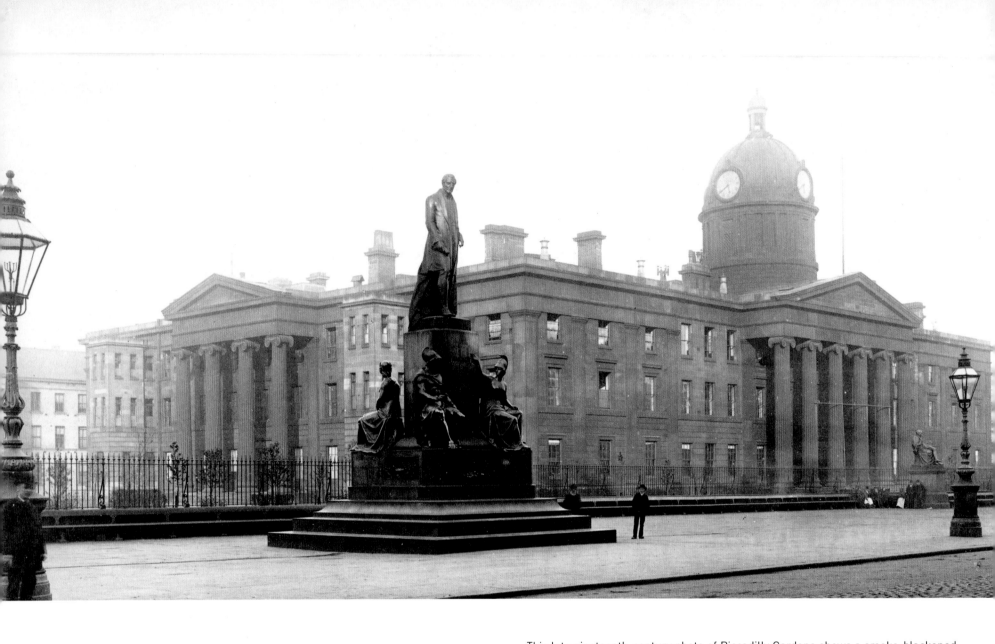

This late nineteenth-century photo of Piccadilly Gardens shows a smoke-blackened Manchester Royal Infirmary. Piccadilly was where the stagecoaches from London arrived at coaching inns and this would have been the first notable building that visitors from the South encountered: a hospital with, by the time of this picture, a lunatic asylum and public baths contained within. The statue of the Duke of Wellington by Matthew Noble from 1856 stands prominently in the foreground. The famous soldier is dressed in civvies to reflect his post-Battle of Waterloo political career. The first infirmary was built here in 1755, donated for public use by the Lord of the Manor, Sir Oswald Mosley. Before then the area had been previously known as Daub Holes, where clay was taken for wattle and daub to fill the gaps in timber-framed buildings.

ROYAL INFIRMARY

In the 1900s the hospital included public baths and a lunatic asylum

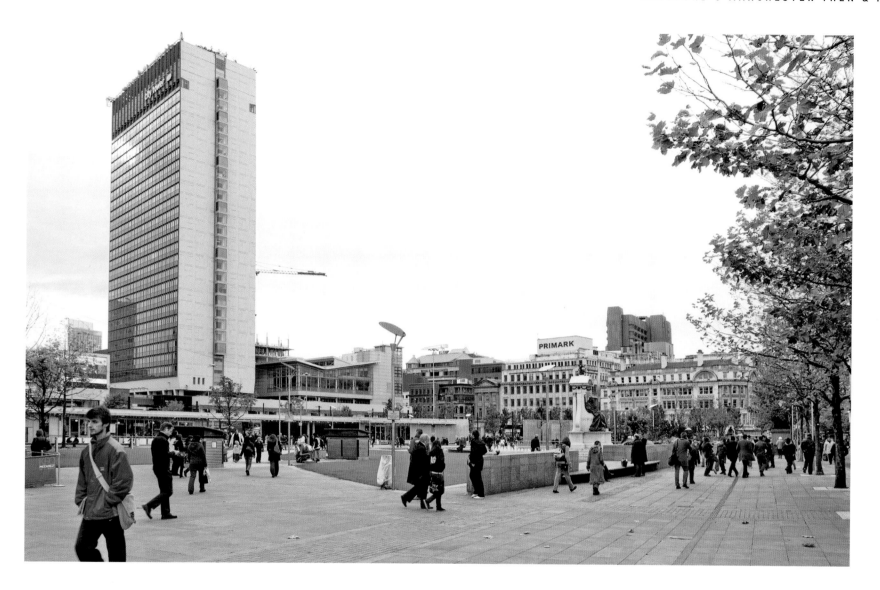

The infirmary was closed in 1908 and moved to Oxford Road. Eventually, the infirmary's old site was cleared and plans for a new art gallery were drawn up. Whilst the arguments raged about how to fund the project, sunken gardens were introduced. None of the gallery plans came to fruition and by the 1990s lack of maintenance had resulted in the sunken gardens becoming populated by drunks. For the 2002 Commonwealth Games Piccadilly Gardens was re-landscaped with a series of lawns and fountains under the direction of the Japanese design practice of Tadao Ando. The statue with the worst press is to the right of the centre in this picture. This seated statue of Queen Victoria, framed in Portland stone and unveiled in 1901, was described by one critic as 'at once the most pretentious, incoherent, and inept monument ever seen in England'. The 107m (350ft) City Tower dominates this view.

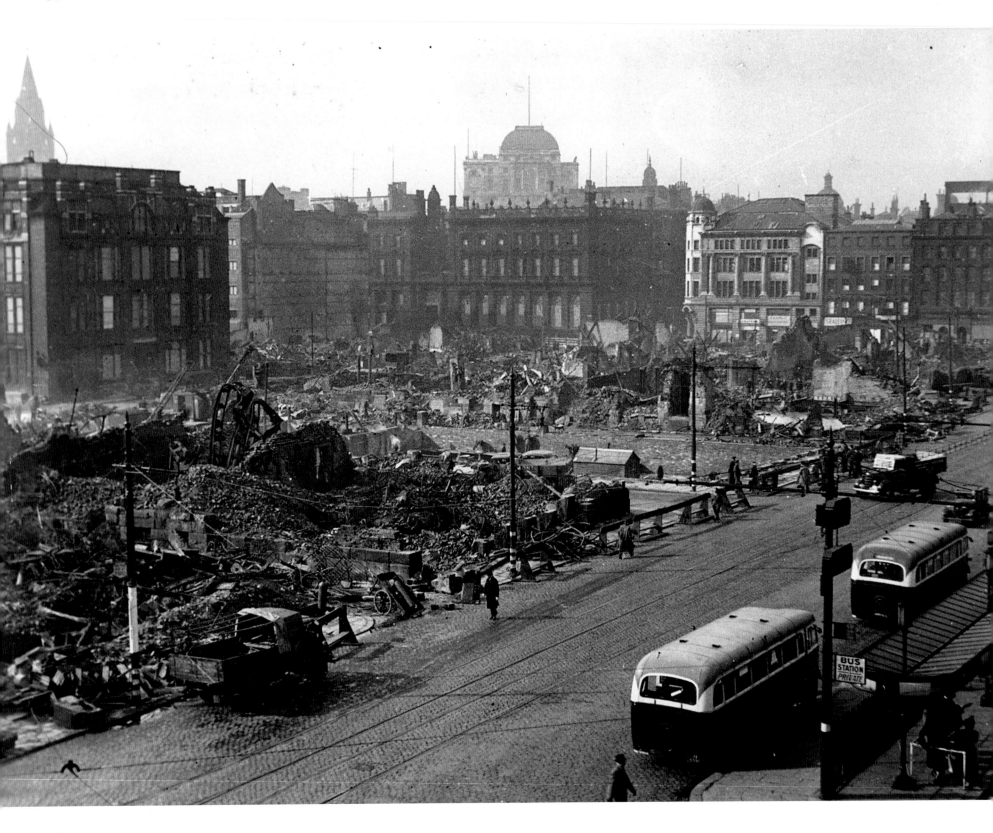

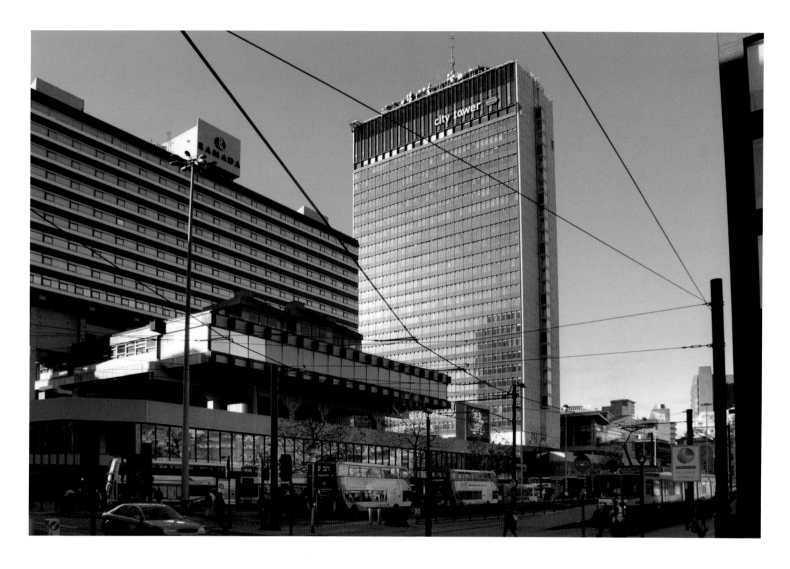

PARKER STREET

Piccadilly Gardens, following the 'Christmas blitz' of 1940

Left: This is Parker Street in 1941, the year after Manchester was hit hard by Nazi night bombers. The most intensive attacks took place between 22 and 24 December 1940 – the so-called Christmas blitz – killing around 684 people and injuring more than 2,300. The city centre was heavily damaged at great cost to some of Manchester's best buildings. The range of textile warehouses along Parker Street, which made up one side of Piccadilly Gardens, was destroyed. The cotton bales within caught fire and the flames were so intense that people on the moors 15 miles away gathered to watch Manchester burn. In contrast, here a placid bus station operates next to the ruins.

Above: In the modern picture the buses are still here. Trams, as seen on the right, have joined them too. The buildings occupying the bomb damaged area in the older view are those of Piccadilly Plaza. The 1945 Manchester Plan had envisaged the area between Piccadilly and Oxford Street as a mini-Manhattan with towers occupying every block. The post-war economy wouldn't support that but a belated start was made with the city's most adventurous experiment in Brutalism – the series of buildings seen here, arranged on a huge concrete podium. Completed in 1965 by Covell, Matthews and Partners they comprised office space, shops and a hotel. The latter (now The Ramada) is on the left and once shared space with the famous but now defunct Piccadilly Radio. The imposing City Tower has circuit-board decoration on its narrow side, underlining Manchester's development of Baby, the first stored programme computer from 1948. When first built, Mancunians saw the Piccadilly towers as an exciting vision of the future. Over time the buildings were dismissed as ugly examples of 1960s architecture, but they have recently been refurbished and local affection for them is returning.

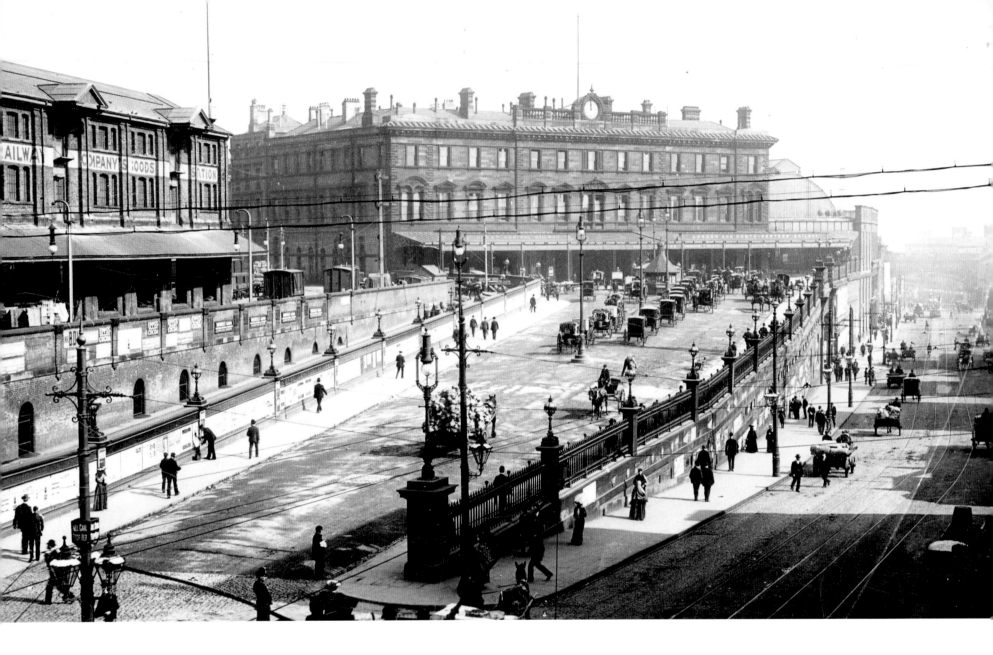

This splendid sunlit picture from 1901 shows off London Road Station on its elevated brick platform. This was the main station for travel to London, just over four hours away. Cabbies are strung along the road in front of the station waiting for passengers. The cabs were known as 'growlers', either because of the noise they made as they creaked through the streets or because of the way the drivers would grumble. On the left is the London and North Western Railway Company warehouse. The latter company shared occupancy of the station with the Manchester, Sheffield and Lincolnshire Railway Company. The first station had been built here in 1842.

LONDON ROAD / PICCADILLY STATION

The main station for travel to London

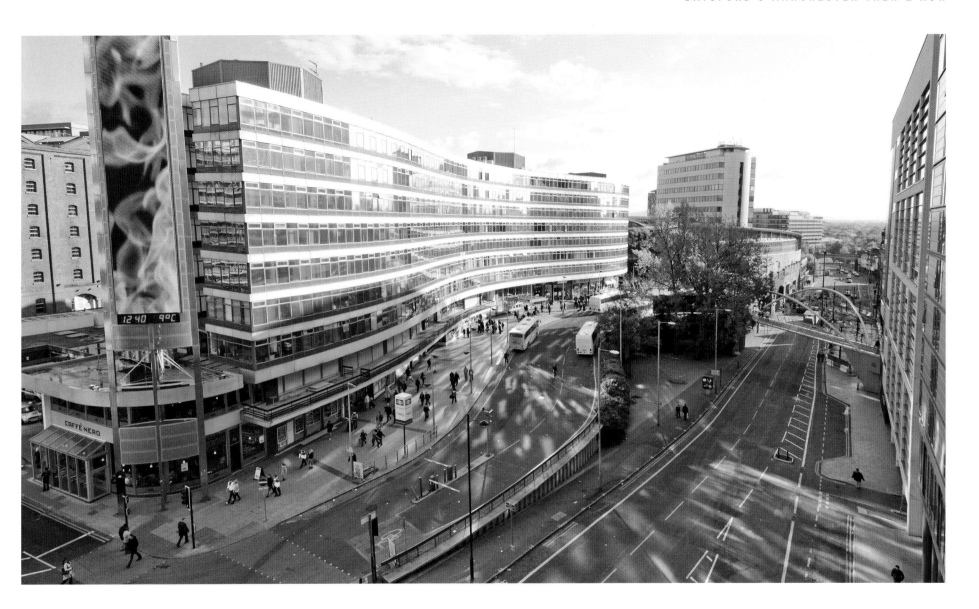

The constant in the two pictures here is the Station Approach, the long ramp to the
engine sheds. Everything else has changed, although the red-brick Manchester,
Sheffield and Lincolnshire Railway Company warehouse of 1867, now an apartment
hotel, can be glimpsed on the extreme left behind the tall digital advertising display.
The latter is an echo of the posters lining the Station Approach in the earlier photo.
The serpentine building snaking up the Approach is Gateway House by Richard Seifert
from 1969. It was at this time when London Road Station became Piccadilly Station.
Journey times to the capital, at their optimum, are now just over two hours. The new
footbridge on the right is called the Manchester Curve and dates from 2006. While
taxis have been relocated to Fairfield Street on the south side of the station the cabbies
themselves are still sometimes known to growl.

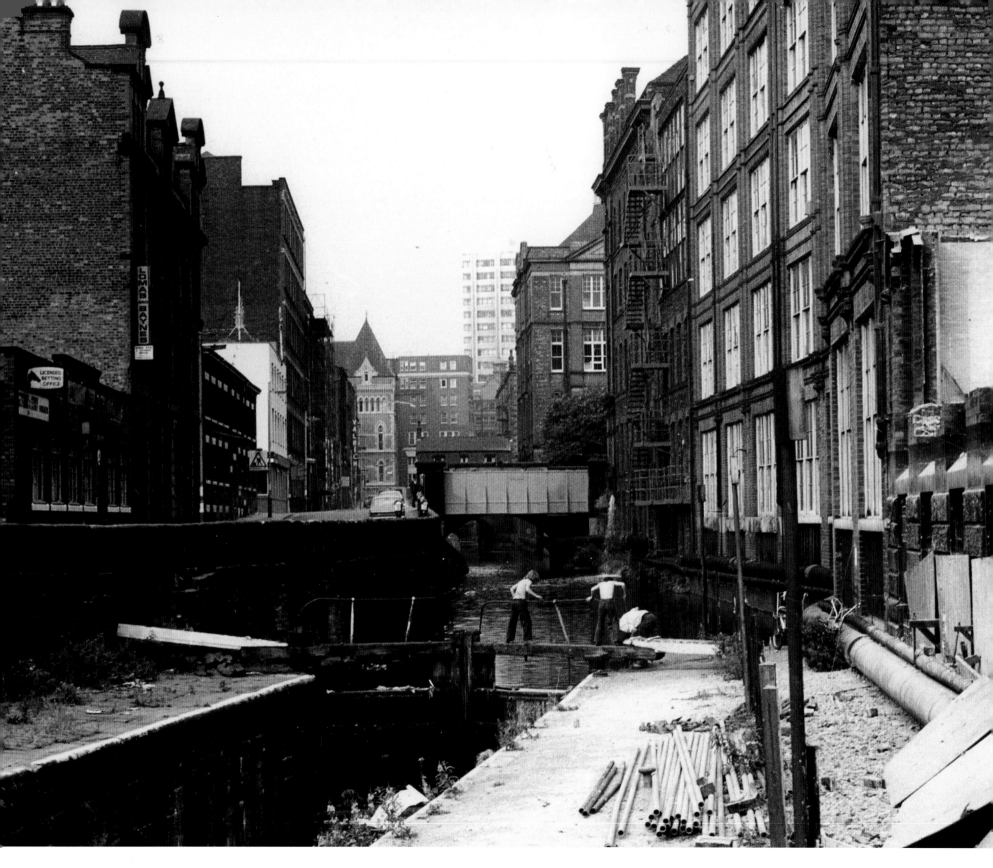

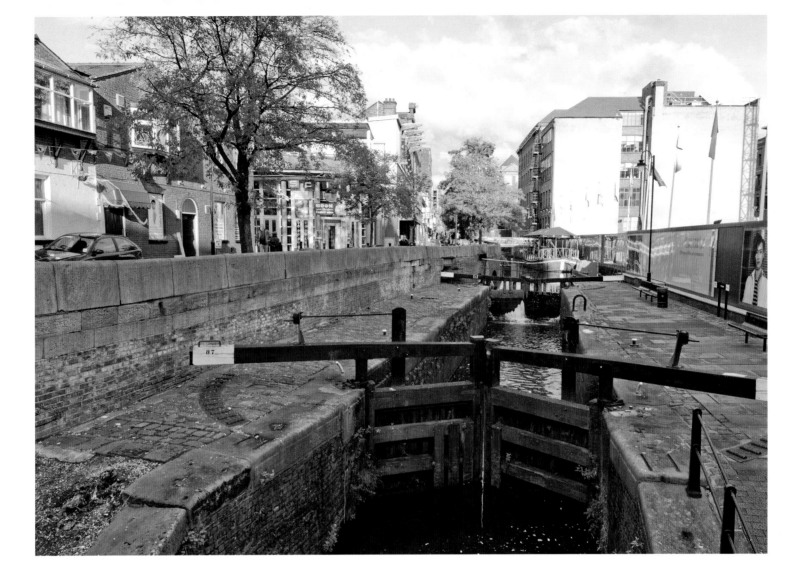

CANAL STREET

Now the centre of Manchester's Gay Village

Left: This photo from 1973 shows boys playing on lock gates along the Rochdale Canal – lock 87 of 92 to be precise. The Rochdale Canal was the first waterway to cross the Pennines and create a water link between the Irish and North seas. The Manchester stretch of the Rochdale Canal first opened in 1804–06. In the mid-nineteenth century, canal arms pushed into the surrounding streets creating a vast inland port serving the mills and warehouses. By 1973, after the decline in the cotton industry, the properties seen here were becoming vacant or being earmarked for demolition and the canal itself was almost entirely disused. However, change was in the air: the country was about to join the European Economic Community and in 1974 Manchester left the old county of Lancashire to become the centre of the 2.5 million strong county of Greater Manchester.

Above: Since the 1973 photo, Rochdale Canal has been reborn to tourist traffic, with a fundamental change in the character of the area. The street behind the wall on the left of the picture is Canal Street – the central axis of Manchester's Gay Village. The street is lined with bars and restaurants and hosts one of Manchester's key festivals, Pride, on the last bank holiday in August. The 'Village', as an idea, had been around for several decades – at least since the 1960s – but it was only fully realised in the 1990s. It has a long pedigree, however. The location was industrial, little frequented by polite society and with few dwellings. Even in the nineteenth century, this twilight zone, was a rendezvous for 'queer' folk – grudgingly tolerated by the police, with occasional raids to show who was boss. The building on the extreme left (out of frame in the 1973 photo) is the New Union, a public house for more than 150 years.

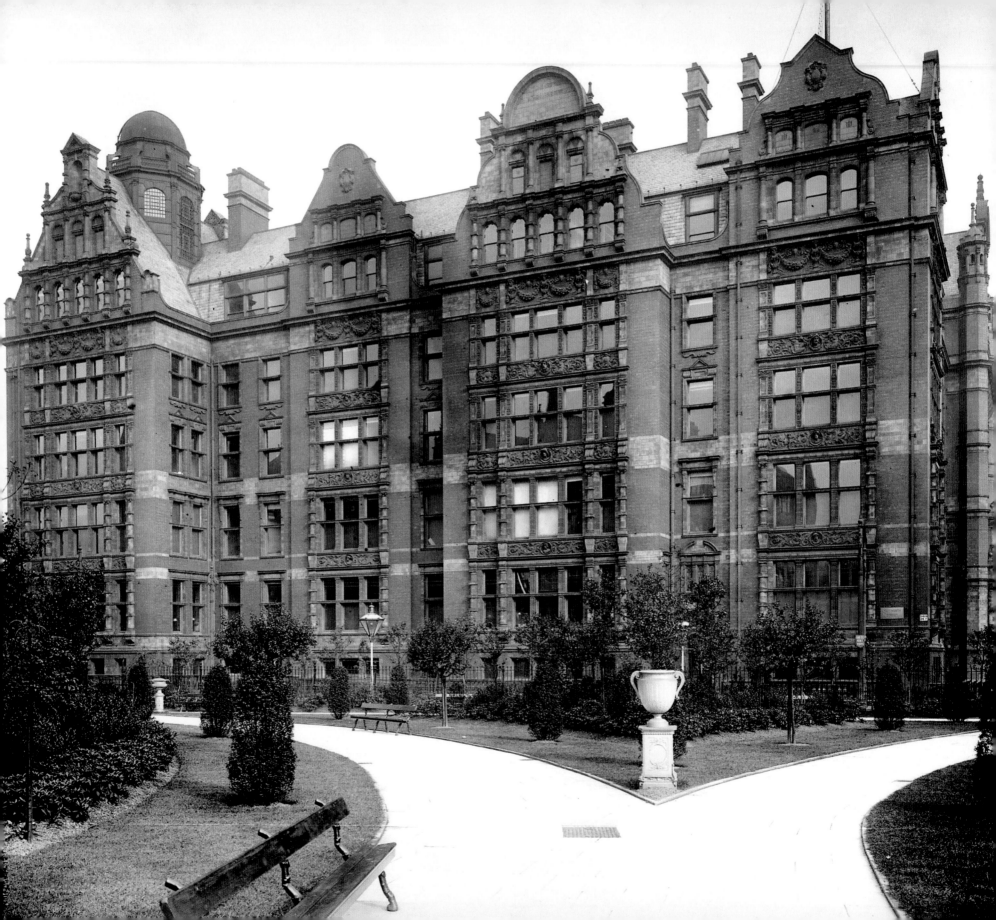

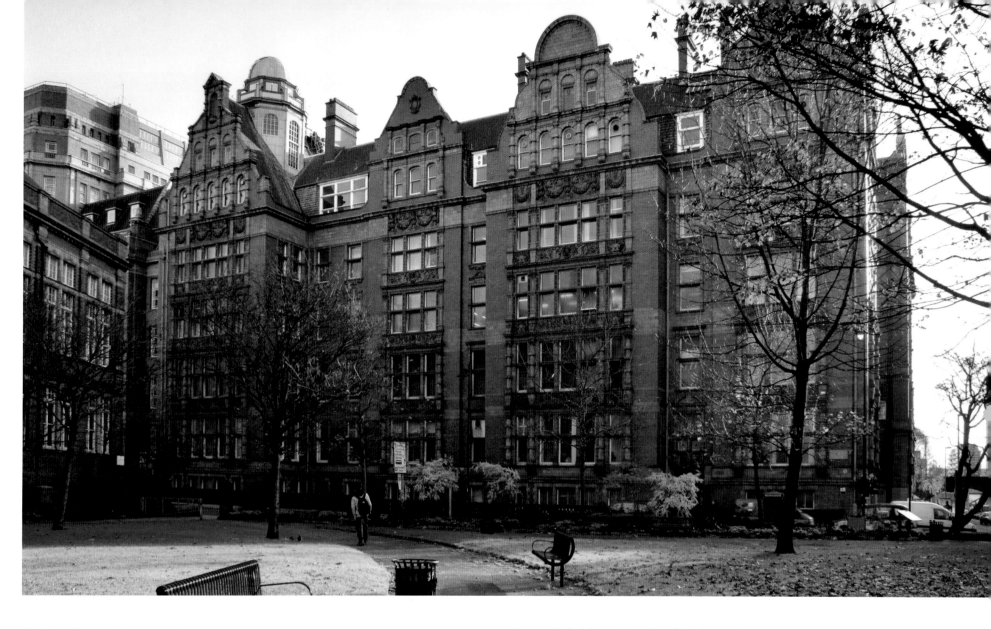

SACKVILLE GARDENS

The Renaissance-inspired Municipal School of Technology was completed in 1902

Left: Sackville Gardens was bought by the Education Committee at a cost of £25,526 in the 1880s to provide an uninterrupted view of its technological school. This photo from 1907 shows the technical school's second home, the imposing Municipal School of Technology, constructed between 1895 and 1902. Designed by the architects Spalding and Cross, it is an elaborate phantasmagoria of Renaissance inspiration in brick and terracotta mixed with the occasional Elizabethan touch. The Victorians and Edwardians were nothing if not architectural magpies. This grand building proclaimed Manchester's importance in the fields of science and technology. After decades of domination by countries such as Germany and the United States – who were beginning to threaten Britain's and therefore Manchester's industrial hegemony – the city responded with an institute offering technical and scientific training.

Above: The urn has gone, and so has some of the more elaborate shrubbery, but past and present still look remarkably similar here. Today Sackville Gardens provides a welcome green space in the city. After being owned by the city council, the Municipal School of Technology became part of the University of Manchester Institute of Science and Technology. In 2004 the latter merged with the Victoria University of Manchester to become one institution – the University of Manchester. On top of the building is the domed Godlee Observatory. This is still the home of the Manchester Astronomical Society and still has its original Grubb telescope. The dome rotates to allow views of the heavens from all quarters.

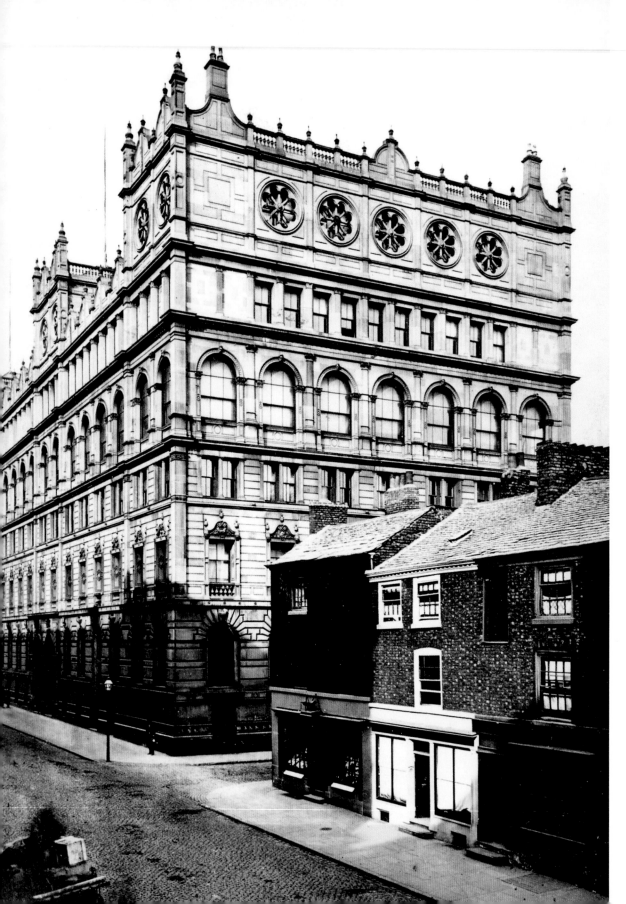

WATTS WAREHOUSE / BRITANNIA HOTEL

Designed by the architects Travis and Mangnall in 1857–58

In this 1866 photo the vast S&J Watts Warehouse dwarfs early nineteenth-century houses on Portland Street. The Watts Warehouse was the biggest of the city's sole occupancy textile warehouses. It was designed by the architects Travis and Mangnall in 1857–58 and cost £100,000. Each floor has a different architectural treatment: Egyptian at the base rising through Italian Renaissance, Elizabethan and French Renaissance, to four great roof projections lit by rose windows. In its heyday, the warehouse would process 1,000 large-to-small orders each day. In 1867, a journalist from *Freelance* magazine wrote: 'I am not naturally of a sceptical or suspicious cast of mind. I have eaten sausages and kidney pudding without asking questions but when I was told that this was only a warehouse, I felt that it was necessary to draw the line of credulity somewhere.'

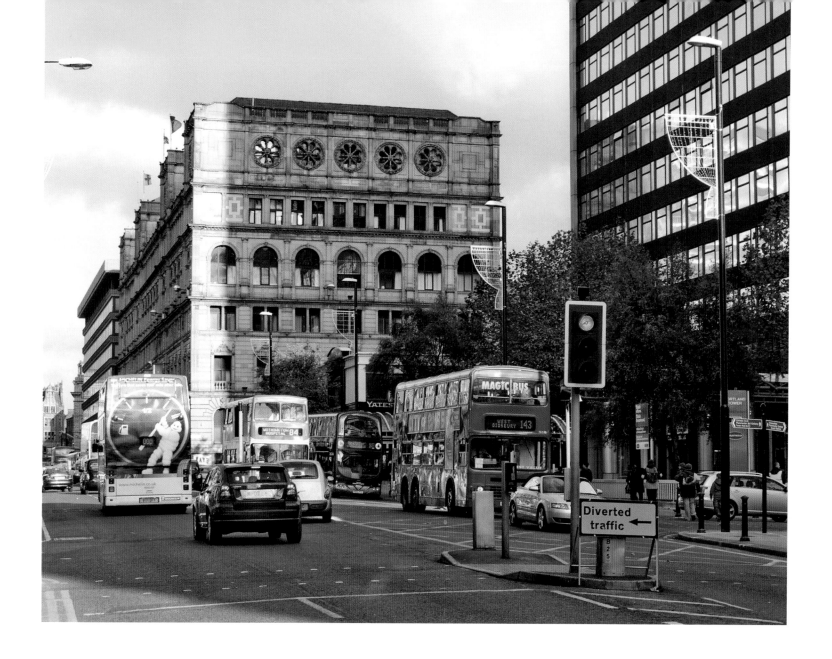

Today Watts Warehouse is the Britannia Hotel and has the 1960s for company in the shape of Portland Tower. That it's here at all is a surprise. In December 1940, the whole area was hit by incendiary bombs. With the cotton bales blazing at thousands of degrees, many buildings were consumed, whilst others were demolished to prevent the fire spreading. One of those that had to be sacrificed was this one. The decision was passed to Chief Fireman Wilf Beckett of the company's own brigade. He refused to budge. Incredulous, the authorities cut off the supply of water to Beckett. The little volunteer force then fought the fires with blankets and sheets until the temperatures outside cooled. In 1972 the building closed as a textile warehouse and in the 1980s was converted to the hotel we see today. Originally opening with 25 bedrooms and a nightclub, today the hotel offers 365 bedrooms.

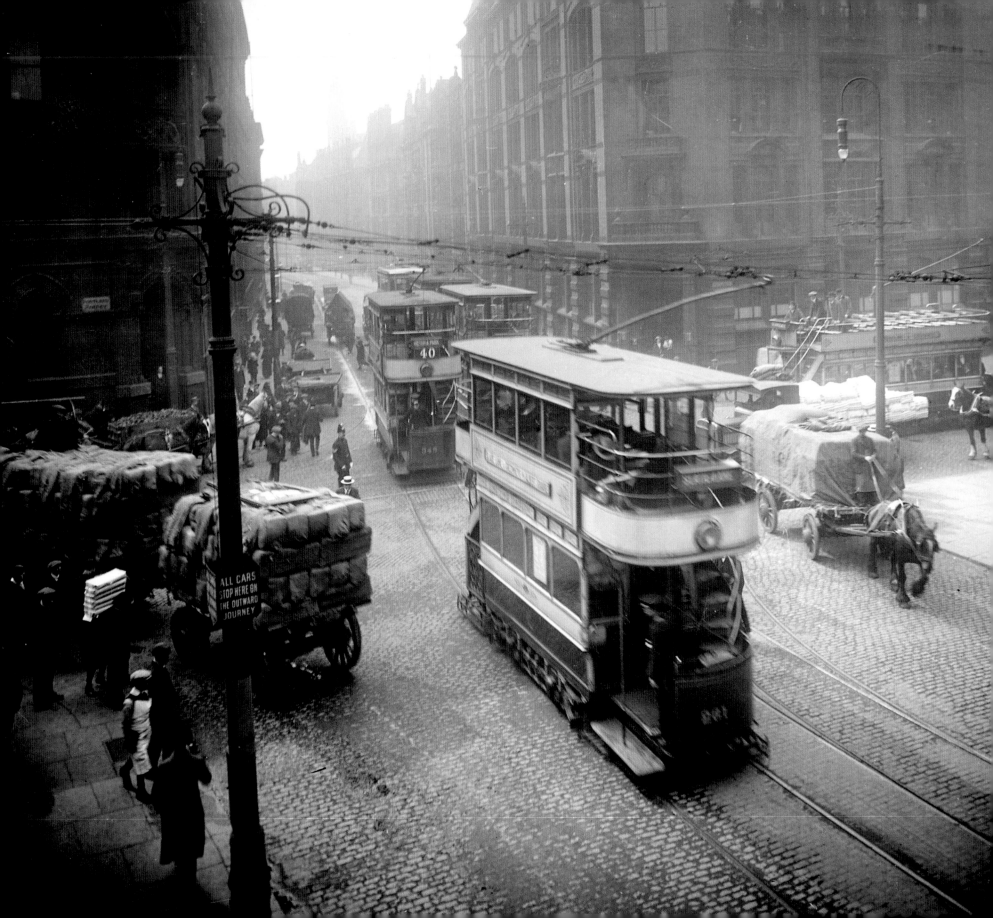

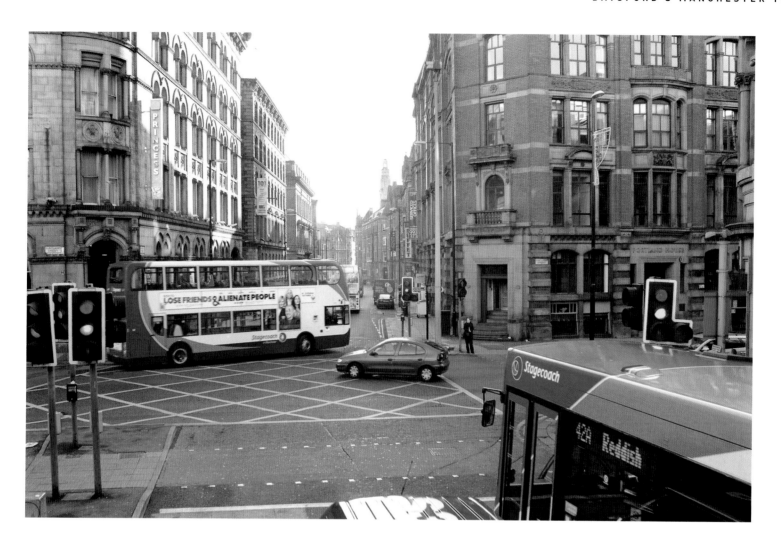

PORTLAND STREET JUNCTION

Once the centre of Manchester's warehouse district

Left: This remarkable picture from 1914 shows traffic congestion at the junction of Portland Street and Princess Street (straight ahead). Here electric trams vie with cotton carts in the centre of the warehouse district. The word warehouse doesn't do the buildings justice though as they were always much more than that: more like textile showrooms, each competing to make a bigger impression. The Baroque tower just visible at the end of Princess Street is Lancaster House. Owned by Lloyd's Packing Company, it opened in 1909 as a cotton warehouse. One man on the left is carrying cotton samples, noticeable by their astonishing whiteness in this murky scene. There is not an internal combustion engine in sight. The young men in the picture are soon to experience Flanders and Gallipoli: within six years the buildings will start to carry memorials to their dead.

Above: Today many of the buildings are still there but none of them has its original use. Portland House, the redbrick building on the right (designed by Pennington & Bridgen in 1887) has been converted into offices with a Mexican restaurant in the basement. The distinguished stone building on the left (built between 1858 and 1863 by Clegg and Knowles and originally known as the Pickles Building) is now the Princess Hotel. Lancaster House, whose tower is still visible, has been converted into apartments. There is no cotton industry left in Manchester but the stately showrooms of the industry still define this area. Modern vehicles, buses in particular, dominate the photograph just as trams do in the older one. The helpless-looking policeman, centre left in the 1914 picture, has had his work replaced by traffic lights.

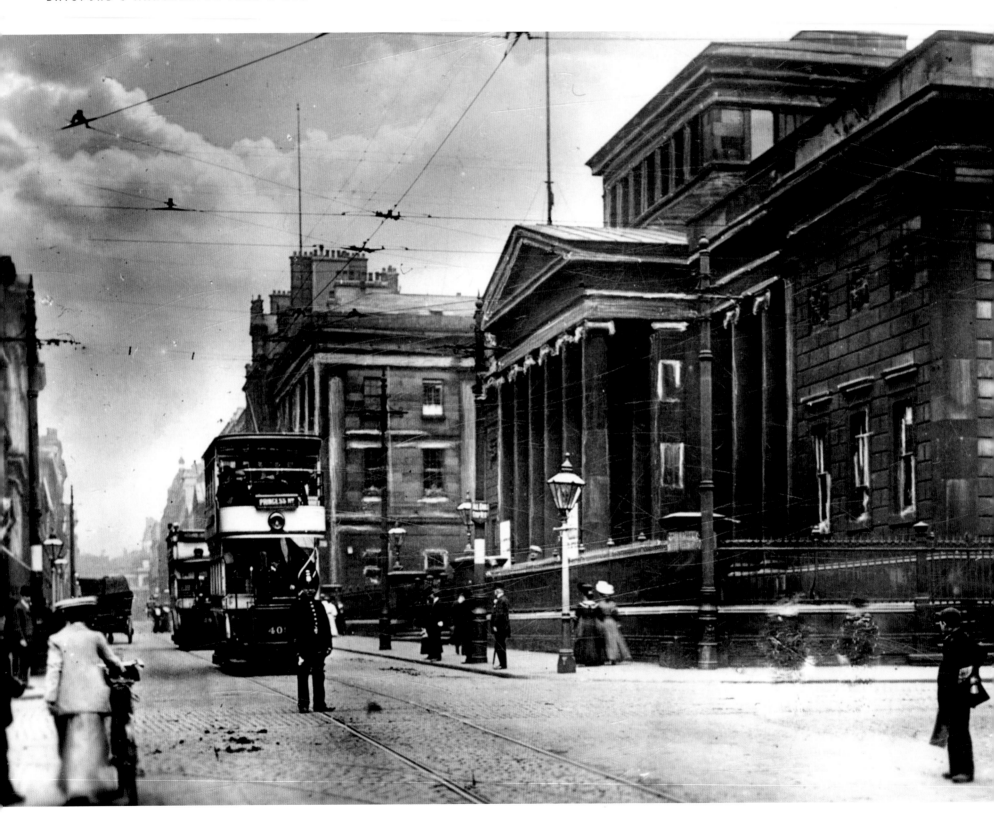

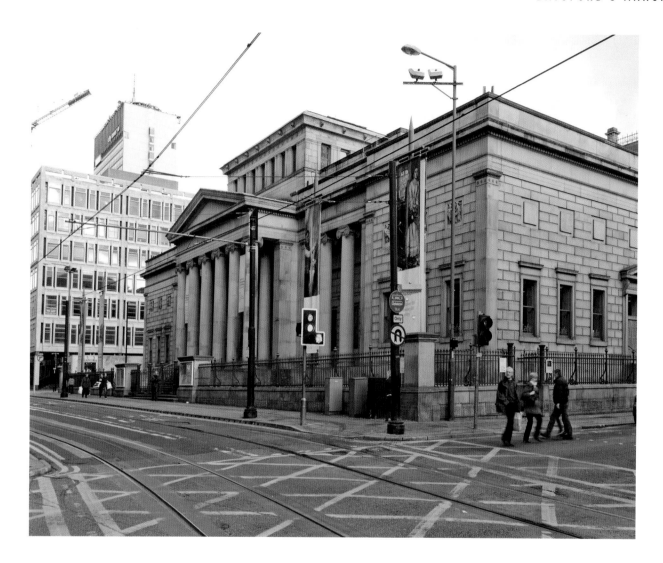

MANCHESTER ART GALLERY

Charles Barry's building marks the climax of Greek Revival architecture in the city

Left: When this photo was taken in 1905 Manchester Art Gallery on Mosley Street had been open to the general public for 23 years. The gallery was acquired by the city in 1882 and endowed with £4,000 per annum to spend on new works. The impressive columned building dates from the 1830s and began life as the private Royal Manchester Institution, an august body pursuing art and culture through display, lectures and meetings. The architect was Charles Barry and the building marks the climax of Greek Revival architecture in the city. The motto of Barry's competition entry for the building was *Nihil Pulchrum Nisi Utile*, which in Latin means 'nothing beautiful unless useful' – an apt Manchester statement. Charles Barry went on to design the Palace of Westminster, more commonly known as the Houses of Parliament.

Above: Cleaned, polished and given a £35 million dose of affection prior to the Commonwealth Games in 2002, Charles Barry's building looks as good as ever. The gallery's 2002 extension project included a new stone and glass wing designed by architect Sir Michael Hopkins. The extension project tripled the floor space available for the gallery's permanent collection. The gallery houses notable national collections of nineteenth-century work, especially from the Pre-Raphaelites, and key collections of twentieth century British art. Highlights include *Work* (1852–65) by Ford Madox Brown and *Hylas and the Nymphs* (1896) by John William Waterhouse. Outside the building the trams and tramlines have returned after a 50-year absence.

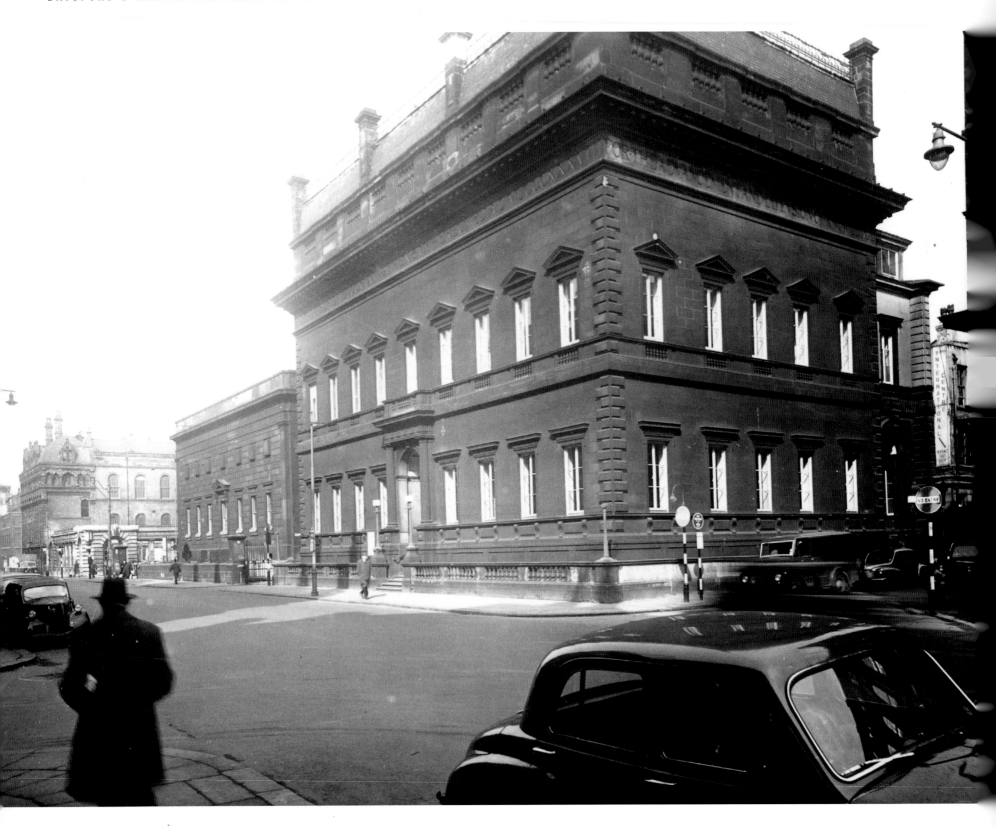

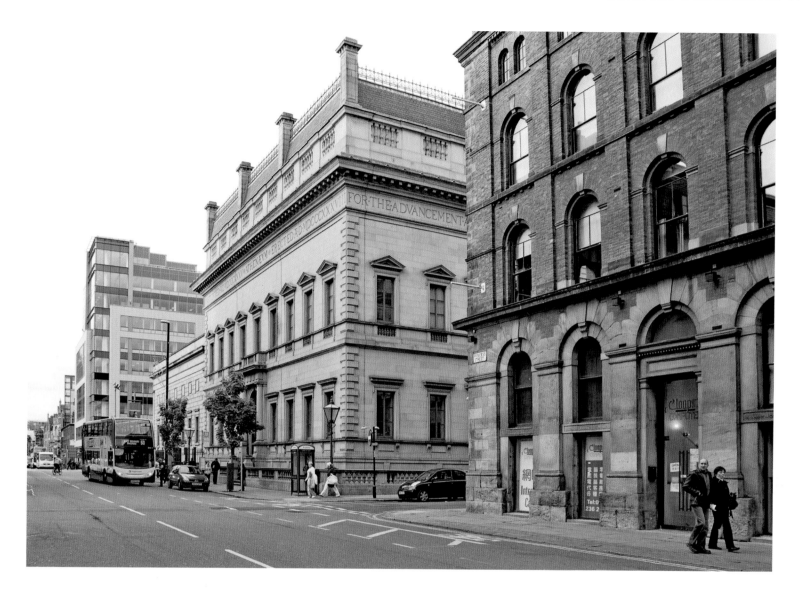

ATHENAEUM

Designed by Charles Barry as a gentleman's club in 1837

Left: The main building in this photograph from 1950 is the sooty Athenaeum. Along with the Manchester Art Gallery, whose side can be seen to the left, it's by Charles Barry. Completed in 1837 as a gentleman's club, the Athenaeum hosted guest speakers such as John Ruskin and Charles Dickens. The building marks a watershed in Manchester architecture. Barry modelled his design on the Italian Renaissance palaces of Florence and Rome, which set a precedent in Manchester that lasted decades. The 'palazzo' style, with its dignified proportions, grand entrance and regular windows appealed to the city's textile magnates and they aped it across the centre.

Above: In 1938 the Athenaeum was taken over as government offices. Eventually it was handed over to the City Art Galleries department, as overspill exhibition space for Manchester Art Gallery. With the 2002 Commonwealth Games pending and funding available, the two buildings were married together. A third new building was added to make one large structure that was at last adequate to hold the city's art collection, whilst also providing more room for temporary exhibitions. Now free of the soot that had blackened its surface, it is easy to see why buildings such as the Athenaeum would have impressed Manchester's nineteenth-century cotton traders.

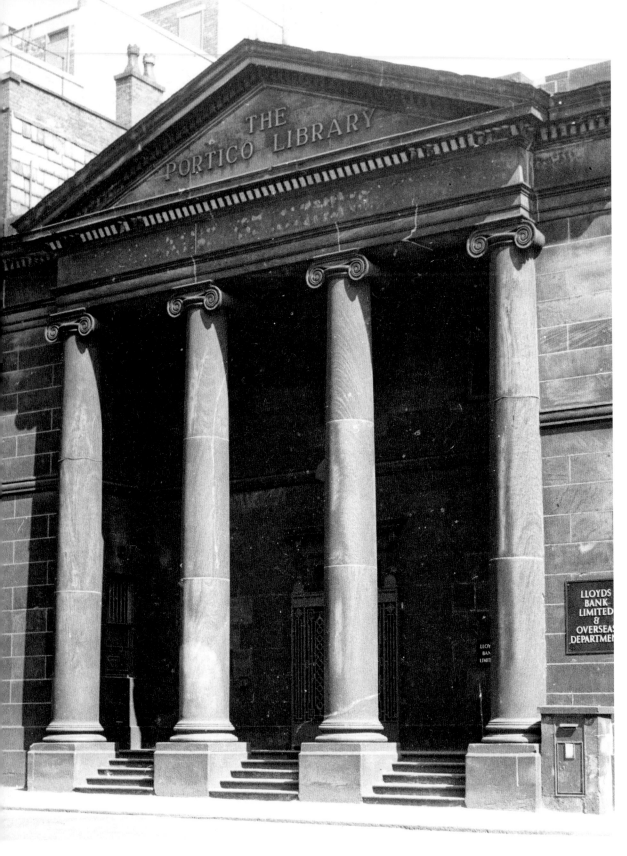

THE PORTICO LIBRARY

One of the UK's oldest subscription libraries

By the early 1800s Manchester was clearly on the up. Manufacturing in textiles and other products had increased exponentially and the city was feeling important, and perhaps slightly self satisfied. However, it also felt that it lacked a little culture. This area around Mosley Street was wealthy with large townhouses. A group of local men decided to build themselves a subscription library to enhance the city's cultural reputation. The result was the Portico Library, completed in 1806 to the designs of Thomas Harrison. The defining feature was the entrance, the neo-Greek portico that gave it its name. The first secretary was Peter Mark Roget, who would later go on to compile his famous thesaurus. Other members included John Edward Taylor, founder of *The Manchester Guardian*, and scientists John Dalton and James Prescott Joule. Novelist Elizabeth Gaskell's husband William was the second secretary; Elizabeth and her friend Charlotte Brontë were both visitors to the library.

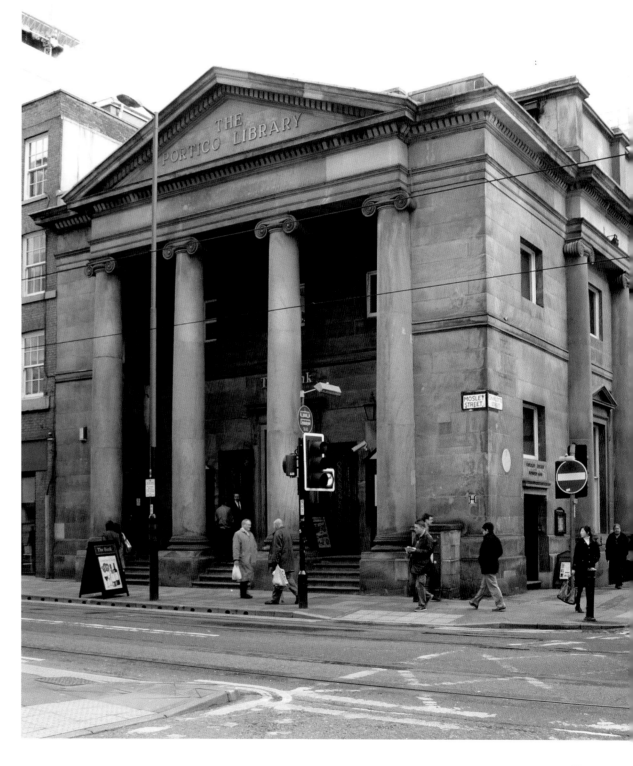

Many old buildings in Manchester have changed function. In the 1920s financial difficulties caused the lower floor to be sold off as a bank. In more recent years the lower floor opened as a pub, The Bank. However, The Portico upstairs is a constant and remains one of the UK's oldest subscription libraries. The interior, under an elegant saucer dome, still allows members to escape the city streets into an oasis of calm and culture, just as the founders intended. With initiatives such as the Portico Prize, given to books set in the North, plus lectures and art shows, the old building remains a focus of city life. Outside, all is changed; the residential character of the area disappeared not long after the building's construction, as textile warehouses took over. These, in turn, have been demolished or converted into modern office use. The post box on the Portico is the oldest in the city.

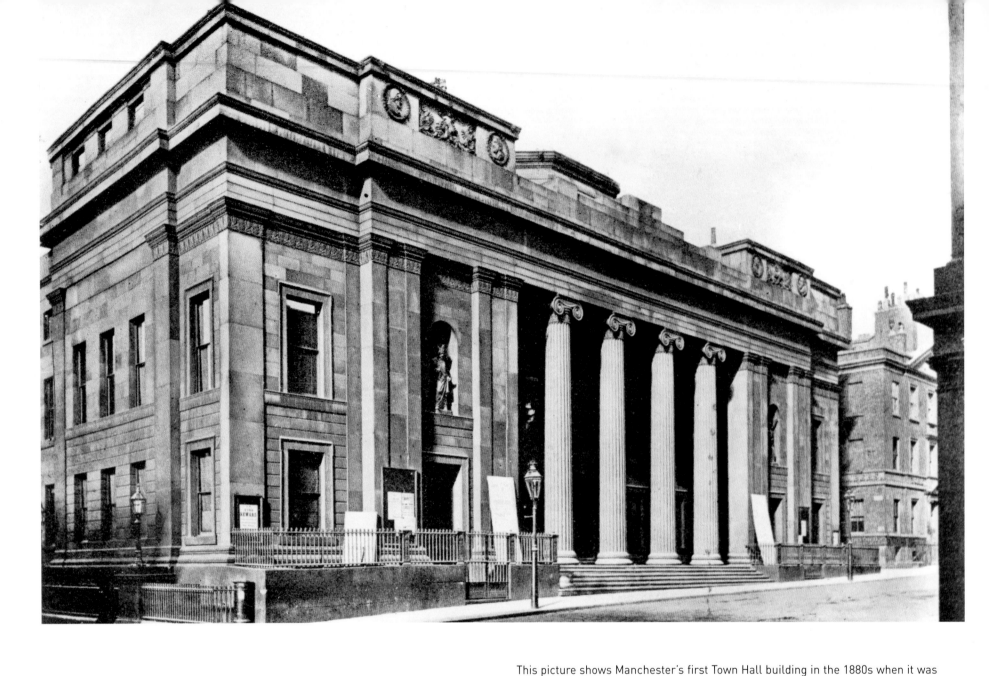

OLD TOWN HALL

Designed in 1825 by architect Francis Goodwin

This picture shows Manchester's first Town Hall building in the 1880s when it was used as the city's Reference Library. The Greek style building was designed in 1825 by architect Francis Goodwin and was home to the Police Commissioners. In the previous century, *Robinson Crusoe* author Daniel Defoe had called Manchester the 'greatest mere village' in the kingdom. This was because the town wasn't incorporated and had no elected officials, just a set of appointees from the Lord of the Manor, the absentee Mosley family – in other words it was run like a village. This archaic situation remained the same until 1838 with the Police Commissioners the key officers in the arrangement. Next door in this picture is one of the old town houses from the eighteenth century, which once housed the wealthy of Manchester bang in the city centre.

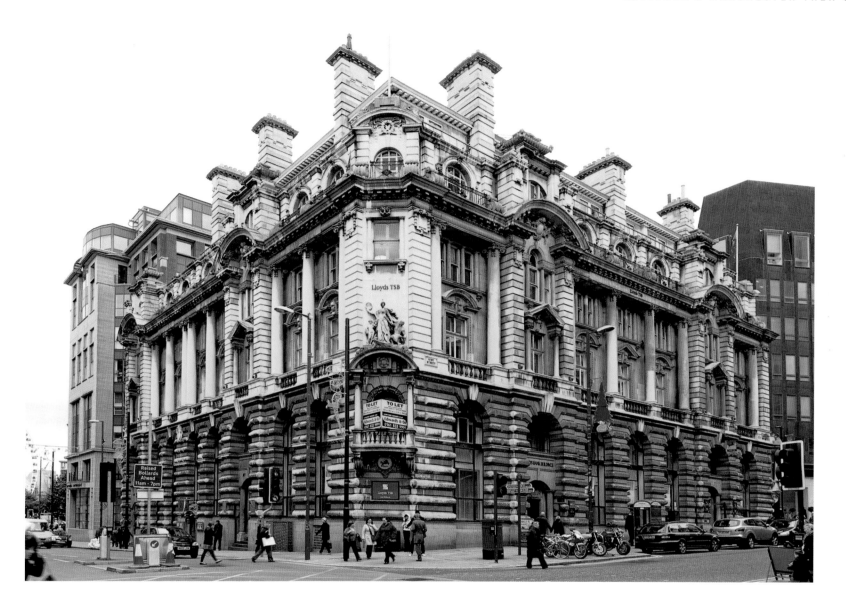

The former Lloyd's TSB building has taken the place of the old Town Hall. Designed by Charles Heathcote, this Portland stone building was completed in 1915. Although Heathcote was a prolific and acclaimed Manchester architect, this building was criticised for being excessive; one commentator writing: 'We are clearly supposed to find it magnificent but so much luxuriance cancels itself out and in the end the bombast seems hollow'. Next door in black Swedish granite is the former National Westminster Bank by Casson, Conder and Partners from 1969, now converted into offices and shops. This powerful building used black granite to match the smoke-blackened buildings of Manchester at the time. These have now been cleaned, making the Lloyd's building all the more prominent. The old Town Hall was demolished in 1911 but its facade was saved and re-erected in Heaton Park in north Manchester.

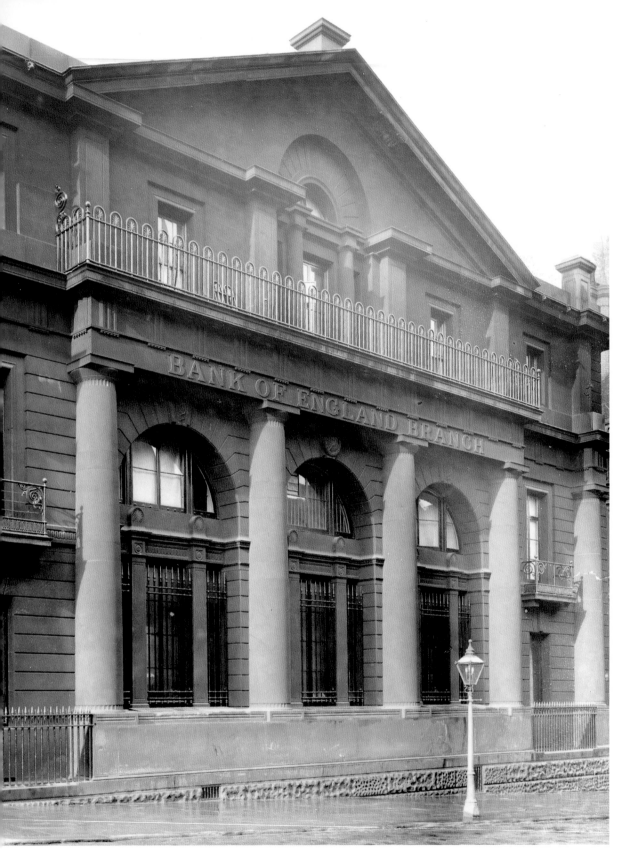

BANK OF ENGLAND

The first provincial branch of the Bank of England

This 1890s photo shows the Manchester branch of the Bank of England. It was designed by architect, archaeologist and writer, Charles Cockerell and finished in 1846. This handsome King Street building is based on ancient Greek ideas. It is a dignified yet clearly commercial Victorian building. Cockerell's genius, wherever he built, was to combine different epochs effortlessly. This was the first provincial branch of the Bank of England. It was built as a response to the opening of many local banks providing money to the entrepreneurs of the burgeoning industrial metropolis. In effect, the Bank of England wanted a piece of the action. By the mid-nineteenth century the eastern King Street area was the domain of finance and commerce: known as the 'Half Square Mile' in mimicry of London's 'Square Mile'.

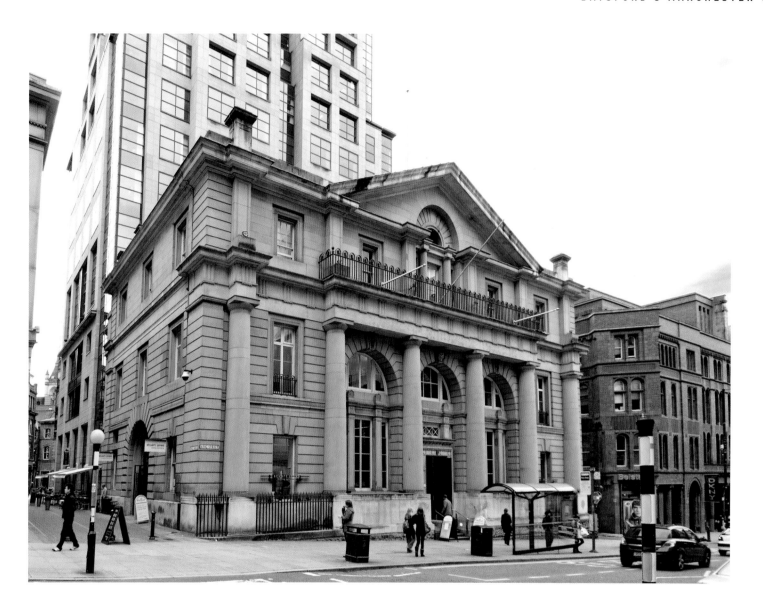

Today, technology, bank mergers and the changing needs of modern finance have left these buildings seeking new uses. The Bank of England has moved out of the city completely. There are fewer local banks as well, only the Co-operative Bank has its head office in the city. Still, despite conversion into offices and shops Cockerell's old building remains as graceful as ever, a splendid contribution to the King Street streetscape. Those who like 'spot the difference' games will notice the addition of a central doorway added to the building in the early twentieth century. Another larger addition is the 15-storey office block by Holford Associates, which rose behind the building in 1995. To the right of the building is the Prudential Assurance building by Alfred Waterhouse from 1896. It was through the use of such strong red terracotta that Waterhouse got the nickname 'Slaughterhouse Waterhouse'.

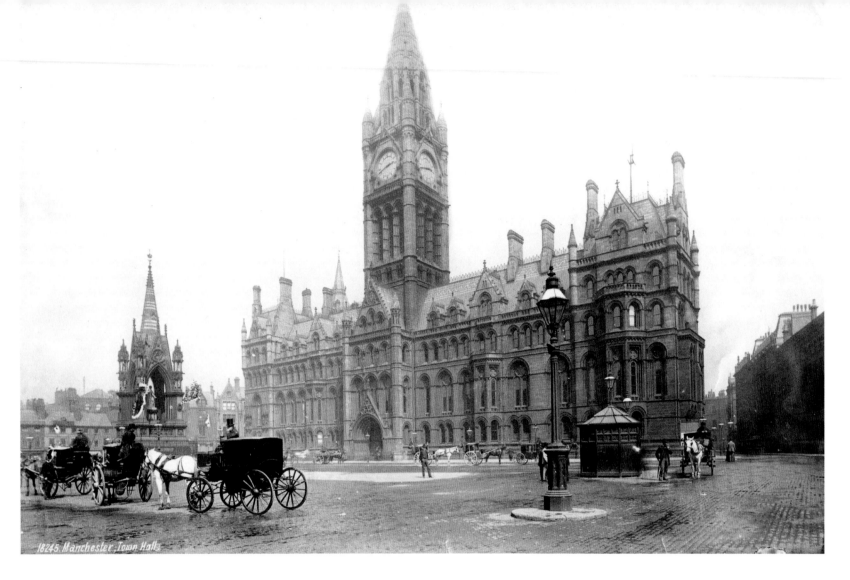

18245. Manchester; Town Hall.

TOWN HALL

Designed by Alfred Waterhouse, the Town Hall opened in 1877 at a cost of £1 million

Above: Manchester Town Hall has been called 'a classic of its age'. In some ways it is the Victorian civic building of all Victorian civic buildings; the arrogance, intelligence, dynamism and exuberance of the age carved in stone. Designed in the Gothic style by Alfred Waterhouse at a cost of over £1 million of local ratepayers' money, it was meant to show Manchester off as its own city state, in control of its own destiny and rich. When it opened in 1877 there was a procession by more than 40,000 working people from the region with examples of their crafts. During the opening banquet John Bright, MP, said: '(We are) standing in a district more wonderful in some respects than can be traced out on a map in any other kingdom of the world. The population is extraordinary ... for its interests and industries, for the amount of its wealth, for the amount of its wages, and for the power which it exercises on other nations.' Here it's pictured in the 1890s with Thomas Worthington's Albert Memorial from 1866 on the left of the picture.

Right: Cleaned of the soot that had adhered to it in industrial times, the true power and dignity of Alfred Waterhouse's design for the Town Hall can be admired more easily today than at any other time since it was built. The scene has changed though and not just with the inclusion of a post box. The area in front of the Town Hall is known as Albert Square and was originally a thoroughfare for taxis, carriages and trams. The taxis remain, but most of the remainder of the square has become a venue for public events and the city's very popular Christmas celebrations. Vincent Harris's Town Hall Extension of 1938 hosts the current council chamber and its 96 councillors. (The bridges leading to Harris's extension are just coming into view far right.) The extension hasn't always been appreciated, at one time being christened 'a £1 million waste of money' on account of its strange interface of architecture between the Gothic Town Hall on one side and the Classical Central Library (out of view) on the other.

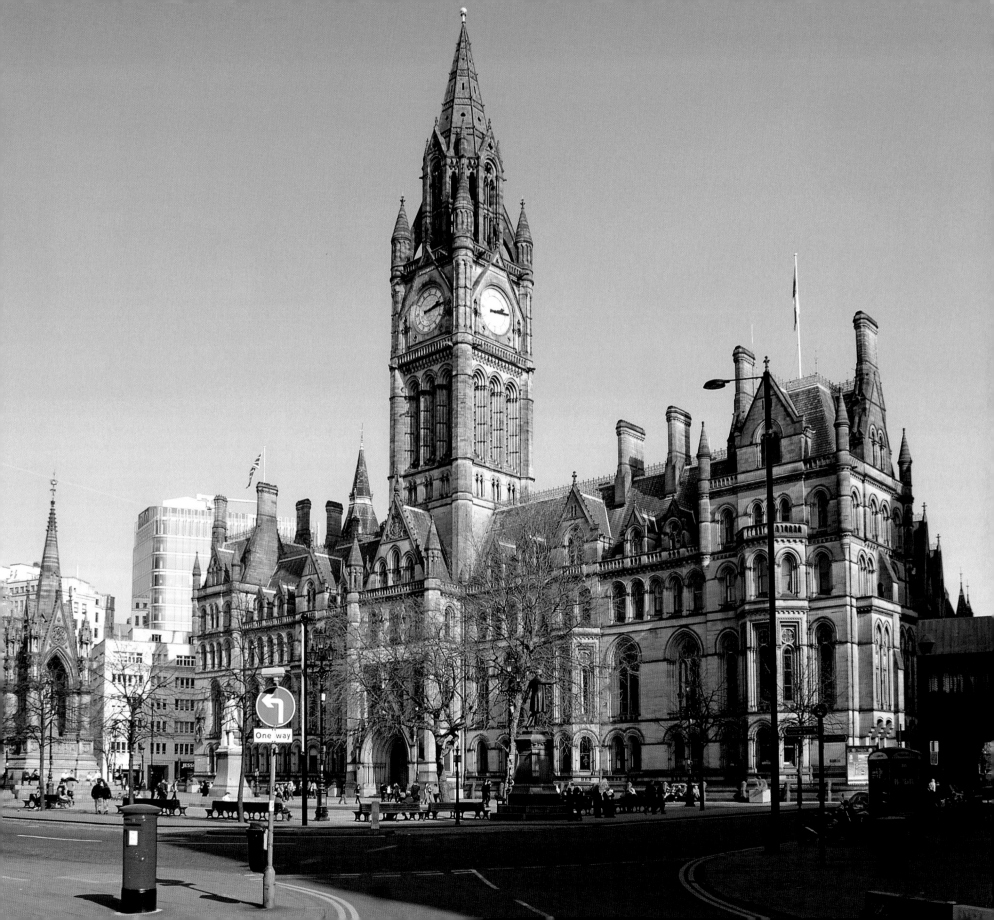

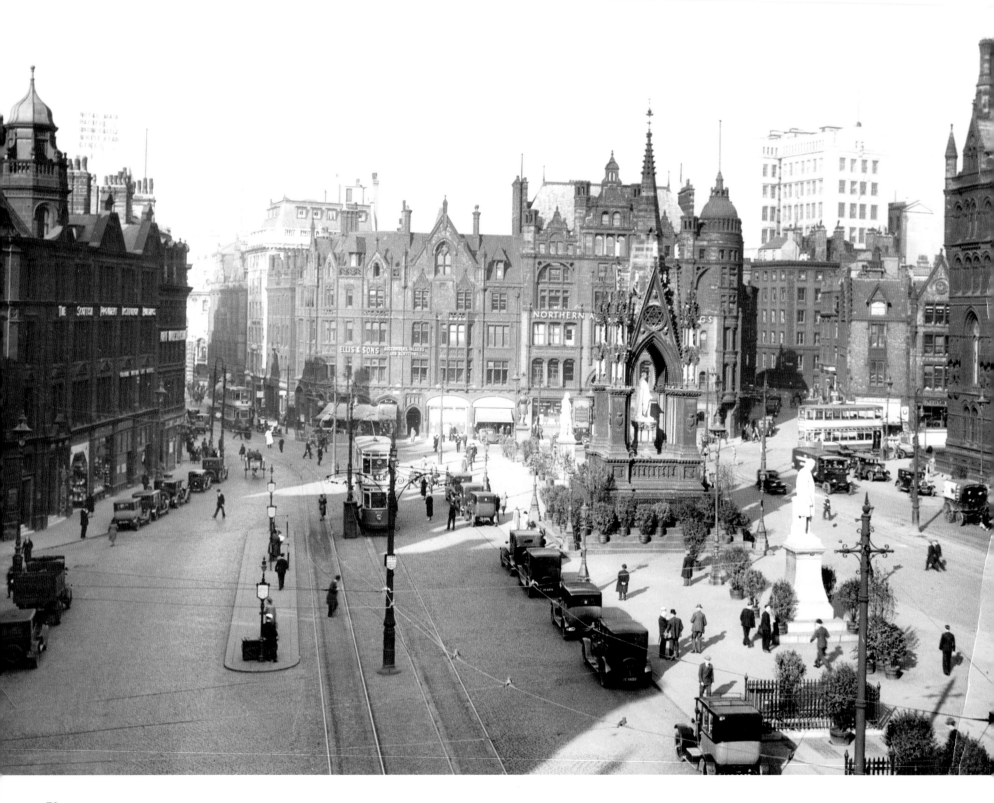

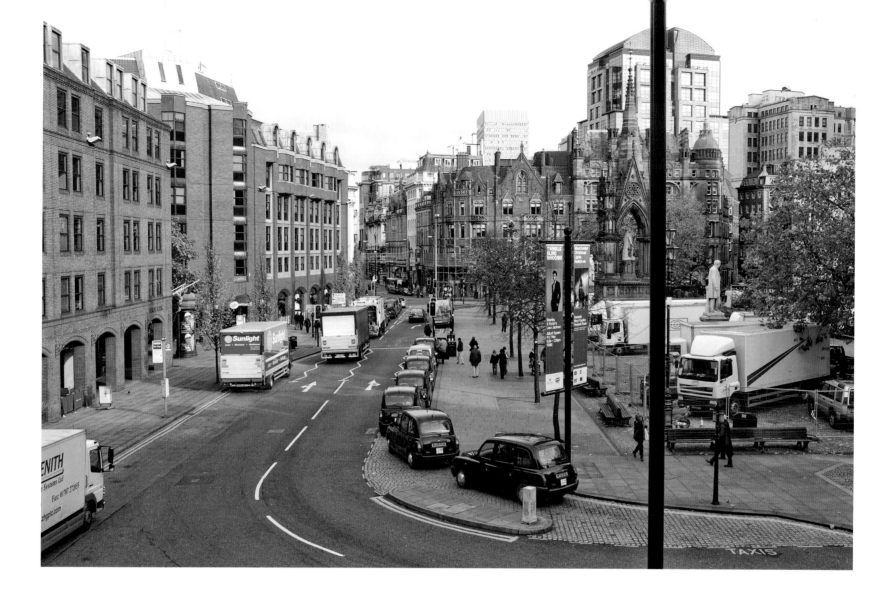

ALBERT SQUARE

Named after Thomas Worthington's Albert Memorial of 1867

Left: Despite the Depression, Manchester looks active in this photo from the 1930s. Ship Canal House, the tall, white Portland stone block in the right distance, is not long finished. In the left near distance the telegraph system on the roof hints that the city's diversified manufacturing and commercial profile is standing it in relative good stead. Taxis stand in front of the Albert Memorial. Finished in 1867 the memorial was designed by Thomas Worthington, with a statue of the Prince by Matthew Noble. Albert was much loved in the city for his belief in progress, education and commerce. His tragically early death from typhoid in 1861 provided the excuse for Manchester to create a new public space in his honour, complete with an appropriate artwork. The design of the latter would inspire the larger memorial in Hyde Park, London. The two

statues on either side of the monument are: in the foreground, Oliver Heywood (1825–1892), Manchester banker and philanthropist; in the background, John Bright (1811–1889), Rochdale-born British Radical and Liberal statesman.

Above: The traffic in Albert Square has now been squeezed and the square has become a focus for events of all description, from concerts through to speciality markets. The square has assumed a truly public nature after more than a century of the Albert Memorial being a rather elaborate traffic island. Trucks are parked in the square in this picture installing another event. Trees have also been planted adding to the attraction of this corner of the city. The only backward step relates to the buildings on the left of the picture. These substandard 1980s office buildings were constructed through expediency during another economically blighted decade and are a poor foil for the magnificent Town Hall on the eastern side of Albert Square. A fresher addition to the skyline is the 1995 Holford Associates 15-storey office block on King Street.

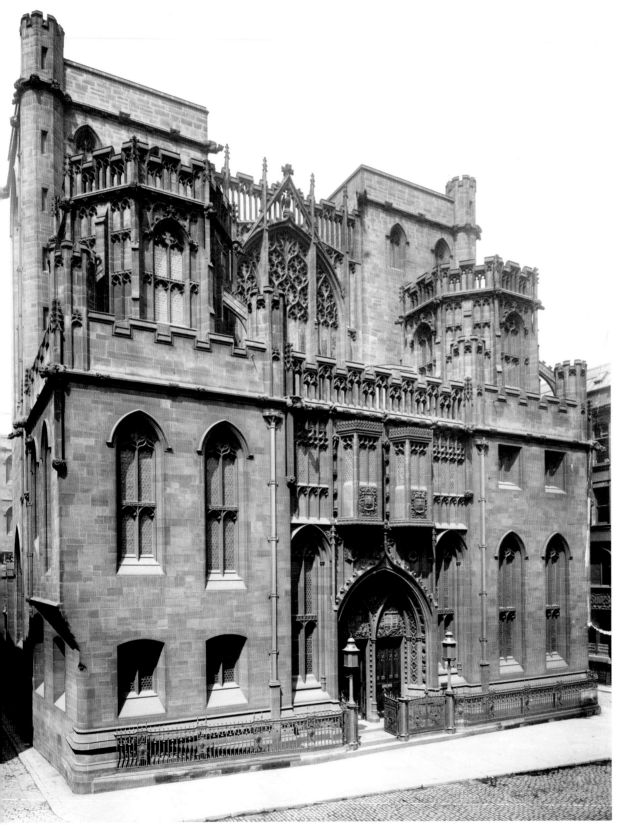

JOHN RYLANDS LIBRARY

Now one of the most important library collections in the country

This is John Rylands Library on Deansgate, photographed shortly after it opened on New Year's Day 1900. Often confused with a church, its Gothic appearance was designed by Basil Champneys to recall the great medieval libraries. The money was given by Enriqueta Rylands, the third wife of textile magnate John Rylands. The library served as a gift to the city and a memorial to her husband. John Rylands had been devoted to charitable works with the poor in his life and this donation was consciously built in an area of the city centre that was still a byword for rough drinking houses, brothels and less than abstemious behaviour. Money was no object: the building cost £230,000 (around £10 million in today's money) and one of the collections cost £210,000. The library holds what is possibly the oldest existing New Testament document. Known as the St John Fragment, it dates from circa AD 125.

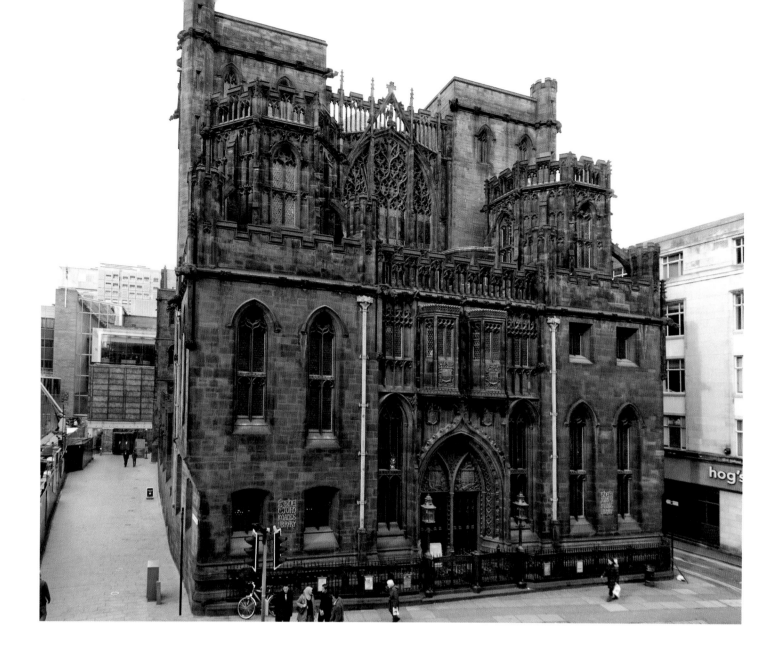

John Rylands Library is now owned by the University of Manchester. With more that four million printed books, John Rylands University Library is one of the most important academic collections in the country. A recent refurbishment, glimpsed in dark grey down the left-hand side of the building, was completed in 2007 to provide extra study space, disabled access, and a shop and café. Behind the building, the rundown Thirteenth District has become Spinningfields; almost £1 billion of office and apartment development in shiny glass and steel. In the distance, the light grey building closing off the view with its temperature-control grills is one of Manchester's most expensive buildings. Designed by Denton Corker Marshall of Melbourne, at a cost of £112 million, it houses the Civil Justice Centre and its 47 courts. It came second in the RIBA Building of the Year award in 2008 – separated by a century, it's a civic donation to match John Rylands.

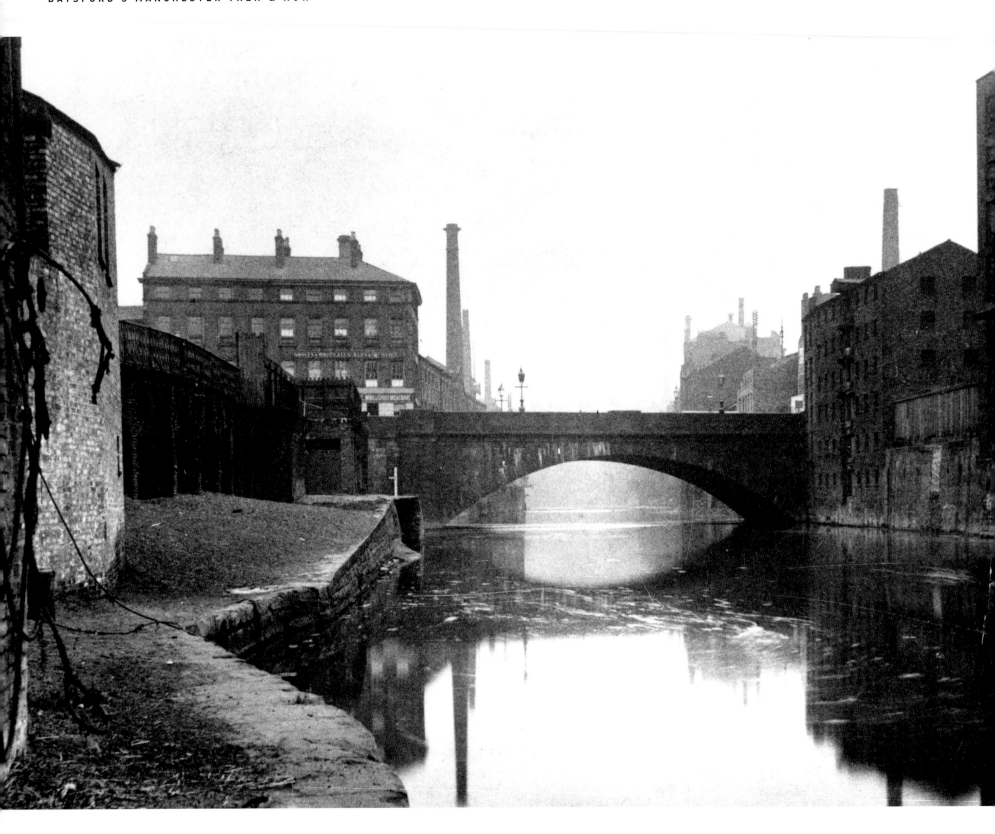

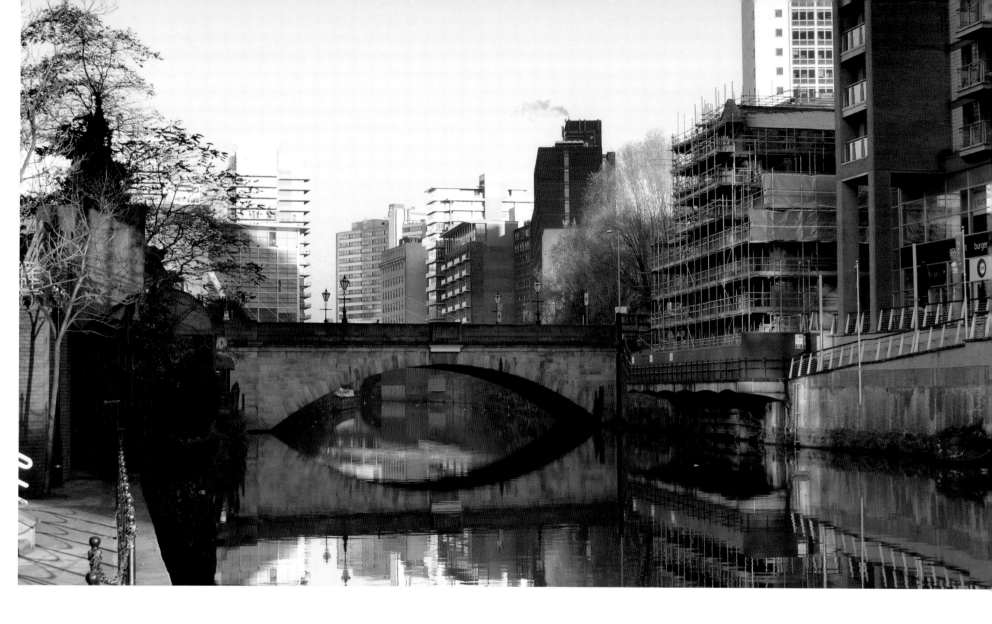

ALBERT BRIDGE

Built by Jesse Hartley, who also designed Liverpool's Albert Dock

Left: An 1870s view of the River Irwell looking north through Albert Bridge; the left bank is Salford and the right bank is Manchester. The river is utterly unpopulated and dead; a rolling liquid mass of human and industrial effluent, sometimes murky brown, sometimes bright yellow or green as dyes drain into it. It's the so-called 'hardest worked river in the world', filled with the waste of almost a century of unregulated filth. There's a cotton mill on the right and over the bridge on the left is a brewery chimney. The bridge was designed by Jesse Hartley and completed in 1844, at the same time as he was working on Albert Dock in Liverpool.

Above: The modern view shows a river transformed. Trout can now be caught in the river and herons are known to nest here. The building covered in scaffolding to the right is the People's History Museum, dedicated to the struggle of working people for civil rights and part-funded by the TUC, which was founded in Manchester in 1868. Behind the shrubs on the left is the Mark Addy pub, dedicated to a gent who saved more than 50 people from the river before succumbing to the liquid poison he'd swallowed in 1890. The fact that offices and apartments now face the river, rather than turning their backs, indicates a transformation. Just coming into view at the left of the bridge is the five-star Lowry Hotel, another success story for the river's rehabilitation.

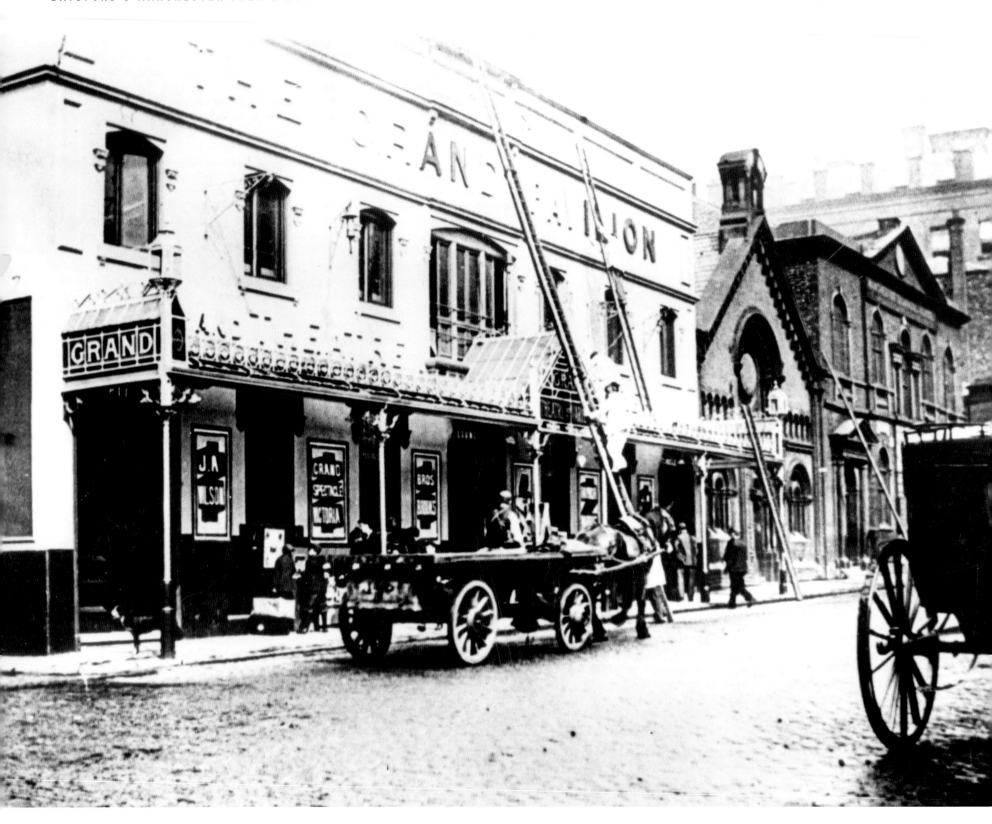

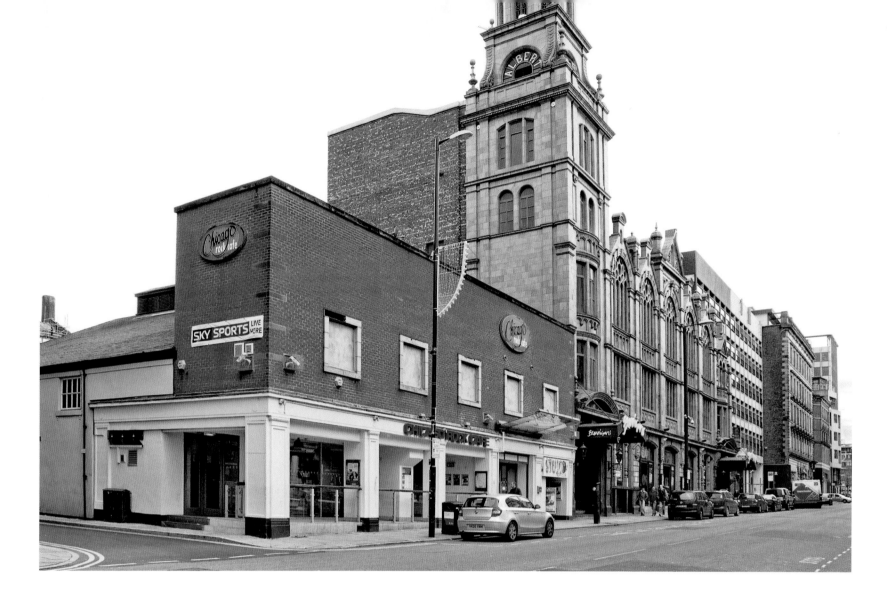

THE GRAND PAVILION

This popular venue was also known as the Grand Theatre of Varieties

Left: Peter Street's Grand Pavilion, also known as the Grand Theatre of Varieties, opened in 1883. This photo from 1900 shows men on ladders, fixing the roof, washing the windows, changing the sign, or possibly just having a race up ladders for their own amusement. Under the management of E.H. Jones the variety here included the 'Paddock Troupe of Lady Trick Cyclists', the 'Mechanical Mannikins', the 'Living Pigmies' and 'Serpentello, the Marvellous Contortionist'. The building next but one up the road is the Swedenborgian Church: for many years a popular Christian sect in Manchester. Here it represents an outpost of faith amongst the fleshpots of theatre land.

Above: The theatre facade has been replaced by a drab brick structure. However, the rear of the building is still that of the original Grand Pavilion. After the theatre closed the building had a chequered history, including use as a car showroom and now as a bar (the Chicago Rock Café). The dominant structure here though is Albert House next door, built as a Wesleyan Mission Hall in 1910 to the designs of W.J. Morley. It's a florid extravagance in the fashionable terracotta of the period. This building was strictly temperance and famous for the singing quality of the Methodist choirs that gathered here. For a time (until 2011) it was a Brannigans bar, where most evenings were alcohol-fuelled. The dramatic change of use probably accounts for the angry ghost that is said to haunt the building.

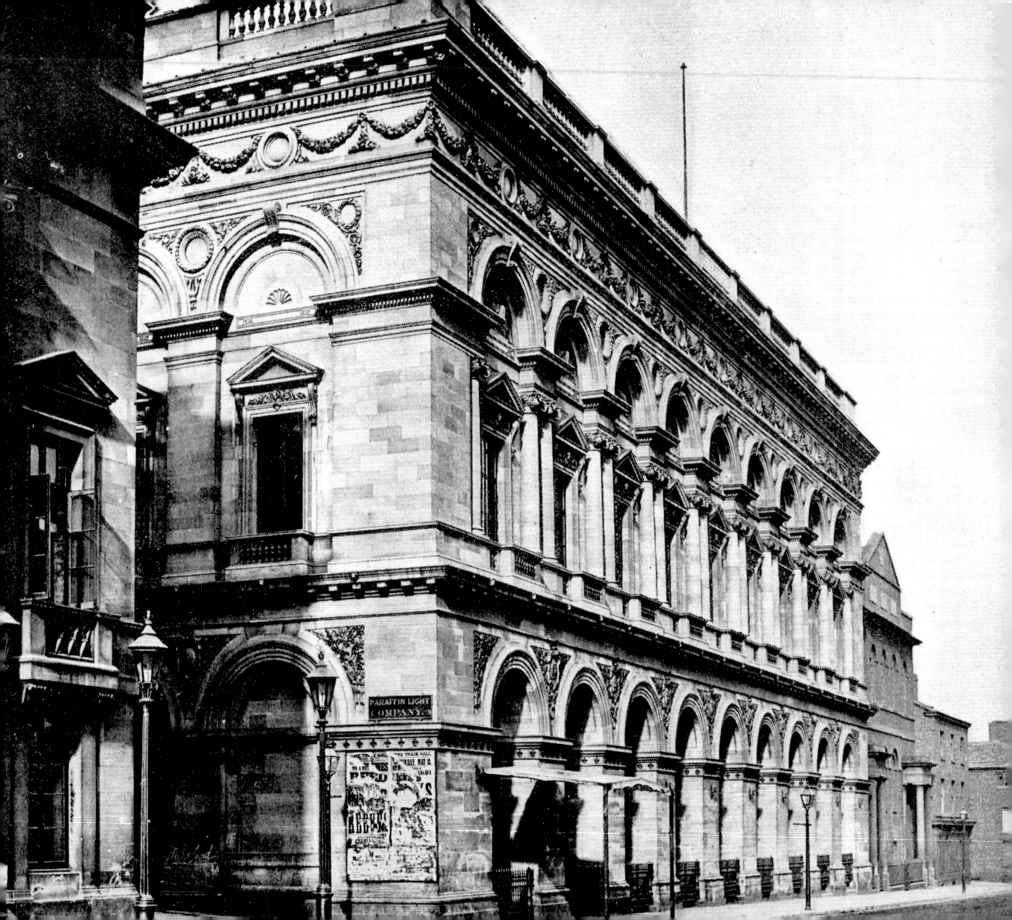

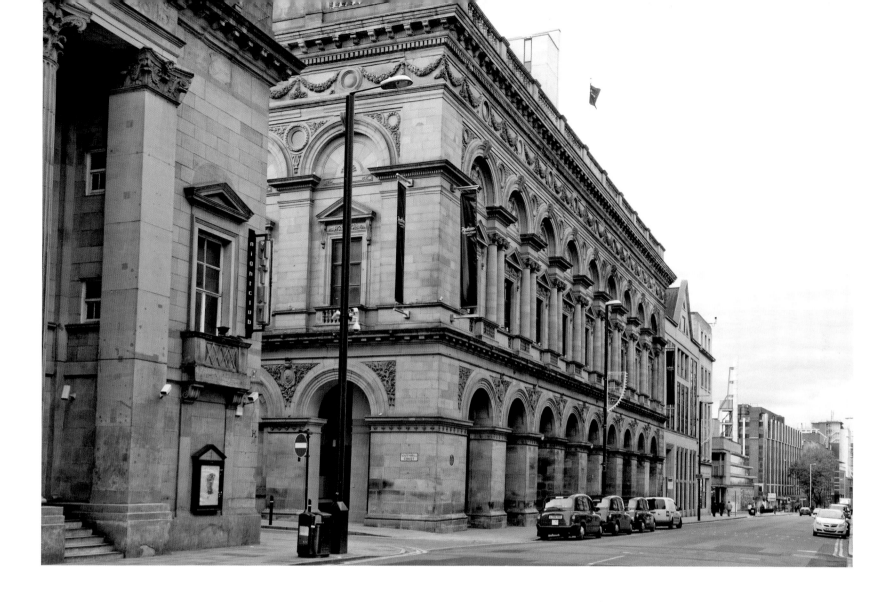

FREE TRADE HALL

Guest speakers included Charles Dickens, Benjamin Disraeli and Winston Churchill

Left: This view of the Free Trade Hall dates from 1930. It's the only building in the UK named after a principle. The building stands on the site of the Peterloo Massacre of 1819 – when 60,000 people protesting about the lack of parliamentary representation were attacked by the authorities and 15 died. This stately Renaissance-style building designed by Edward Walters is the third Free Trade Hall on the site and was completed in 1856. For 150 years the hall hosted speeches, readings, theatre and dancing, and was the home of the Hallé Orchestra from 1858. Guests included, amongst others, Charles Dickens, David Livingstone, Benjamin Disraeli, David Lloyd George and Winston Churchill. The Suffragettes Christabel Pankhurst and Annie Kenney unfurled a 'Votes for Women' banner here in 1905 – they were thrown out of the hall and

subsequently imprisoned. To the right of the Free Trade Hall is Ebeneezer Chapel, a Methodist church.

Above: The Free Trade Hall still looks grand, stately and beautifully proportioned. However, the building behind the facade was gutted in World War II by incendiary bombs. When the Hallé Orchestra moved out in 1996, it was converted into the five-star Radisson Edwardian hotel. Only the two external walls visible in this view have survived from the 1930 picture. Before the latter conversion the hall still hosted notable events, particularly in 1966 when a visiting Bob Dylan went electric and was booed by local folk fans shouting 'Judas' at him. In 1976 the Sex Pistols played here twice, on one occasion supported by the Manchester band The Buzzcocks: this was the beginning of the city's well-known independent music scene. The neighbouring building is no longer a chapel but an insurance call centre.

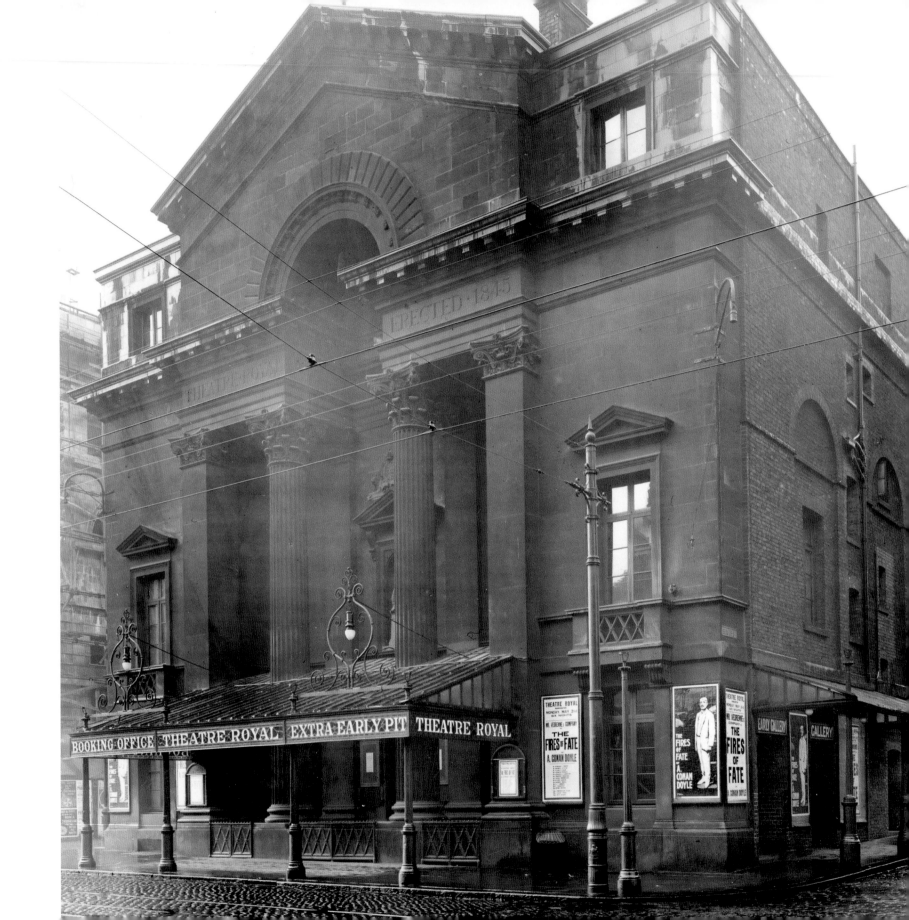

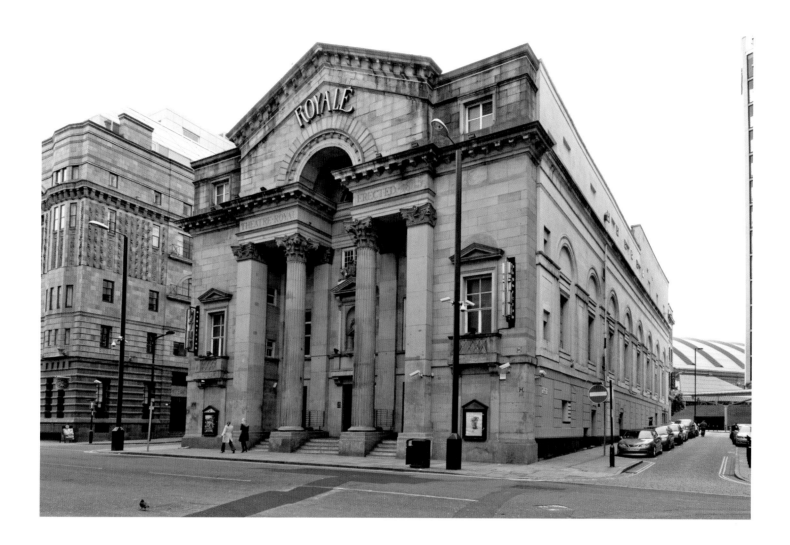

THEATRE ROYAL

The first production of *La Bohème* in English was performed here in 1897

Left: Next door to the Free Trade Hall (see pages 80–81) on Peter Street is the former Theatre Royal. Built in 1845 by Irwin and Chester, the venue featured water up on high, with a 20,000-gallon tank placed in the roof space as a fire precaution – the previous theatre had burnt down. The grand classical portico shelters one of the very few, but perhaps not the best, external statues of Shakespeare in the country. Some of the greatest Victorian and Edwardian actors appeared in the theatre, including Henry Irving, William Macready, Edmund Keen and Jenny Lind. The first production of *La Bohème* in English was performed here in 1897 with composer Puccini in the audience. In this 1910 view Arthur Conan Doyle's *The Fires of Fate* is headlining.

Above: Manchester was 'the West End of the North' for much of the nineteenth and the beginning of the twentieth centuries, until cinema took over. Many American shows, such as *Oklahoma* in 1937, would make their British premiere here before going south. For the Theatre Royal the curtain came down in 1921. The next 50 years or so were spent as a cinema, then a bingo hall, and more recently as a night club (the Royalé). On the right in this picture can be seen the engine shed of the former Manchester Central Station. The terracotta building to the left is the former YMCA, the first city building with a reinforced concrete frame. It opened in 1911, with Art Nouveau panels, a copy of Donatello's *St. George* and a swimming pool on its top floor. The building is now called St George's House and is used for office space.

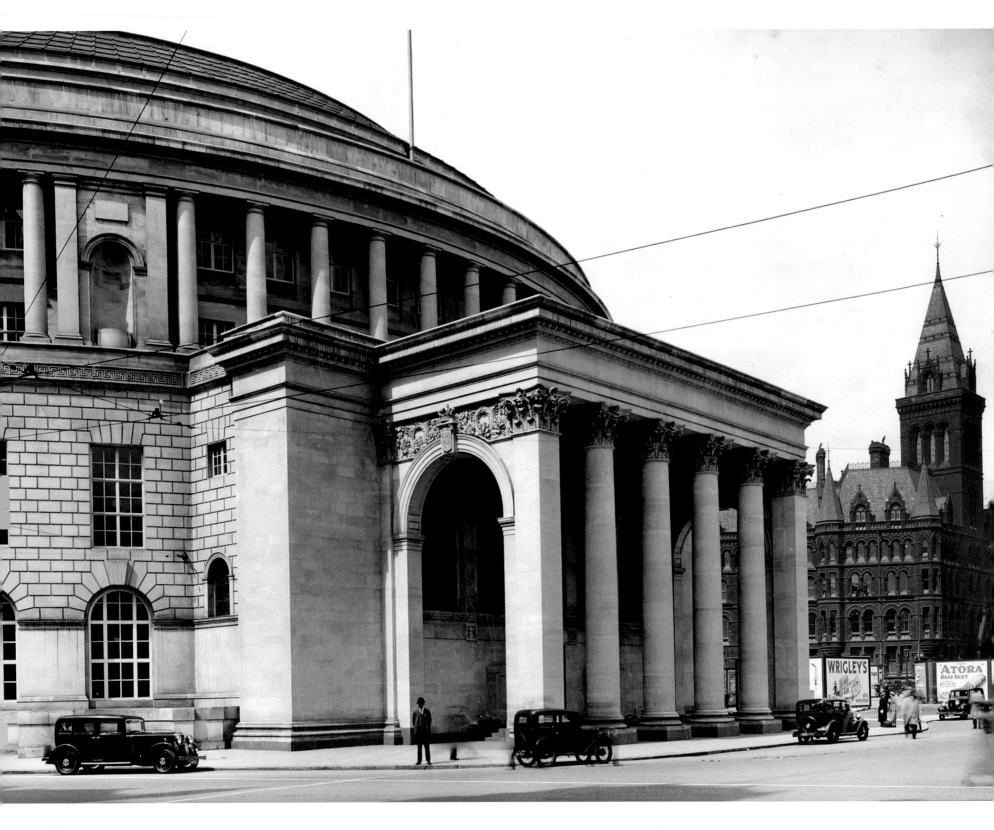

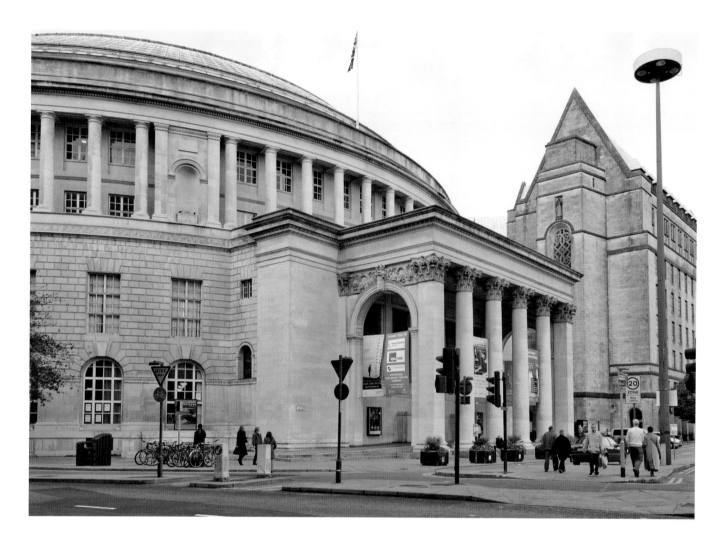

MANCHESTER CENTRAL LIBRARY

King George V officially opened the library on 17 July 1934

Left: A Manchester icon, the Central Library was brand new when this 1934 photograph was taken – King George V officially opened the building on 17 July 1934. Handkerchiefs with the words 'Knowledge is Power' were distributed to mark the occasion. Manchester had been one of the first local authorities to open public libraries in the mid-nineteenth century. This building was seen as a celebration of that and also as a focus of a new civic centre. The building was designed by Vincent Harris and freely based on the Pantheon in Rome. Above the Corinthian portico, the second and third floors are encircled by a Tuscan colonnade. The domed roof of unrelieved Portland stone is topped with a leadlight window. The rear of the sooty Town Hall from 1877 is clear in the distance, whilst hoardings surround the site of Harris's next project, the Town Hall Extension.

Above: Today Central Library looks just as splendid, although the scene has changed. There's more street furniture out front but the big point of difference is the huge gable wall of Vincent Harris's Town Hall Extension, completed in 1938. This mighty building in sandstone is a curiosity: a mix of Modernist and historical motifs together with the downright odd. The open fretwork decoration, glimpsed over the library's portico, is especially impressive. Famous users of the library have included Anthony Burgess, author of A Clockwork Orange (1962), and the singer Morrissey, who spent time here studying for his A Levels. A civic theatre, the Library Theatre, was installed in the old lecture theatre in 1952 and is still going strong today.

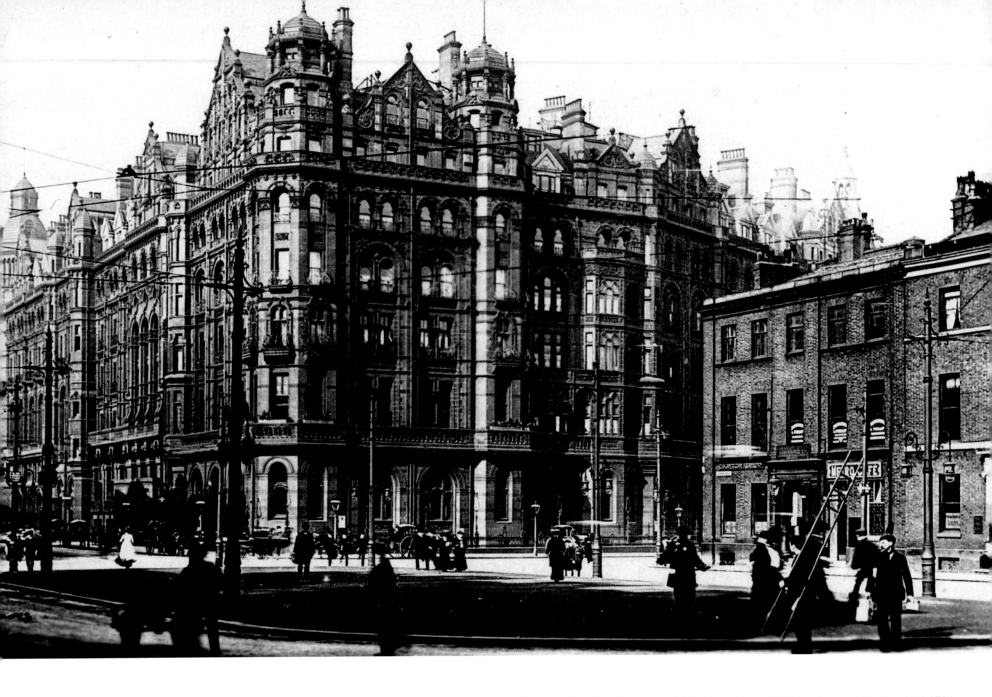

MIDLAND HOTEL

Where Charles Rolls met Frederick Royce to found the Rolls-Royce Motor Company

The paved void in the centre of this picture from 1910 had housed the beautiful 1794 St Peter's Church. Due to its dwindling congregation the church was demolished in 1907. Dominating the picture is the Midland Hotel, completed in 1903 by architect Charles Trubshaw for the Midland Railway Company. The eye-catching building mixed stylistic motifs with wild abandon and became a magnet for the wealthy with its roof gardens, plush French restaurant and luxury suites. American cotton traders regularly stayed at the Midland while selling to Manchester's cotton cloth manufacturers. Six years prior to this photograph Charles Rolls had met local manufacturer Frederick Royce in the hotel and the Rolls-Royce Motor Company was born.

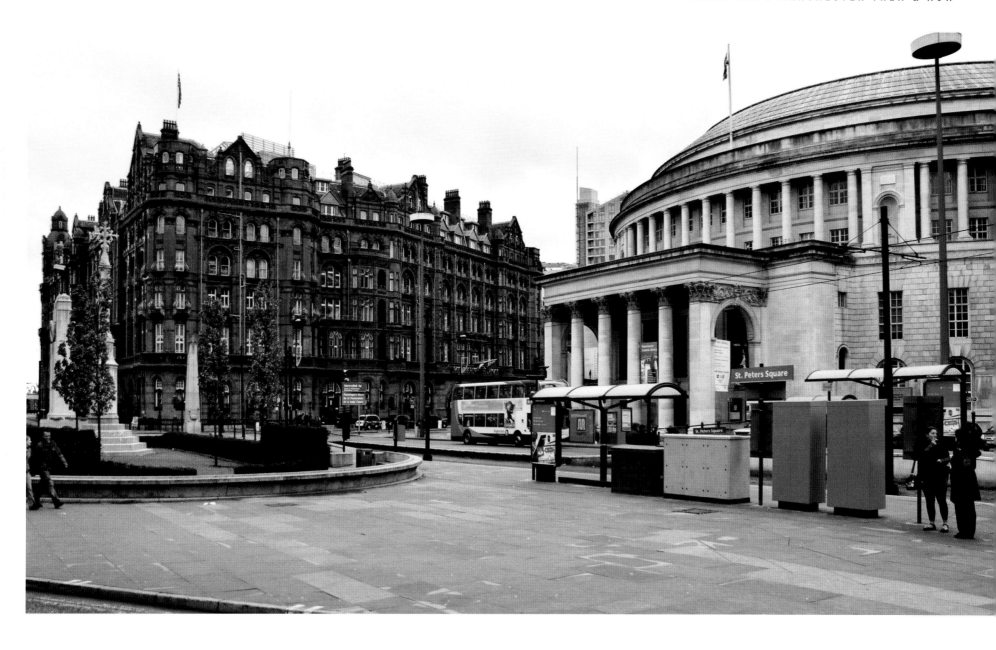

Two buildings now dominate this scene, Central Library (see pages 84–85) and the
Midland Hotel – still impressive in its brick, terracotta and marble grandeur. The
previously vacant area in the foreground is now called St Peter's Square. The Metrolink
(tram) station, which opened in 1992, has dissected the square and limited its use as a
truly public space. The Cenotaph, the white stone block seen behind the grassed area,
offers gravitas and dates from 1924. It was designed by the celebrated British architect
Sir Edwin Lutyens. To the left, a tall stone cross designed by Temple Moore marks the
site of the former St Peter's Church. Famous guests at the hotel have included Paul
McCartney, George Best, Luciano Pavarotti and former Prime Minister Tony Blair.

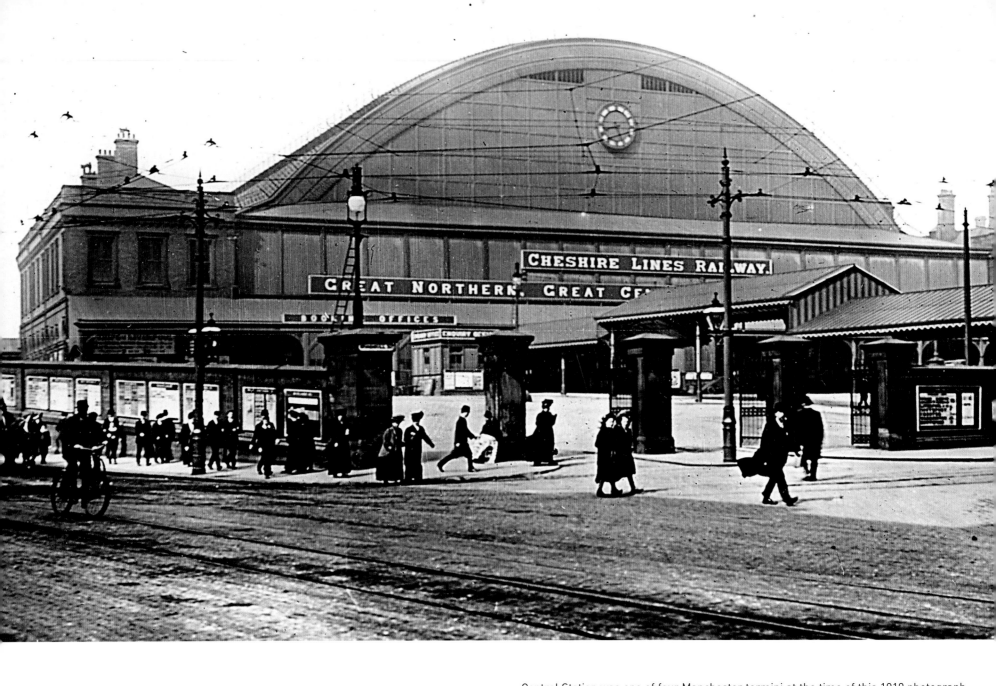

CENTRAL STATION

The former station is now a conference and exhibition centre

Central Station was one of four Manchester termini at the time of this 1910 photograph. This was always the best of them, a great uninterrupted arched space designed by Sir John Fowler with Sacre, Johnson and Johnstone. It was opened in 1880 by the Midland Railway Company although used by other companies such as Cheshire Lines, as advertised here. The hotel planned for the front of the station, the Midland Hotel, was finally built in 1903 on Peter Street, a better and busier location (see pages 86–87). The low canopied structure in the picture, which moves from the centre of the station to the right, was a covered walkway to the hotel to prevent first-class passengers being discommoded by inclement weather. In 1909, 300,000 fans gathered at the station to welcome home Manchester United with the FA Cup.

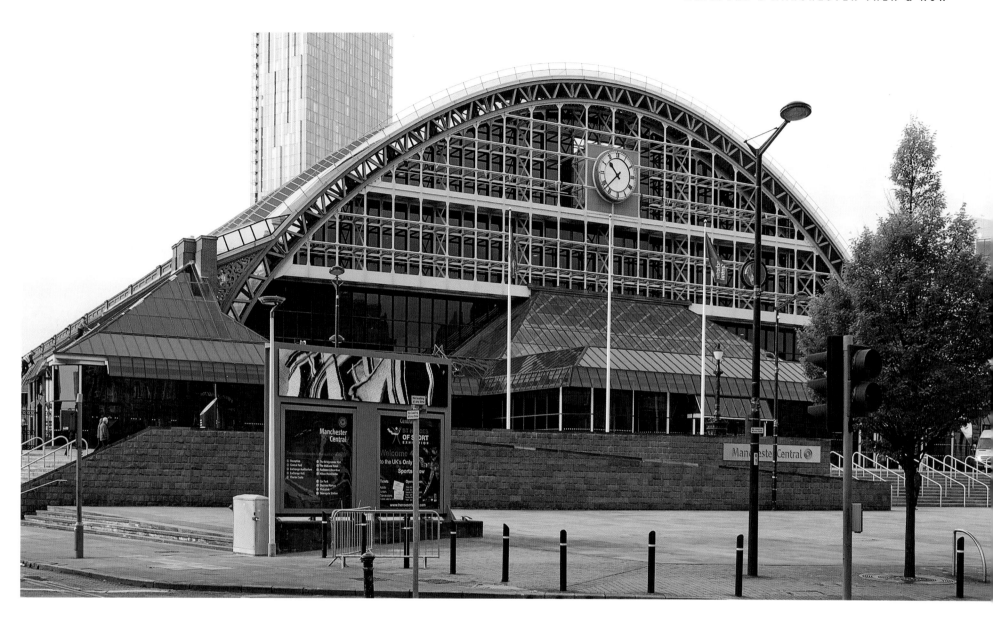

As part of the Beeching reorganisation of British Rail in the 1960s it was decided that Manchester
had too many railway termini. Central Station was one of two of the city's stations to be closed. For
many years it was one of Manchester's grandest car parks, then, in the mid-1980s, it was converted
by EGS Design, working for the now-defunct Greater Manchester Council, into an Exhibition Centre:
G-Mex. Now the name has changed again to Manchester Central, a name that covers both the
Exhibition Centre and the neighbouring (out of view) Convention Centre. Recently the old Central
Station has been the venue of choice for the annual Labour Party Conference and has also hosted
several key rock gigs. Aside from the change of station use the main variation in the view is the 2006
injection of Beetham Tower, which rises into the sky behind Manchester Central. Home to
Manchester Hilton Deansgate, the 171m Beetham Tower is the city's tallest structure.

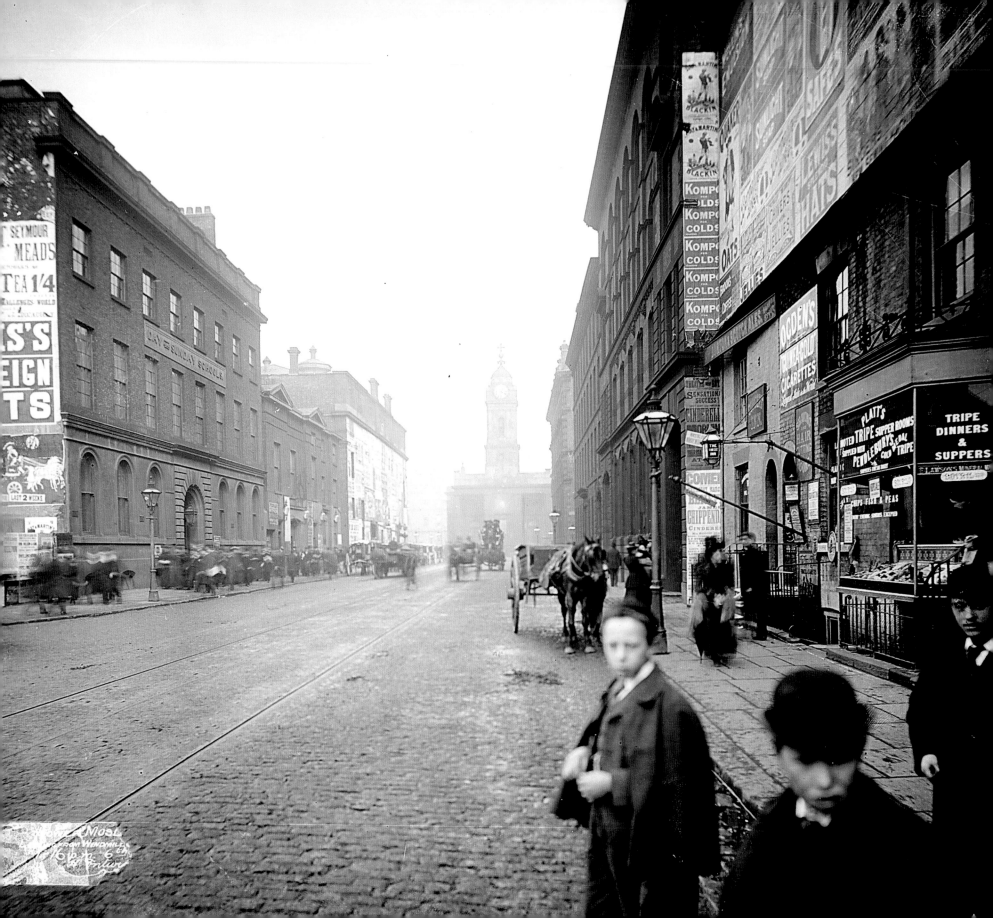

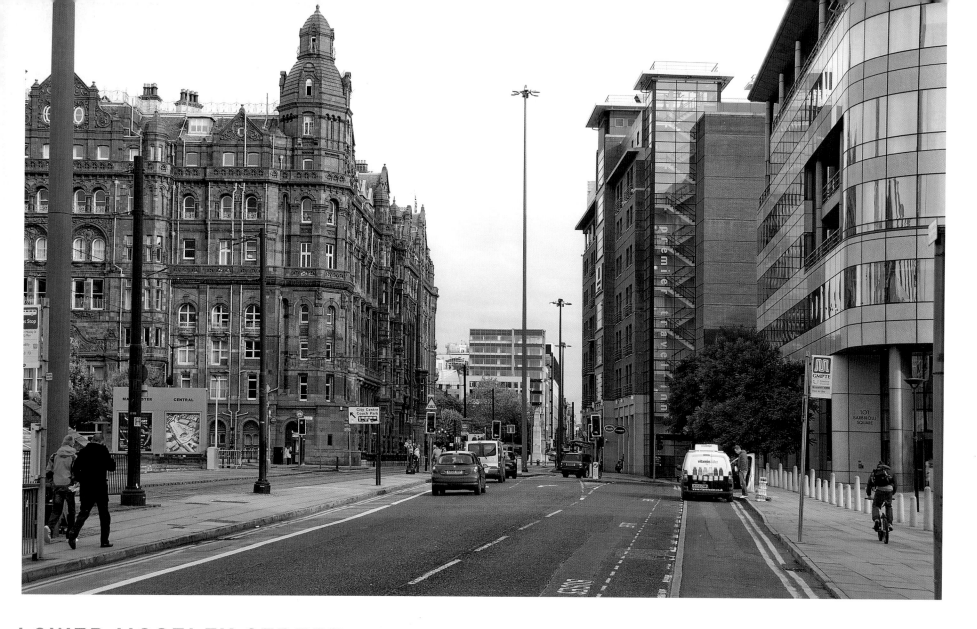

LOWER MOSELEY STREET

This 1880s photo offers a glimpse of James Wyatt's St Peter's Church

Left: This photograph dates from the late 1880s and is looking north up Lower Mosley Street. The likely lads in the foreground are very sharply dressed and are probably apprentices or runners in the warehouses that dominate the view. Behind the boys is Platt's, an eaterie offering tripe dinners and suppers (this being the North, dinner means lunch and supper means dinner). Posters are draped off buildings on the near right and the far left, advertising, amongst other things, the shows taking place in the many music halls and theatres roundabout. In the shadowy distance the street is closed off by James Wyatt's 1794 St Peter's Church. The last building before the church on the left is the Gentlemen's Concert Hall where Liszt, Paganini and

Chopin all played. Tucked behind the low buildings midway down the street on the left is the People's Concert Hall, where the audience occasionally become so animated that a wire net had to be hung over the stage to protect the performers.

Above: In this modern view the buildings on the left have been swept away, replaced by the splendid bulk of the Midland Hotel from 1903. On the right side, in blue-grey, are the 1996 buildings of Barbirolli Square. These host well-known names from the accountancy and legal fraternities. St Peter's Church was demolished in 1907 but trees have arrived for the first time in 200 years as the city council attempts to make its central areas more green.

LIVERPOOL ROAD RAILWAY STATION

The world's oldest-surviving railway station building

Left: The train tracks, overgrown with weeds, decayed buildings and general air of dilapidation in this photograph indicate a potential heritage tragedy. This view from 1978 shows the tracks and buildings of the world's oldest passenger rail station (right) and commercial warehouse (left) from 1830, as well as the oldest surviving set of railway buildings anywhere. Liverpool Road Station was built for the Liverpool and Manchester Railway, which made profit within the first year and began the 'railway age'. The Duke of Wellington, the then Prime Minister, attended the station's opening day ceremony on 15 September 1830. The passenger function was moved to Victoria Station (Hunt's Bank at the time) in 1844 and these buildings became a backwater. By 1975 British Rail had abandoned them.

Above: In the same year as the 'then' photo was taken, the now-abolished Greater Manchester Council responded to pressure from volunteer groups, enthusiasts and official bodies and purchased the site. In 1983 a seven-acre chunk of this area of Manchester, including the former Liverpool Road Station, opened as the Museum of Science and Industry (MOSI). The buildings have been restored and a reconstructed train from the earliest days of rail travel, Stephenson's *Planet*, seen here, chugs round the site. The slim shape of Beetham Tower dominates the skyline; one of the thinnest buildings in width-to-height ratio on the globe. This 171m, 47-storey building is a hotel (Hilton Manchester Deansgate) to just above the cantilever, and then apartments to the top. The fin that crowns the building is decorative, to balance the overhang below.

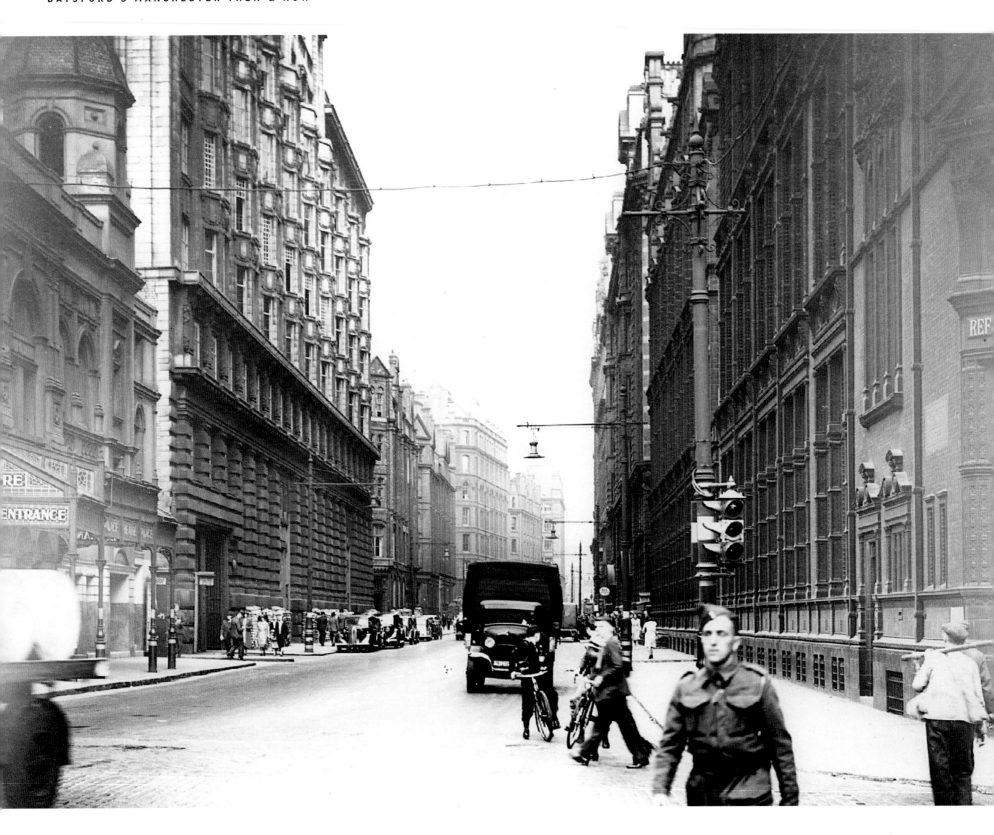

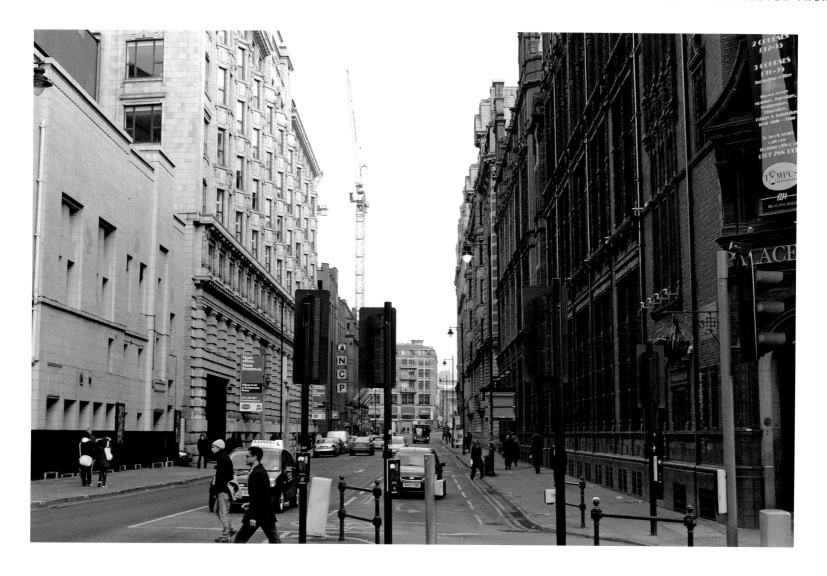

WHITWORTH STREET

Shown less than a month before the Battle of Britain

Left: This picture of Whitworth Street was taken on 18 June 1940. The soldier in the foreground and the military truck behind show Manchester less than a month before the Battle of Britain: by Christmas much of central Manchester was in ruins from enemy bombing. The Whitworth Street canyon of textile warehouses stretches into the distance, although the first building on the right is the terracotta extravaganza of the Refuge Assurance Company from 1895. The warehouses were built following the opening of Manchester Ship Canal in 1894 and were packing warehouses – buildings split between several companies where cloth was prepared for export. On the left is one of the glass canopies of the Palace Theatre built in 1891.

Above: The modern scene is remarkably similar to the 1940 image. The street furniture, vehicles and fashions may have changed but the great canyon of buildings is largely intact. In the 1950s the Palace Theatre's beautiful and flamboyant French-style classical exterior was wiped away to be replaced by unremarkable yellow tiles – almost as though it were a prototype Arndale Centre. The splendid interior, however, remains and it has played host to a diverse range of acts: Charlie Chaplin, Les Dawson, The Smiths, and just about every hit musical. The Refuge Assurance Company moved out of town in the 1980s to a semi-rural site in Wilmslow and their striking Manchester headquarters became, what is today, the Palace Hotel.

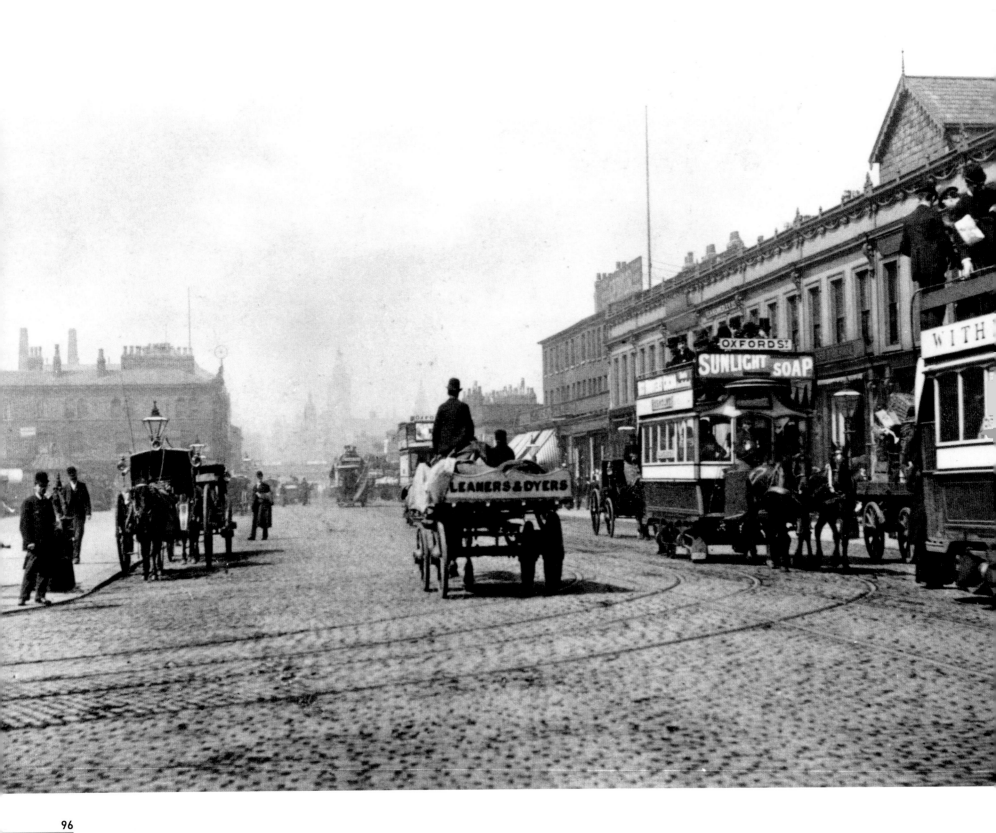

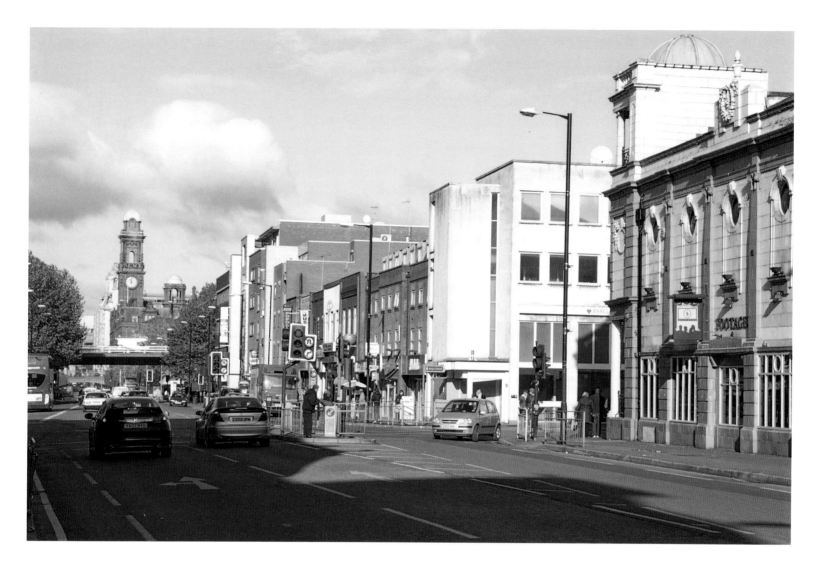

OXFORD ROAD

Now a popular area with students at nearby Manchester Metropolitan University

Left: Pictured in 1894, Oxford Road, in the All Saints area of the city within Chorlton-cum-Hardy, is as busy as it's always been. In the distance, the shadowy silhouette of Manchester Town Hall can be glimpsed. On the right, the open-top Manchester trams, still horse-drawn, are making their way out to the suburbs. The first tram is heading to residential Withington, a couple of miles south. The Oxford Street tram behind is promoting Sunlight Soaps, the first company to fully exploit advertising in its growth. Cabs line the road on the left where there is open ground. Just beyond the left-hand edge of the picture is the churchyard of All Saints Church. Built in 1820, the church was almost in the country when it first opened.

Above: All Saints Church was destroyed in World War II and its grounds are now part of the campus of Manchester Metropolitan University. Many of the buildings in this view now cater to All Saints' student population. A few of the buildings in the right middle distance of the 1894 image are still standing but they have lost their attractive detailing; many are now kebab shops. However, one of these buildings (the one painted white) is the legendary Johnny Roadhouse Music store. Roadhouse, who played saxophone with the Beatles and the Hallé Orchestra, opened his musical instrument shop here in the 1950s and it's still going strong today. The white and green tiled 1915 Grosvenor Picture Palace (extreme right) has been converted into a bar. The terracotta clock tower in the left distance is that of the Palace Hotel, formerly the Refuge Assurance Company. The bridge over Oxford Street belongs to the 1967 inner-motorway, the A57(M) – or, as it's locally known, the Mancunian Way.

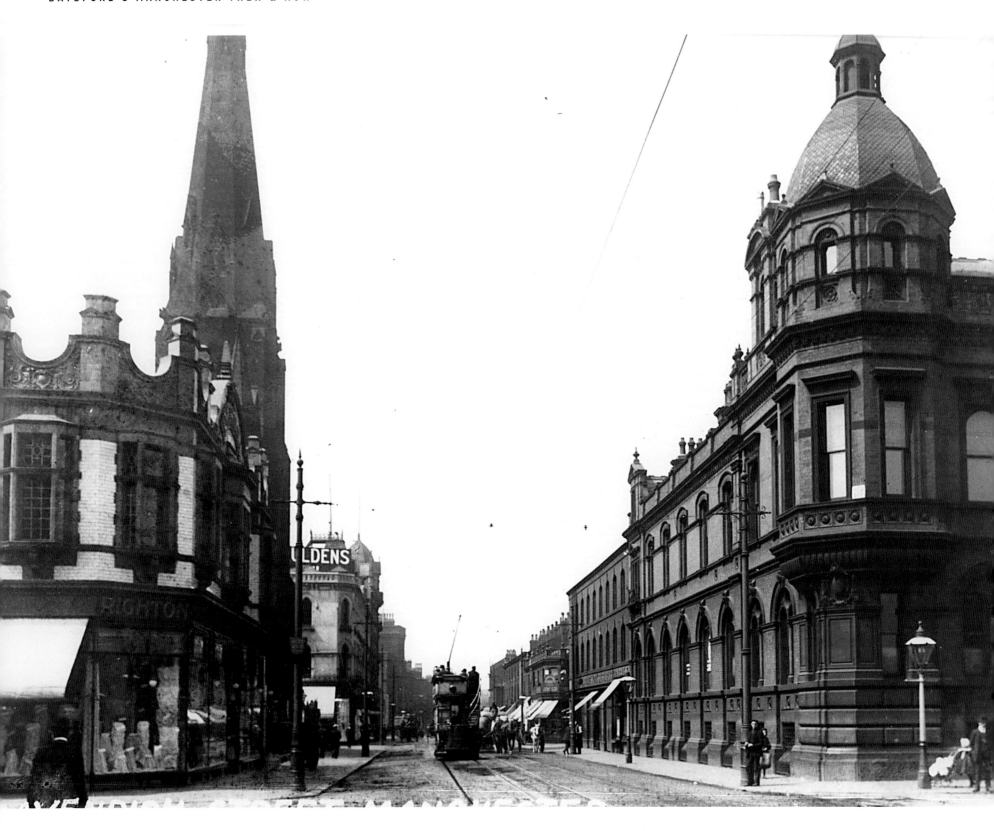

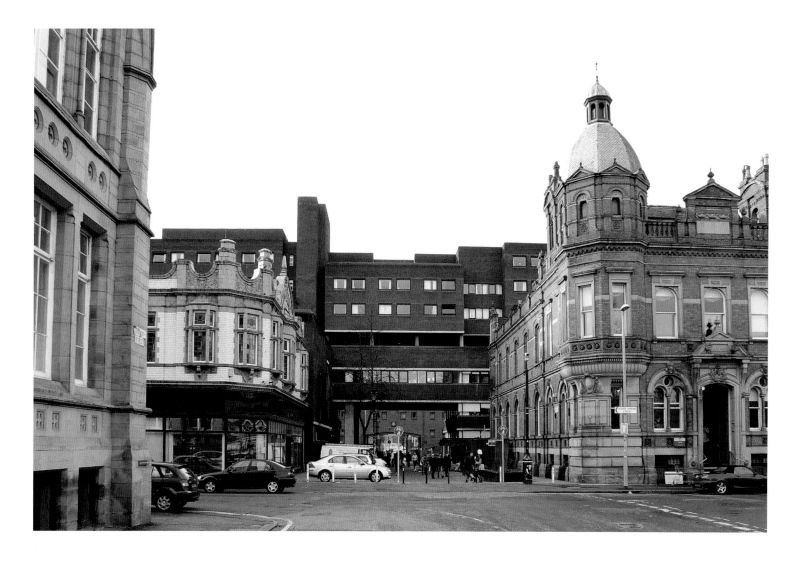

CAVENDISH STREET

In 1905 this was the most important retail area outside of the city centre

Left: This 1905 view is looking west along Cavendish Street towards Stretford Road in the direction of Hulme. These two roads in the All Saints area of Chorlton-on-Medlock made up the most important retail street outside the city centre. The church spire is that of Cavendish Street Congregational Church from 1848 designed by Edward Walters, who would later design the Free Trade Hall. The building behind the church is Paulden's, a department store famous for its bargains. In 1957, following a fire, the shop moved to the larger building presently occupied by Debenhams on Market Street. The elaborate shop on the left foreground is Righton's, a drapers shop, opened in the year of the photograph. The building on the right with the turret and the dome was opened in 1881 as premises for the Poor Law Guardians and a Registry Office.

Above: Following the social planning schemes of the 1960s, the community of domestic residents in this area has disappeared. Students and institutions have taken over and all the buildings in the photograph are now part of Manchester Metropolitan University. The two old buildings on either side of the pedestrianised stretch of Cavendish Street – the Righton Building (left) and the Ormond Building (right) – are now both part of the Faculty of Art and Design. The bridge blocks spanning the street are halls of residence built in two bursts in the 1980s and the 1990s. The stone block peeping out on the extreme left foreground is the School of Art by G.T. Redmayne from 1881. It was here that Laurence Stephen Lowry, famed 'industrial' artist, and Peter Saville, the modern designer for Factory Music and Dior, learnt their trade.

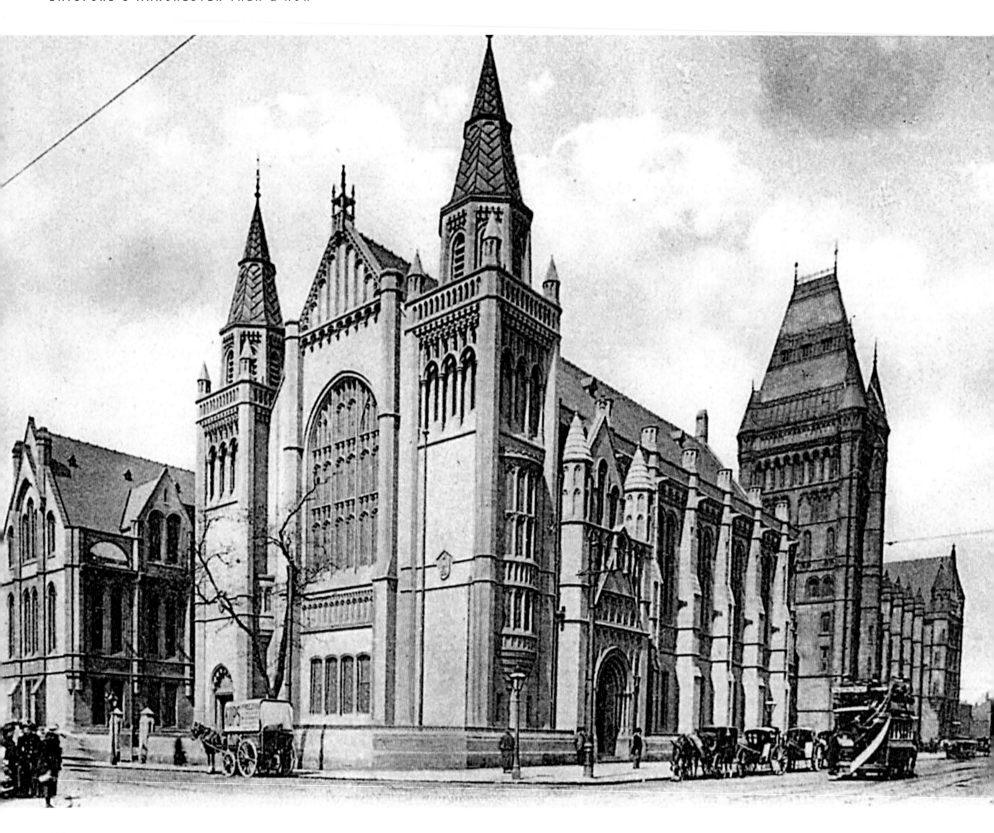

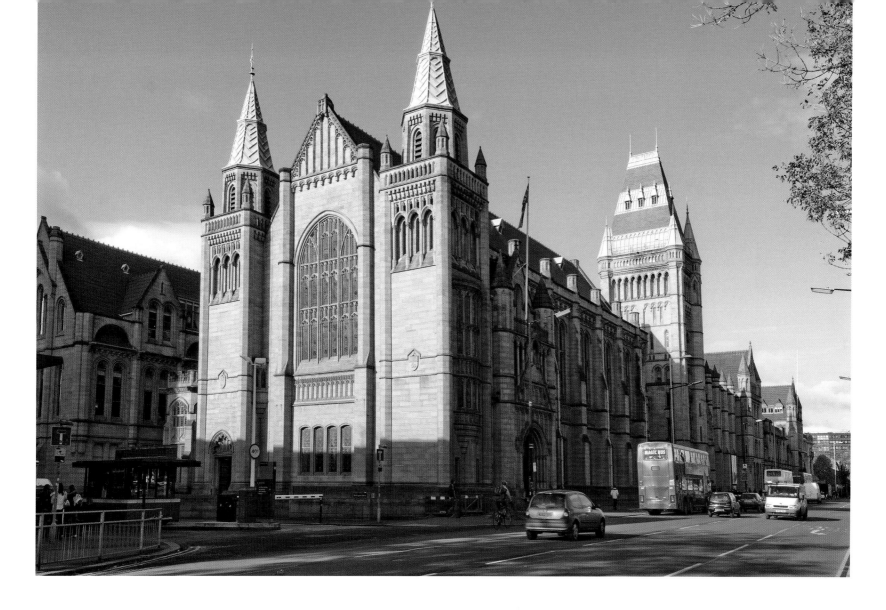

UNIVERSITY OF MANCHESTER

Showing Paul Waterhouse's Whitworth Hall, constructed between 1895 and 1902

Left: When Manchester textile baron John Owens died in 1846 he left a bequest of £96,942 to found a non-sectarian college. The college was established in 1851 and in 1873 it moved to new buildings in Oxford Road, Chorlton-on-Medlock. This picture of Oxford Road from 1903 shows Alfred and Paul Waterhouse's splendid buildings for the Victoria University (often referred to as Manchester University) and its museum, constructed in stages between 1874 and 1902. The nearer and newest part of the complex shown here is Whitworth Hall, with its twin towers and beautiful meeting space hidden behind its huge first-floor window. This 'Modern Gothic' structure – as it was described at the time – was named in honour of Manchester's philanthropic and engineering genius Sir Joseph Whitworth.

Above: With its smoke-blackened brickwork scrubbed and cleaned, the University of Manchester looks much as it did a century ago. Eagle-eyes might spot that further down Oxford Road the university has been extended since the older picture. This is the Manchester Museum extension, an institution owned by the university. Alfred Waterhouse's 1887 museum sits immediately on the far side of the tower. It was doubled in size by his son Paul Waterhouse in the years around World War I. There has been much pioneering achievement here; the later part of the museum sits between Coupland Street, where Ernest Rutherford split the atom in 1919, and Bridgeford Street, where Professors Kilburn and Williams created the first modern computer in 1948. In 2004, Victoria University of Manchester merged with the University of Manchester Institute of Science and Technology to form the University of Manchester, the UK's largest university in terms of student numbers.

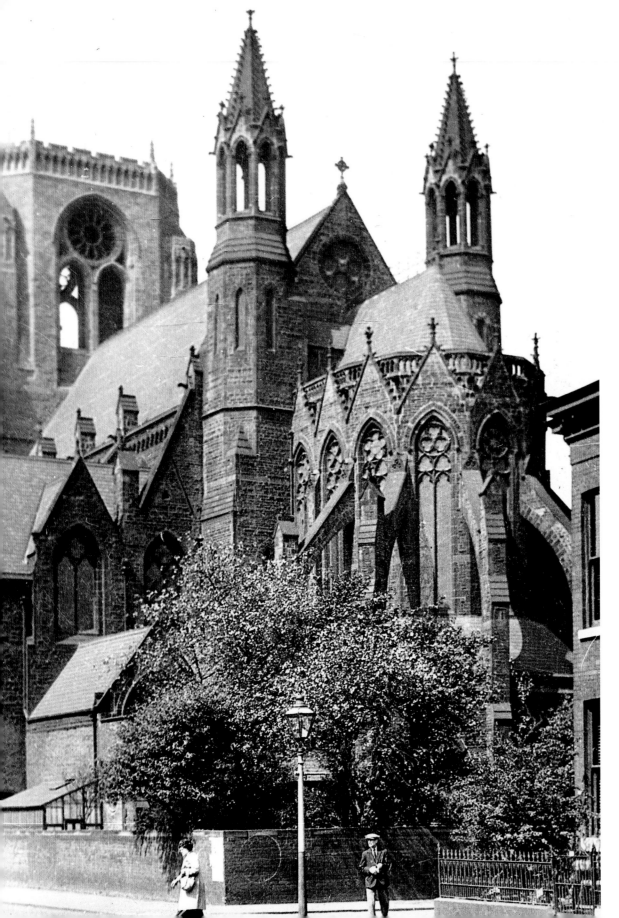

HOLY NAME CHURCH

A design of the very highest quality' (Sir Nikolaus Pevsner)

Left: This 1929 photo shows the rear of Greater Manchester's largest Roman Catholic Church, the Holy Name of Jesus. The church dates from 1871 and was designed by Joseph Aloysius Hansom with his son Joseph Stanislaus Hansom. Joseph Aloysius Hansom was a versatile designer and was also responsible for the two-wheeled Hansom Cab. The church was built by the Jesuits for Manchester's Irish-boosted Catholic community and was said to fit 2,000 in comfort. The church was praised by Sir Nikolaus Pevsner who described it as 'a design of the very highest quality'. The tower is only a year old in this picture and was completed by Adrian Gilbert Scott after funds for Hansom's intended spire ran out.

Right: It may no longer be Jesuit but the Church of the Holy Name still stands proudly in the university area of the city. It is one of the few churches around that still conducts a weekly service in Latin. In the years since 1929 the houses behind the church, glimpsed far right in the 'then' photo, have been replaced by university departments. These houses had been famous as digs for performers in Manchester's theatres in Oxford and Peter streets. The new tower in the 1929 picture helped Liverpool out in subsequent years. When Giles Gilbert Scott had to trim his Liverpool Anglican Cathedral plans down to a single tower he used his brother Adrian's Holy Name tower, and its crown of thorns appearance, as inspiration for his bigger Liverpool work.

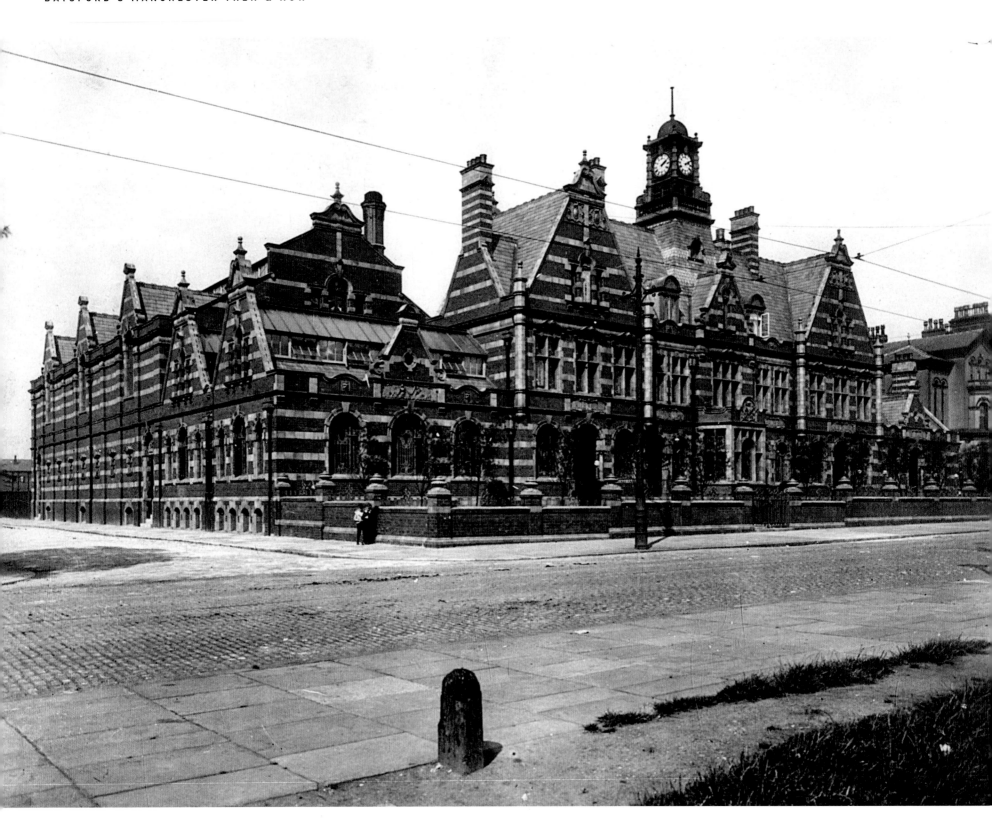

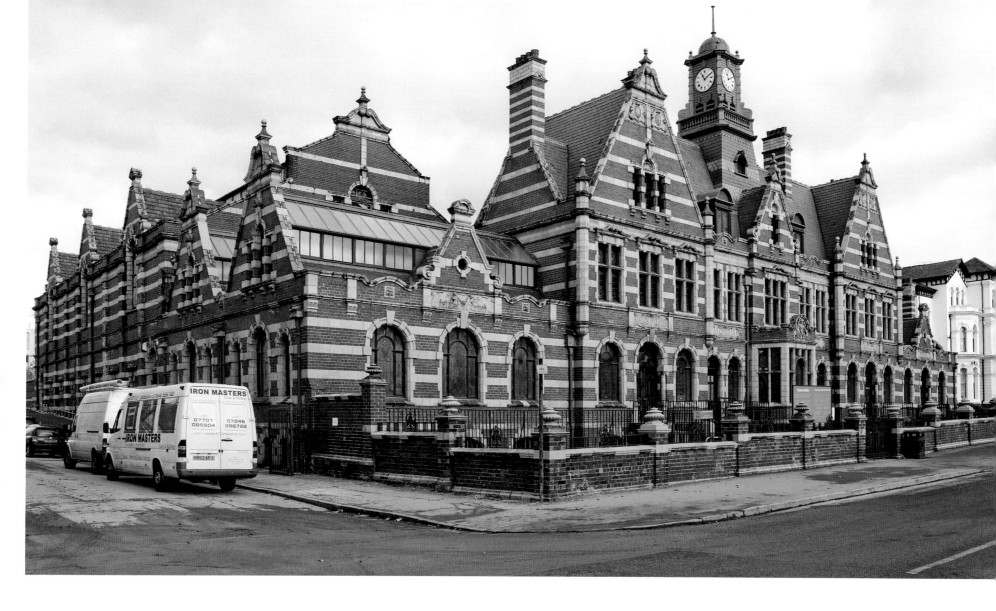

VICTORIA BATHS

'Manchester's Water Palace' was the winner of BBC2's series *Restoration*

Left: This 1905 photograph shows Victoria Baths in Longsight just prior to its opening. This 'Water Palace' cost Manchester Corporation more than £59,000, which was double the budget given to most bath houses of that period. The complex was designed by the city architect's office under Henry Price. There are first- and second-class baths, a single democratic bathing area for women, Turkish and Russian baths, a superintendent's living quarters and a laundry house. The spectacle of mosaic, tile and stained glass on the interior is extraordinary and occasionally amusing – above the men's first-class entrance is a stained-glass image of gents playing cricket; above the second-class entrance is a stained-glass image of boxers.

Above: Victoria Baths closed in 1993, when it had become a rundown, decrepit mess, crawling with cockroaches. In 2003, BBC2 ran a TV series called *Restoration*, in which crumbling UK buildings were given advocates and allowed to compete for monies towards their preservation. Victoria Baths was the runaway winner in a popular TV vote and collected £3.5 million, which has gone towards making the structure safe and partial refurbishment. However, more money is needed before it can be fully re-opened. In the meantime, the baths have become a popular tourist attraction on opening days and a centre for art shows and other activities. It's also a much-used film location and has been used in TV dramas such as *Prime Suspect* and *Life on Mars*.

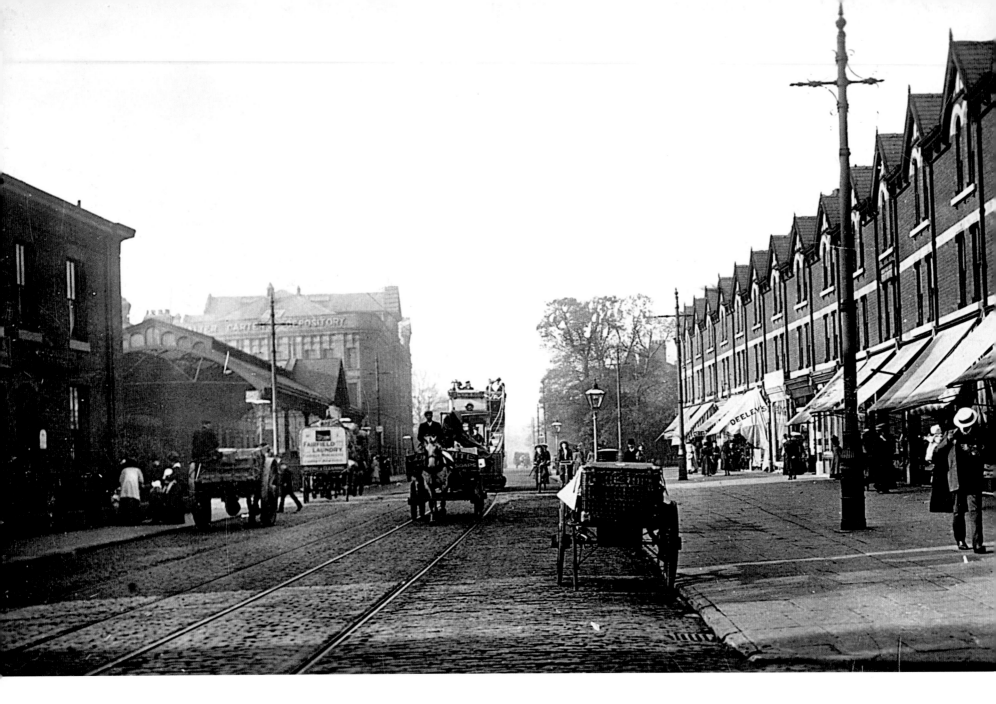

WILMSLOW ROAD, RUSHOLME

Wilmslow Road in Rusholme is now known to many as 'Curry Mile'

This early 1900s photo of Wilmslow Road in Rusholme is looking north towards the city centre, a couple of miles away. The character of this suburb is curious: to the left of the street are terraced houses filled with the working classes; to the right, behind the grand curve of the shops, is Victoria Park, a wealthy enclave. The shops serve both sets of customers. The shed, on the left, about level with the brand-new electric tram – trams were electrified in Manchester from 1901 – has had a varied history. It was a depot for horse-drawn trams, then a riding school and from 1910 the Rusholme Electric Theatre offering films and variety.

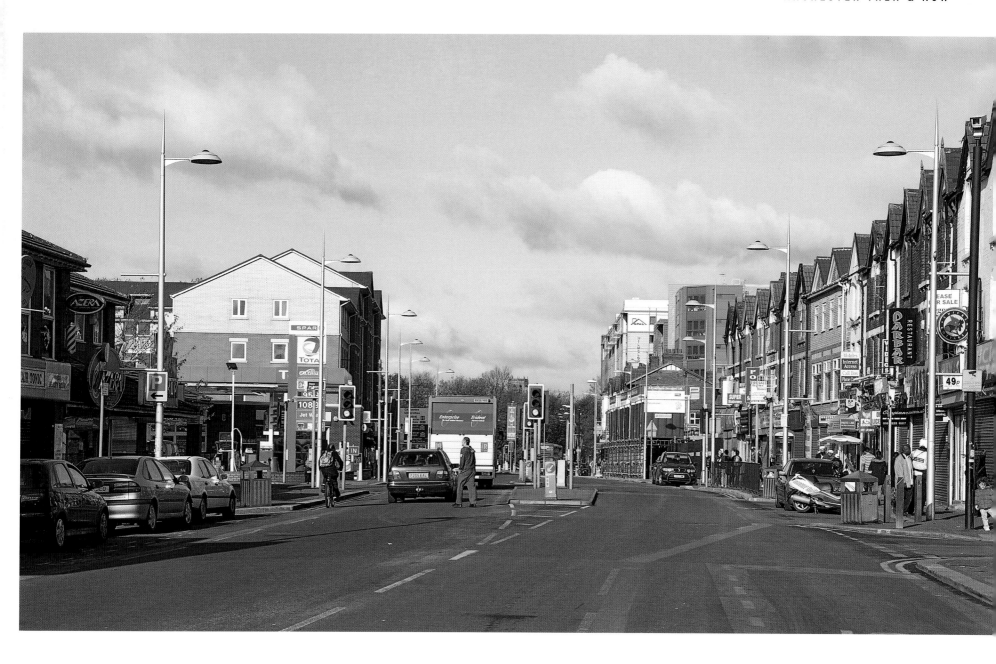

The Rusholme Electric Theatre became the Rusholme Repertory Theatre in 1923 and then reverted to a cinema in 1941. The cinema was demolished in 1971 and a petrol station now stands in its place, a return to the site's transport origins. Rusholme still serves a diverse population, but a very different one. Wilmslow Road is now best known as 'Curry Mile', despite the main drag's half-mile length. There are more than 50 South Asian restaurants, cafés and takeaways on Wilmslow Road, as well as sari shops, groceries and many other Pakistani-owned outlets. At night-time the area is a riot of neon and a magnet for curry fans from across northern England.

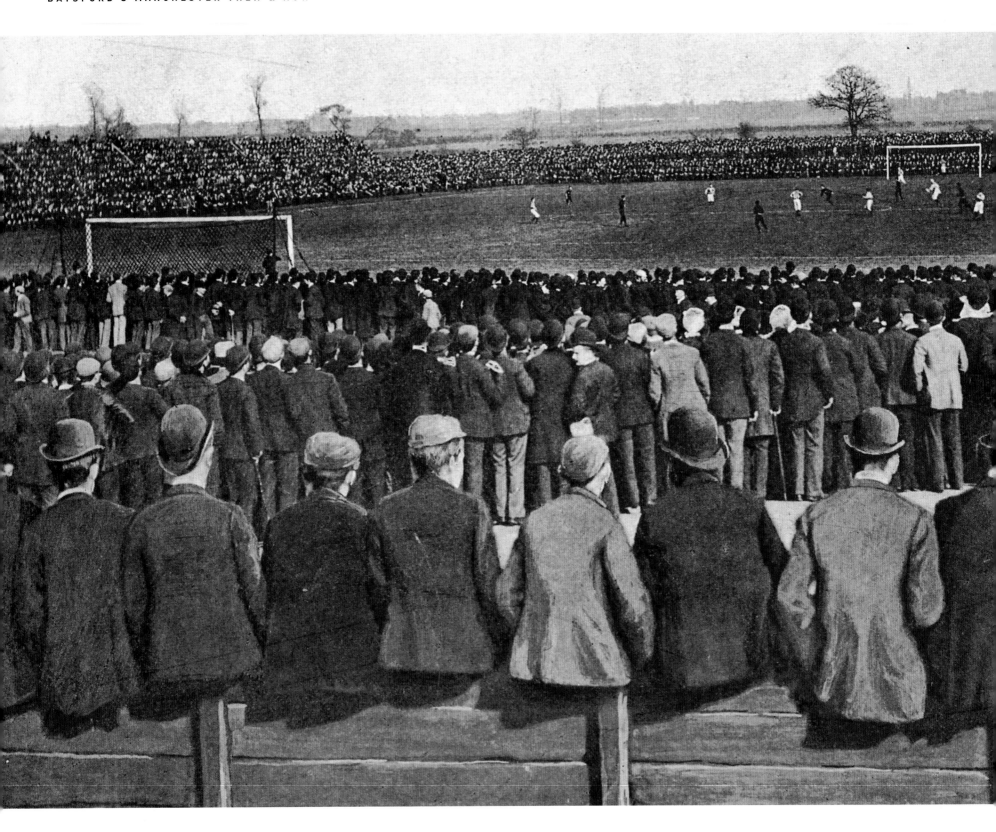

FALLOWFIELD STADIUM

Shown hosting the FA Cup Final of 1893

Left: Fallowfield, a semi-rural area three miles outside of Manchester city centre, always had lots of sports fields and clubs. In 1892, the Manchester Athletic Club built a stadium here with turf banks to hold spectators. The following year the usual venue for the FA Cup Final at the Oval in London became unavailable and Fallowfield was chosen for the match (shown here), in which the Wolverhampton Wanderers beat Everton 1–0. Around 45,000 fans turned up for the 15,000-capacity venue, encroaching on the pitch: most people couldn't see what was happening. In 1899 the stadium hosted a semi-final between Sheffield United and Liverpool that was abandoned due to safety fears.

Above: Fallowfield Stadium was bought by Manchester University in the early 1960s and, despite protests, it was demolished in 1994. The exact site of the stadium, to the left in this picture, is now hidden by a whole village of student halls of residence. Following the 1893 Cup Final the venue hosted an England versus Scotland rugby union match in 1897. It was, famously in the city, the home of the Manchester Wheelers for many years, one of the UK's premier cycle clubs. During the Wheelers' track meet of 1910, 20,000 people gathered to watch the aviator Claude Graham-White take off from the infield. The FA refused to return to Manchester for a final until 1970 and Chelsea's 2–1 victory over Leeds at Old Trafford in a replay, watched, not by 45,000, but an FA Cup record 28-million TV audience.

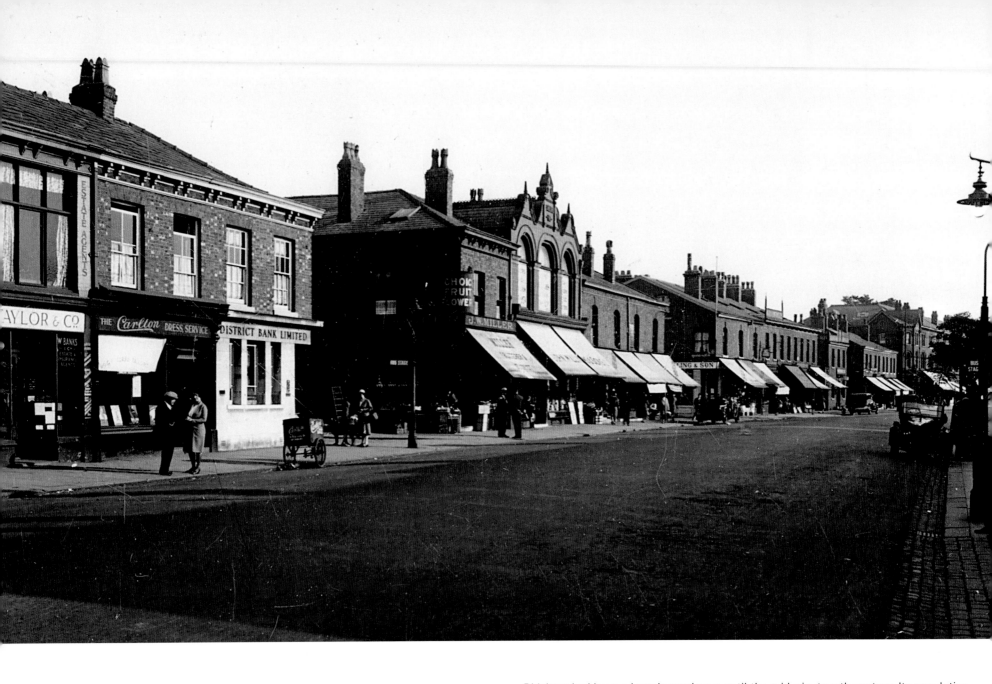

WILMSLOW ROAD, DIDSBURY

Today Wilmslow Road is referred to as 'the busiest bus corridor in Europe'

Didsbury had been a largely rural area until the mid-nineteenth century. Its population doubled, however, when the area was given its own railway station in 1880. This 1932 photograph of Wilmslow Road – the same road that runs through Rusholme (see pages 106–107) – shows a prosperous middle-class suburb, which seems to have been Didsbury's lot from the time Mancunian merchants started to move in and build mansions above the River Mersey a little to the south. Five miles from the city centre, Didsbury was formally subsumed by Manchester in 1904. The first public transport in the form of a motorbus hadn't arrived until the 1920s, but as this photo shows, by the 1930s the car, not the horse, had become king of the road.

The scale of the scene looks much the same today. The bank remains, although it is now a NatWest, not a District Bank. (The Manchester-based District Bank was one of the component parts of NatWest when it was created in 1968). The overriding difference lies in the increased traffic use on Wilmslow Road and the garish shop fronts competing for attention. The station, to the north, has gone, following the Beeching railway cuts of the 1960s. It will, however, be reborn as a tram station for the Manchester Metrolink System in 2013, connecting Didsbury by rail with the city centre once more. Today Wilmslow Road is sometimes referred to as 'the busiest bus corridor in Europe'. J.W. Millers, the ornately gabled building on the left of the 1932 image, went on to become a John Williams and Sons supermarket before turning into a branch of Halifax. John Williams and Sons introduced the concept of the self-service supermarket into the suburb and Didsbury still retains its reputation for exclusivity. As Manchester comedian Les Dawson once put it: 'you can tell Didsbury's posh, they even have grapes on the table when no one's ill'.

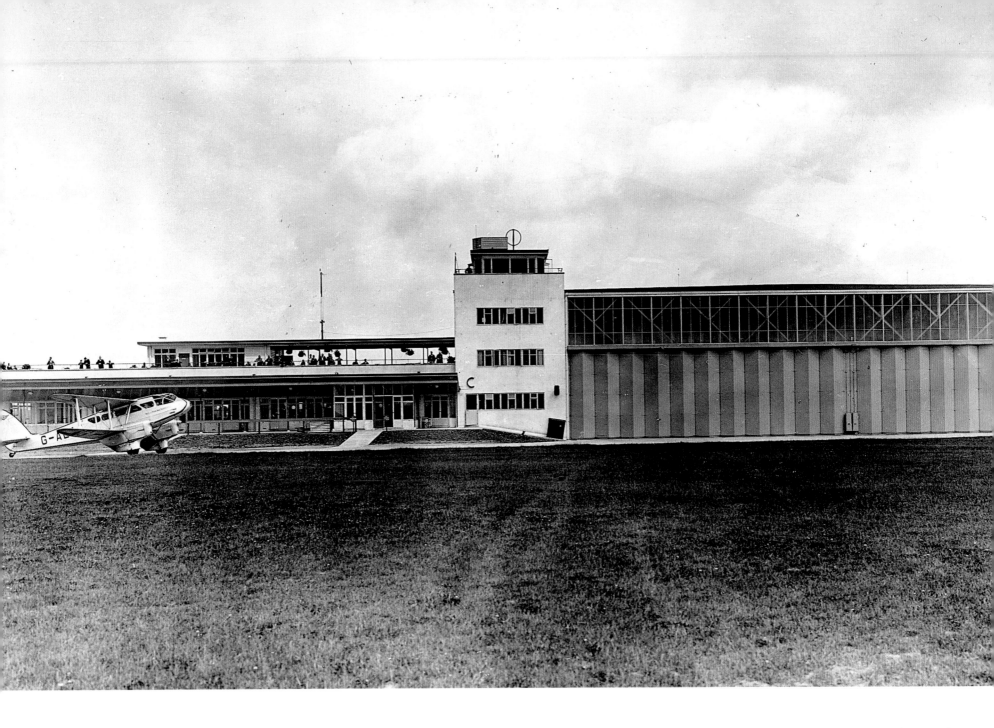

MANCHESTER AIRPORT

Continuing a tradition of pioneering transport links

This is Ringway Airport in 1938 at its official opening. An Isle of Man Air Services de Havilland Dragon Rapide plane graces the runway. Early air links were to Amsterdam, London and the Isle of Man. The city, always pioneering with transport, had been determined to be the first UK city with an airfield licence back in 1924. Early airfields at Hough End and Wythenshawe were replaced by Barton Aerodrome, west of the city, in 1930. This proved unsuccessful due to an inadequate turf runway on unstable boggy terrain, so Ringway, at the southernmost point of Manchester, was settled upon.

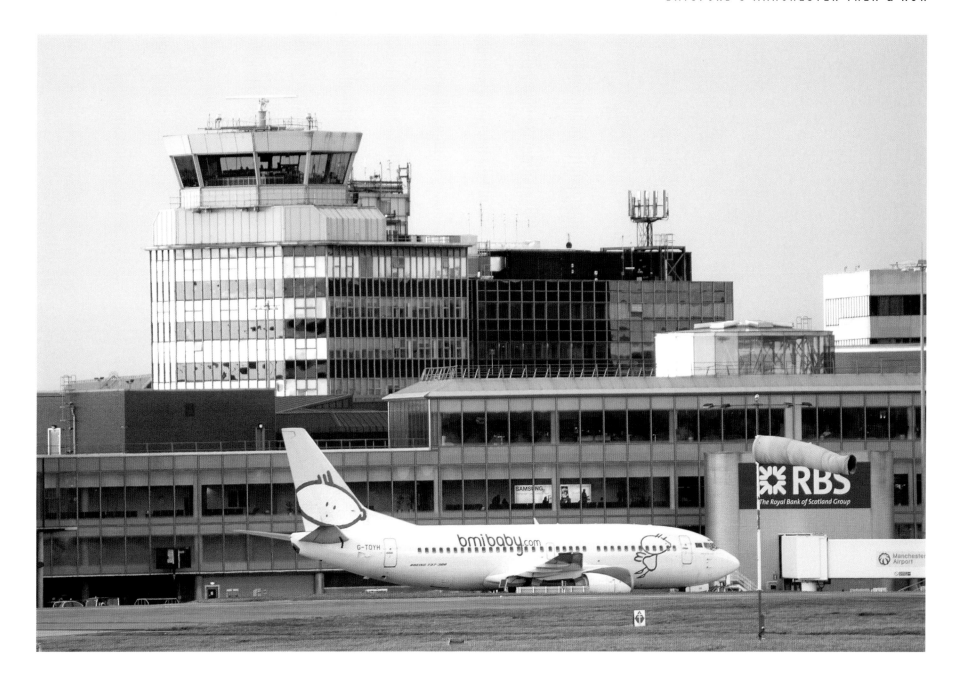

Today Manchester Airport – the Ringway name was dropped in the 1990s – processes some 20 million passengers and has flights across the globe. It has bought other airports too, including East Midlands and Bournemouth airports, and has become the second largest airport operator in the UK after the British Airports Authority (BAA). The difference is that Manchester Airport is owned not privately but by the ten local authorities of Greater Manchester, with the City of Manchester the majority shareholder. Since the 1938 photograph two major new terminals and a second runway have been built, as well as a rail station for onward transit.

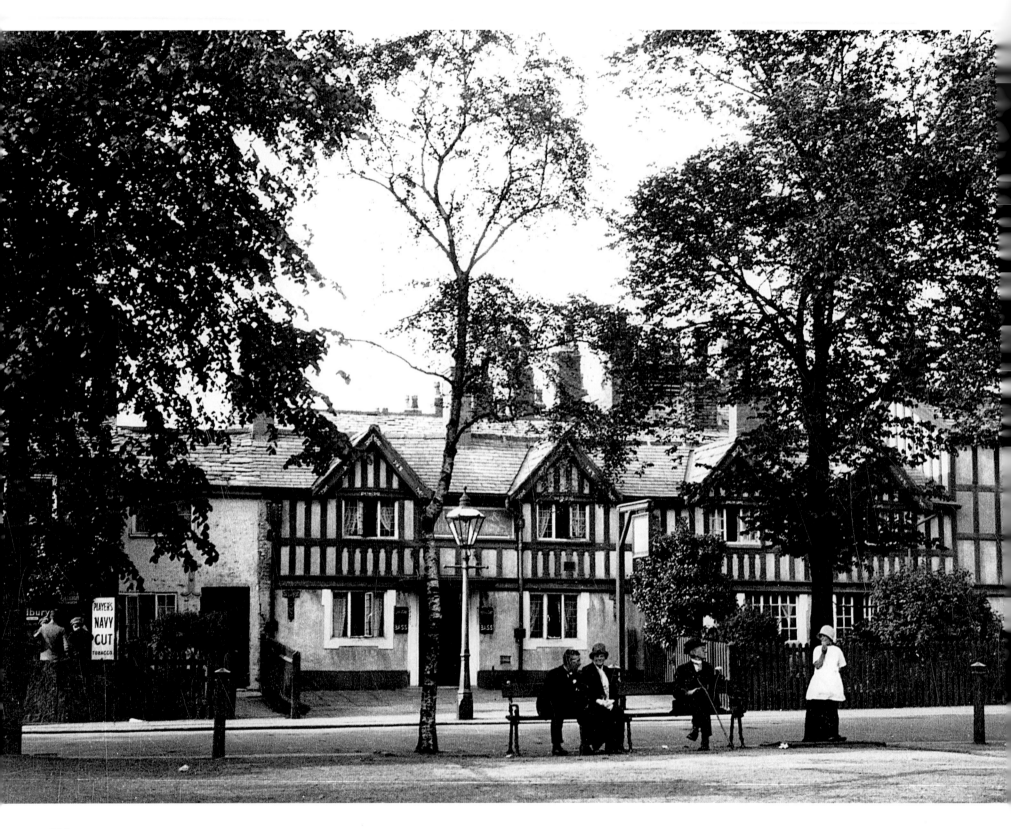

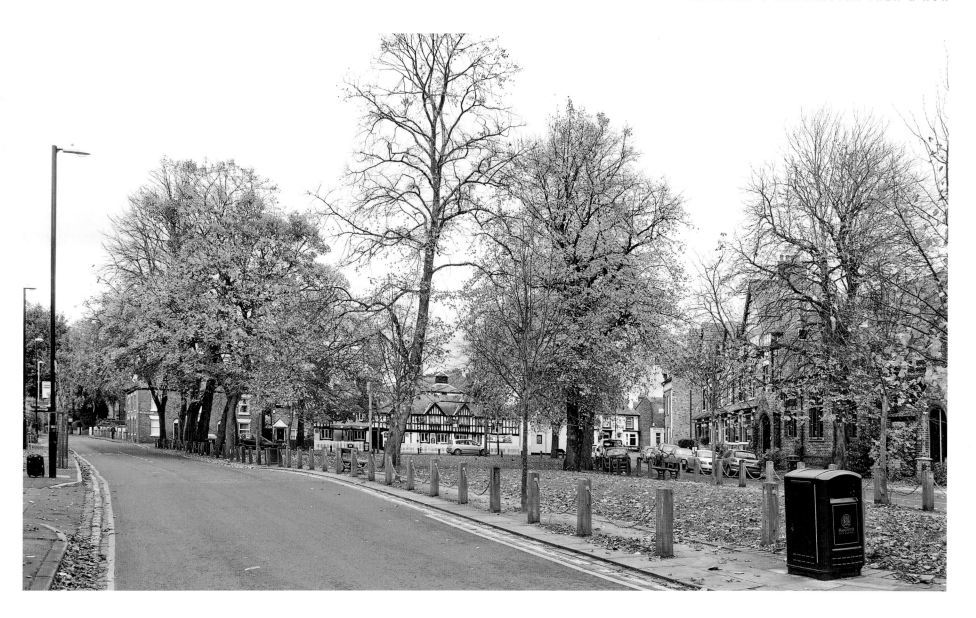

CHORLTON GREEN

Chorlton was incorporated into the City of Manchester in 1904

Left: By the time this 1928 photograph was taken Chorlton had been incorporated into the City of Manchester for 24 years. Chorlton Green, four miles or so south west of the city centre, had been at the heart of the hamlet of Chorlton until the railway arrived three-quarters of a mile to the north in 1880. The green, just visible in the foreground, had become a quiet backwater by the 1920s. The Horse and Jockey pub sits on the site of school buildings that date back to 1512. It was first used as a pub in the early 1800s. The mock-Tudor timbering was added in 1907–08 for an 'olde worlde' effect.

Above: The Horse and Jockey's black-and-white timbered facade can still be seen in the distance of this photograph. The pub has expanded following the acquisition of a former private school to the right. When the 1928 photo was taken the green was in fact a hard, gravel surface. Today it is a true green; a sunshine magnet for people wishing to get a pint from the pub, loll on the grass and watch the world go by. The area is no longer as sleepy as it was in 1928 either, despite the quiet appearance of this picture. Manchester's 'boho' community has moved in and colonised Chorlton Green. Beech Road, the street opening off to the right, has become lined with bars and clothes shops.

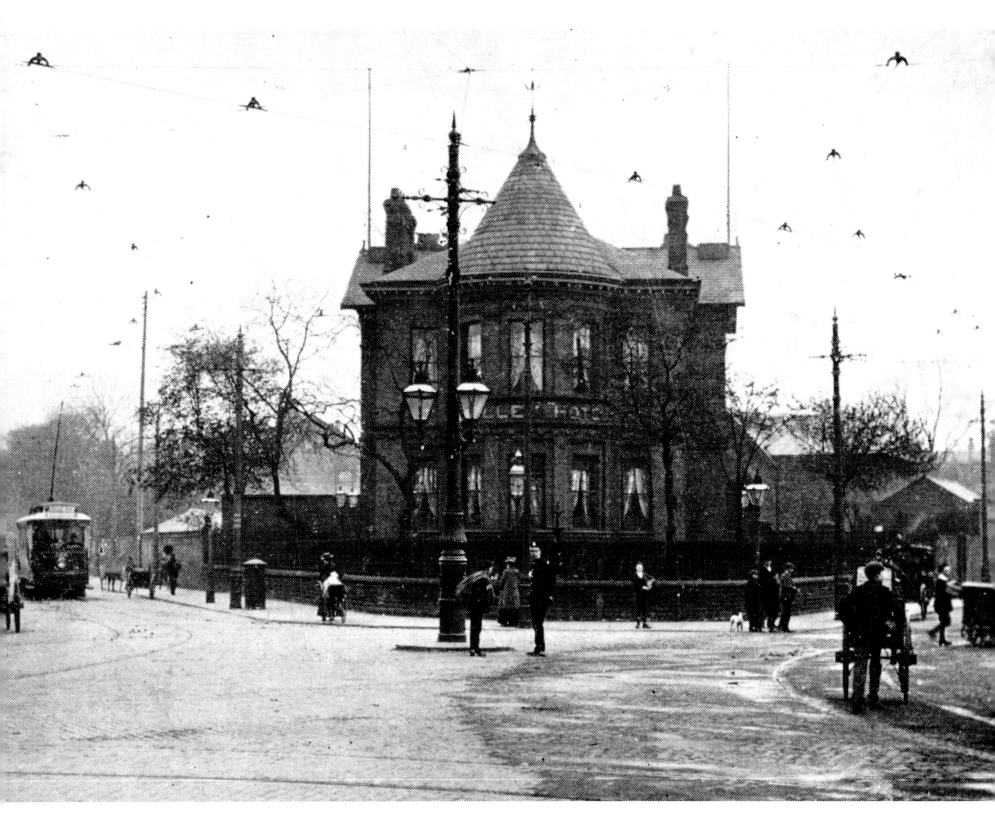

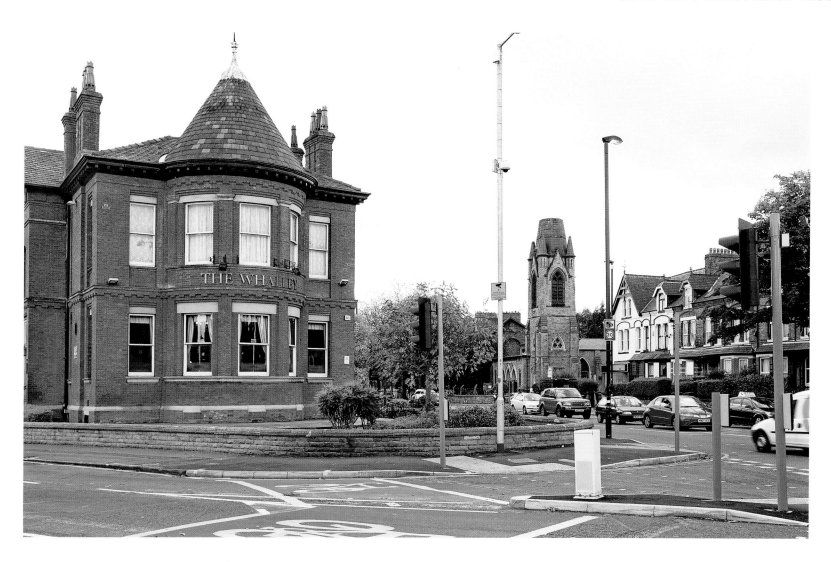

BROOKS' BAR

Named after Samuel Brooks who purchased the land surrounding this area in 1836

Left: Brooks' Bar has always been a key junction in the city and it's been dominated by the Whalley Hotel (pronounced in Manchester as Wolly) since 1868. This is the scene in 1910, with an electric tram passing the pub on the left and a policeman in the middle distance presiding over the junction. The road to the left is Withington Road; the road to the right is Upper Chorlton Road. Four suburbs meet here: Hulme, Old Trafford (part of the separate administration of Stretford), Moss Side and Whalley Range. In 1836 Samuel Brooks, a Manchester banker originally from Whalley in Lancashire, bought 63 acres of land as 'a desirable estate for gentlemen and their families'. This famous junction and the toll gate that originally guarded the area were named after him.

Above: Moss Side and Whalley Range became part of Manchester in 1904; Old Trafford, the area to the right side of this picture, remained resolutely separate as it does to this day. In 1910, despite some nearby terraced streets, the area south of this point was still very much for the merchant classes of the city – some of the 1880s terraced villas can be seen on the right. Today the Whalley Hotel is a rundown pub, The Whalley. While the junction may remain as busy as ever, the area is coming out of four decades of economic decline, with the older properties often split into bedsits and apartments. But the wheel turns and as property prices rose to the south in the 1990s many have been converted back to single-family occupancy. The church on the right is the New Testament Church of God with a mainly Afro-Caribbean congregation. Built in 1873 for the Methodists it had to have its spire cut short after fears of collapse. The economy may have declined but the area is as culturally rich as anywhere in the UK.

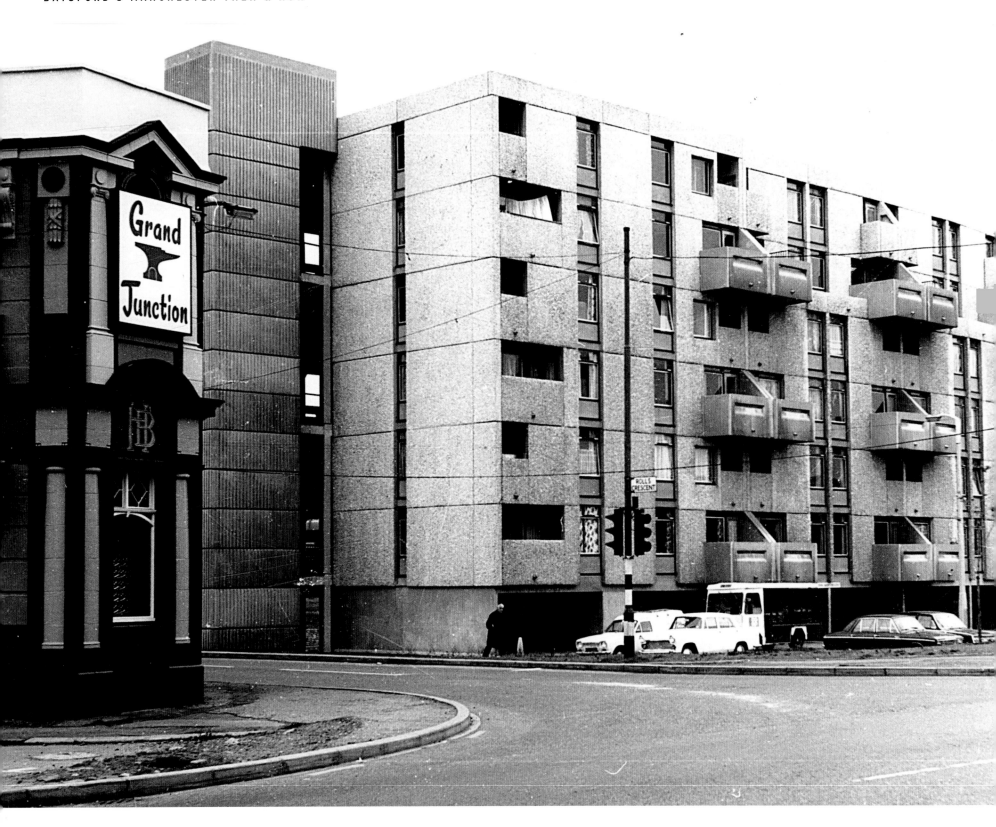

HULME

Hulme has changed from being an area of subsidy to an area of investment

Left: This is 1971 and the late nineteenth-century Grand Junction pub sticks out like a sore thumb amidst a desert of concrete in Hulme. The suburb's Victorian terraces were in poor condition by the end of World War II. Following the demolition of these properties the population density in Hulme was halved. When funds became available in the 1960s, a series of concrete low-level flats (3,284 of them) were built with linking bridges at varying levels. Fifteen tower blocks were built too and in the process the community's shopping streets, theatres and most of their pubs disappeared. Half the population ended up on estates miles away from a city centre they could previously walk to. In this picture people are still trying to go about their usual routine. The milkman, however, would now need to cart his deliveries along floor after floor of flats.

Above: The Grand Junction pub (a Hydes Brewery tied house, with the brewery half a mile away) remains, but the concrete has been felled. Even as they were being completed in 1969, the architectural critic Nikolaus Pevsner wrote: 'Do the tenants want them? Will they not be the slums of 50 years hence?' They didn't last ten. The cheaply built blocks were blighted by damp and overheating, and the design bred anti-social behaviour. After 15 years the conditions had largely driven out the elderly, families with children and the disabled. They became so lawless that rent wasn't collected by the council prior to demolition. One interesting aspect was that these conditions made Hulme a centre of young creativity, in one case flats being run together to create a recording studio. In the 1990s the area was cleared and much of the old street pattern re-created. Hulme has, in part, become a popular place to live and moved from an area of subsidy to investment.

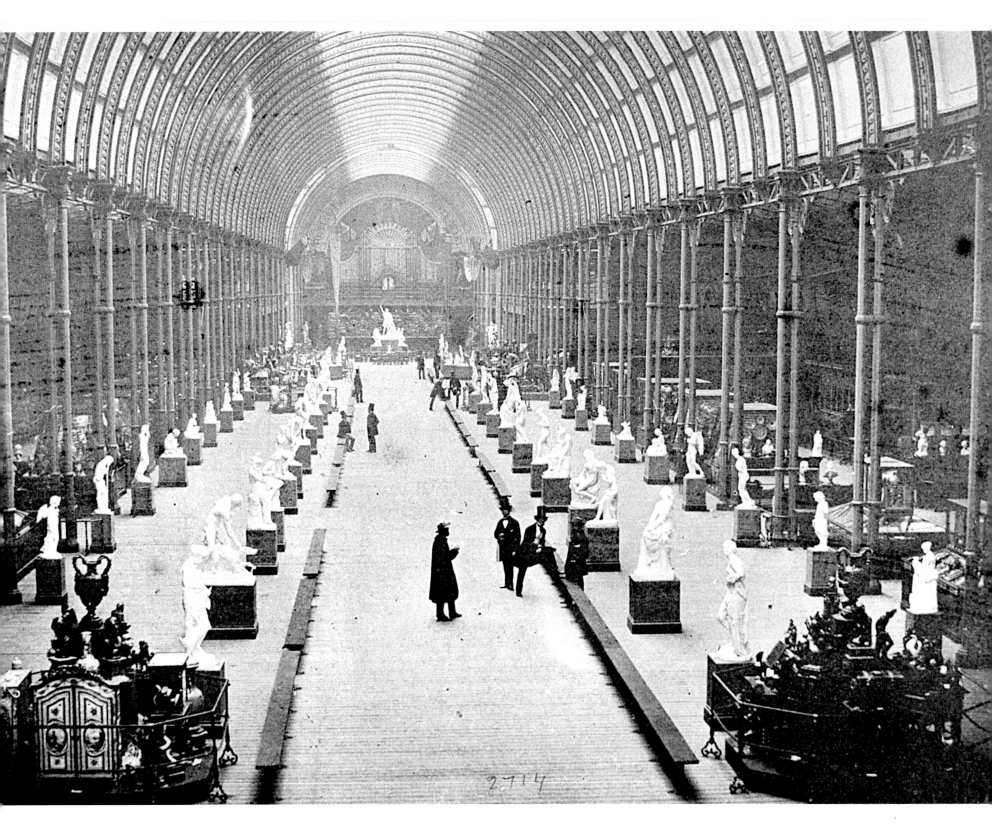

TALBOT ROAD

Site of the biggest temporary art exhibition that Britain has ever seen

Left: This is the view down the central hall of Manchester Art Treasures Exhibition, which took place in 1857 in Old Trafford. The project crystallized the city's industrious nineteenth-century energy. Following the Great Exhibition of 1851 in London and smaller ones in Paris and Dublin, Manchester decided to put the lie to its reputation for lack of culture with an art exhibition. The idea was mooted in March 1856; by May, royal approval was given; by August, the ground was broken; by February 1857, a building twice the size of a football pitch of glass, iron and brick with its own rail sidings was complete; in May, it opened with 16,000 artworks; and by September it closed, after 1.3 million visits. By Christmas it was demolished and the building materials recycled. From conception, through execution to demolition took less than two years – a remarkable feat for Britain's biggest temporary art exhibition ever. Final profits from the exhibition were given to charity – all the money for the exhibition had come from people with a Manchester postal address.

Above: The modern view shows how complete the removal of this vast exhibition space was. We're looking west down Talbot Road in Old Trafford, roughly along the line of the central hall of the Art Treasures Exhibition. In the older picture the end of the hall is closed off with an organ. The organ would have sat where the second set of traffic lights is in this picture. A year after the exhibition in 1858 Charles Hallé, who had entertained guests at the exhibition with music, created his eponymous orchestra, which remains the only city memorial of the event. After the exhibition this area became Manchester's West End with big houses and local worthies, including the parents of Dodie Smith (author of *The Hundred and One Dalmatians*), who grew up here. In the late twentieth century it became an office zone. In front of the distant 1960s block on the left, and out of sight, lies Lancashire County Cricket Club, which moved from the area in the foreground to make way for the Art Treasures Exhibition.

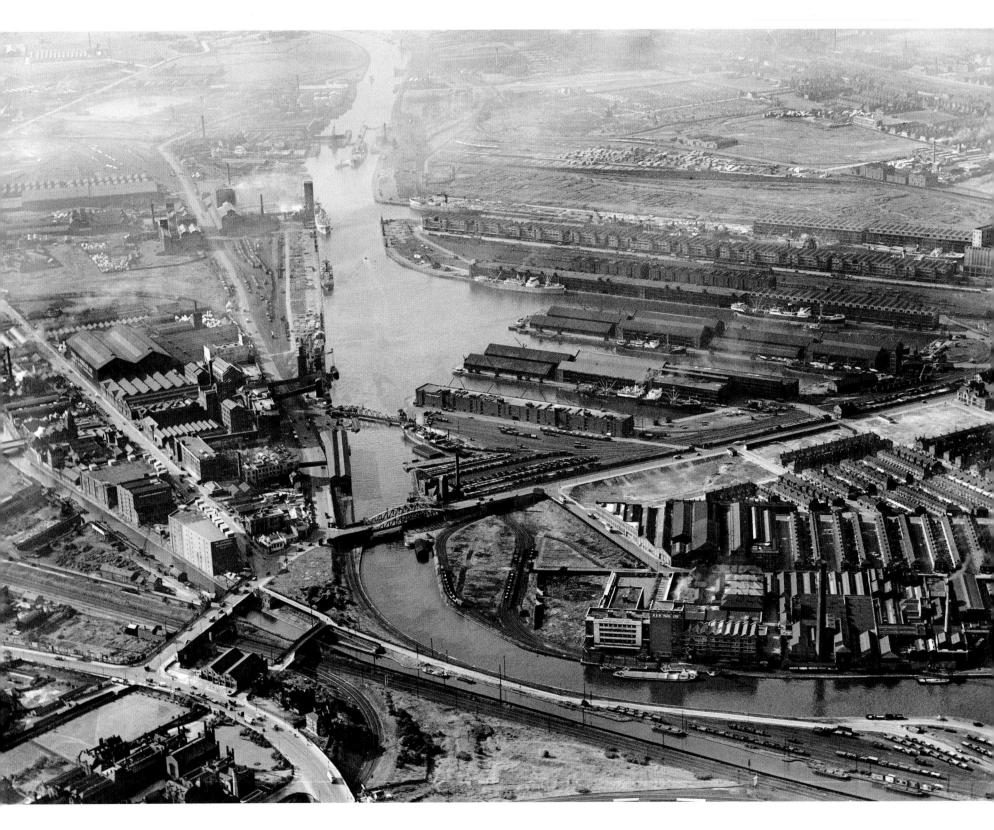

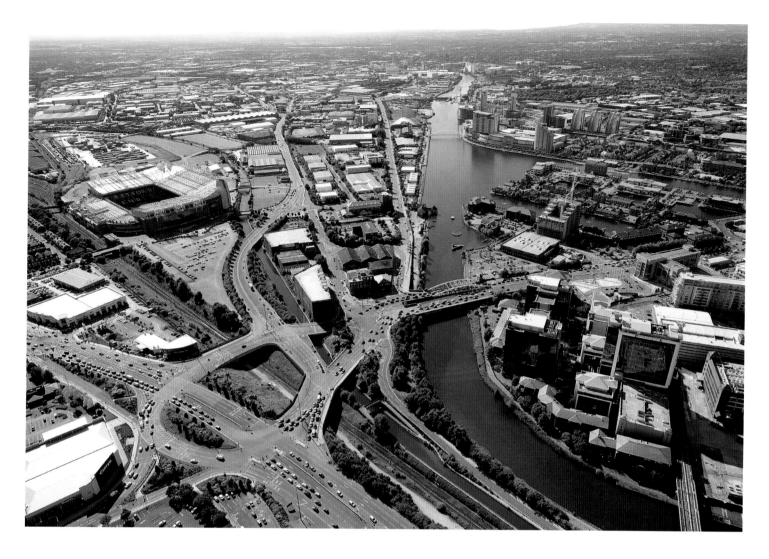

MANCHESTER SHIP CANAL

Showing Trafford on the left and Salford on the right

Left: This is a mid-twentieth century view of Manchester Docks on Manchester Ship Canal (opened 1894) and it's a picture of industrial muscle; a city defined by what it makes not what it plays. The curve of the River Irwell is the dominant physical feature, although here its path has already been smoothed and its waters canalised. Not much remains of the pre-industrial scene, except a memory of the sport that took place here. The point where the river turns in the foreground is called Throstle's Nest (Thrush's Nest) and was a sandstone mini-cliff over the river. In earlier times, thousands would come here to swim in the trout-rich river. In the extreme lower left-hand corner of the picture is the tall gable end and buildings of Henshaw's Blind Asylum. The asylum was built in 1838 when this was a semi-rural area outside of the city.

Above: Today the scene is utterly changed. Of all the buildings shown in the earlier picture only three remain: the warehouses built in the 1920s and 1930s between Manchester Ship Canal and the Bridgewater Canal (1770s). To the left of the Bridgewater Canal is the main trainline to Liverpool. The infrastructure is still there – the two canals, the railway and the newcomer, which takes up more space than anything else: the road. The junction here is known as the most un-navigable for strangers in the city. The other structure that has been enhanced beyond recognition is the world-famous Old Trafford ground of Manchester United in the left of the picture. The left-hand side of the picture is occupied by the Trafford Park area of the Trafford borough; the right-hand side over the river is Salford.

OLD TRAFFORD

With a capacity of 76,212 it is now the largest club stadium in the UK

Left: This view looks down on Old Trafford (far left) when it was a far-cry from the preened turf where pampered millionaires ply their trade. This is Old Trafford bombed and broken. In 1941 German bombers attacked Trafford Park, the western fringe of which is occupied by Manchester United. The south stand, cleared in this picture, was badly damaged as was the north stand, whose torn and ragged roof can be seen here. The War Damage Commission granted Manchester United £4,800 to remove the debris and £17,478 to rebuild the stands. In this picture the white football lines have gone, disappeared under the hayfield of the pitch. In the lower left of the photo is the Bowling Green pub and its adjacent field. Scientist John Dalton (who produced the first atomic table and discovered colour blindness) would take a 'constitutional' here every week in the 1820s and 40s. By wiping the leaves of the trees with this handkerchief he noticed that there was less industrial soot on the trees here – the south-westerly winds blowing

it the other way. He advised a botanical gardens to be set up nearby in 1831. This began the movement of leisure and sporting clubs to Old Trafford, which culminated in Manchester United's move from Bank Street in 1909.

Above: Manchester United returned in 1949 to Old Trafford (left) after using local rival's Manchester City's home ground of Maine Road in the intervening years. During this period they attracted the highest league attendance ever of 86,260 against Arsenal in 1948. Matt Busby (later Sir Matt Busby) had joined the club in 1945 as manager. The club grew into one of the most famous in the world under Busby's direction, but also suffered tragedy in the Munich air disaster of February 1958 when 23 lost their lives including nine players. Under Sir Alex Ferguson's direction, in recent times United has become arguably the most famous club alongside Real Madrid of Spain. The club's commercial and on-field success has created the behemoth of a stadium we see today; with a capacity of 76,212 and easily the largest club stadium in the UK. Being a modern stadium it also has conferencing suites, a museum, a superstore and more executive boxes than any other stadium in the world.

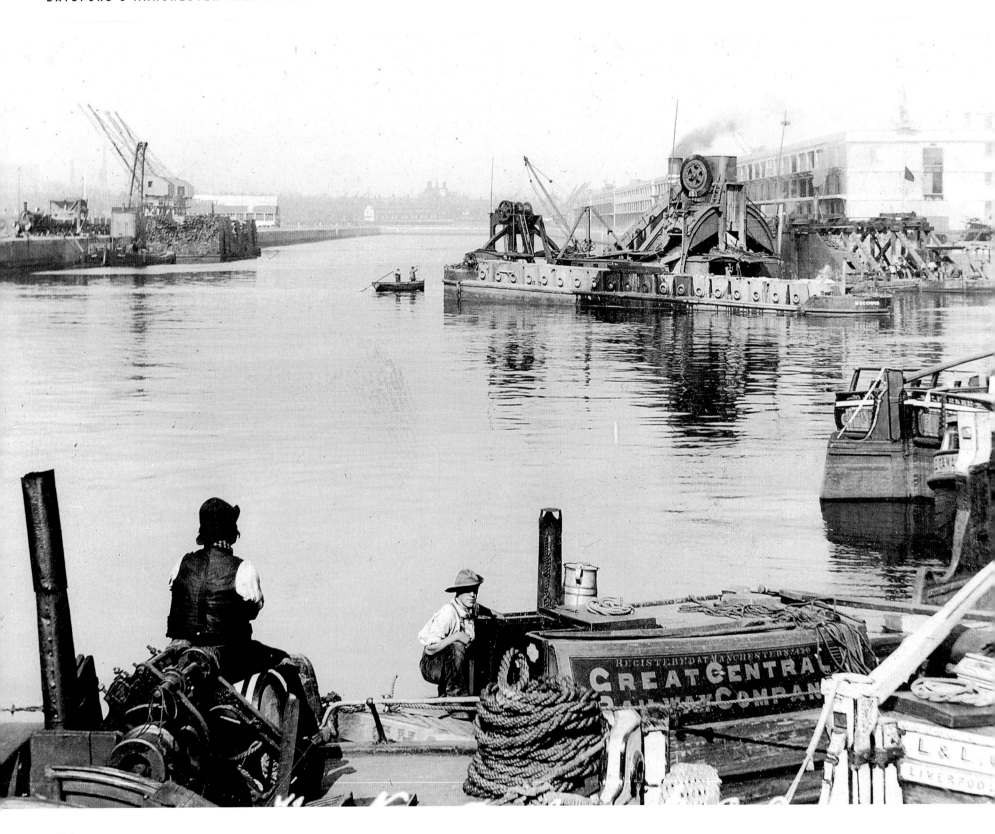

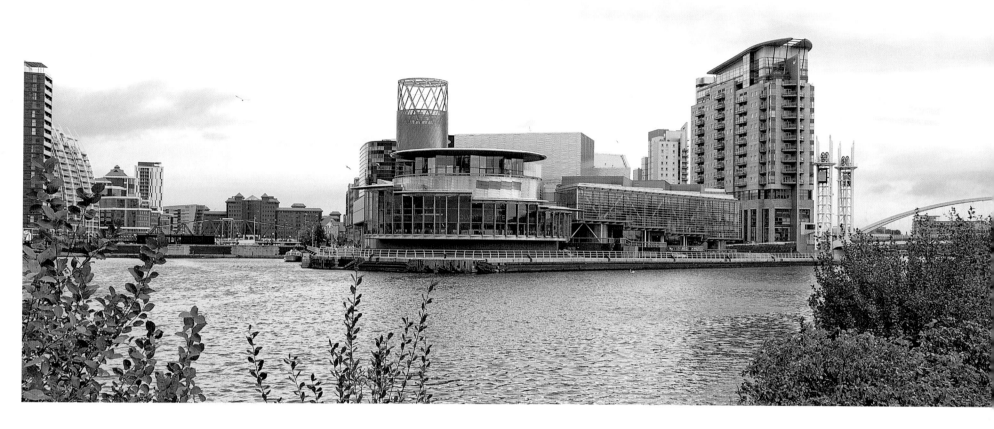

MANCHESTER SHIP CANAL / THE LOWRY

Manchester Ship Canal was Britain's largest Victorian engineering project

Left: This picture shows a view across Manchester Ship Canal ten years or so after its opening in 1894. The figure on the left is looking across to Dock Nine, which was due to open in 1905. The terminal works of the quay wall are still being finished in the right centre of the picture and no major vessels are as yet allowed into the dock. Dock Nine would be largely used for grain imports from Canada. By the time of this picture Manchester Ship Canal had proved a success and was a catalyst in the creation of the Trafford Park industrial estate. Manchester, 35 miles away from the Mersey Estuary and 50 from the open sea, was amongst the UK's top four ports by tonnage. Manchester Ship Canal was the largest Victorian engineering project undertaken in the country. However, greed created it: Liverpool's. The port city to the west was taxing Manchester products so much that the city had no choice but to bring the sea into its heart. Manchester and Liverpool's rivalry has its root in trade not football.

Above: The last commercial vessel arrived at Manchester Docks in 1982. The site was cleared and moved swiftly from blue-collar to white-collar with apartments and offices being built. But by the mid-1990s it was realised that something was missing and a cultural focus needed to arrive and urgently. The result was the millennium project for the North West, the Lowry; a complex of art gallery, two theatres and conferencing built to breathe new life into what is now called Salford Quays. The Lowry's aluminium building, whose curved rear can be seen across the canal, was designed by Michael Wilford. Together with the footbridge pictured on the extreme right (two towers with counterweights can just be seen) the package cost around £84 million. The footbridge lifts to allow a tourist boat – a Mersey Ferry – up for summer excursions: it's the only boat that uses these headwaters in the 2000s. Dock Nine, now overshadowed by apartments and offices, is today so clean that the swimming section of the annual Triathlon takes place here.

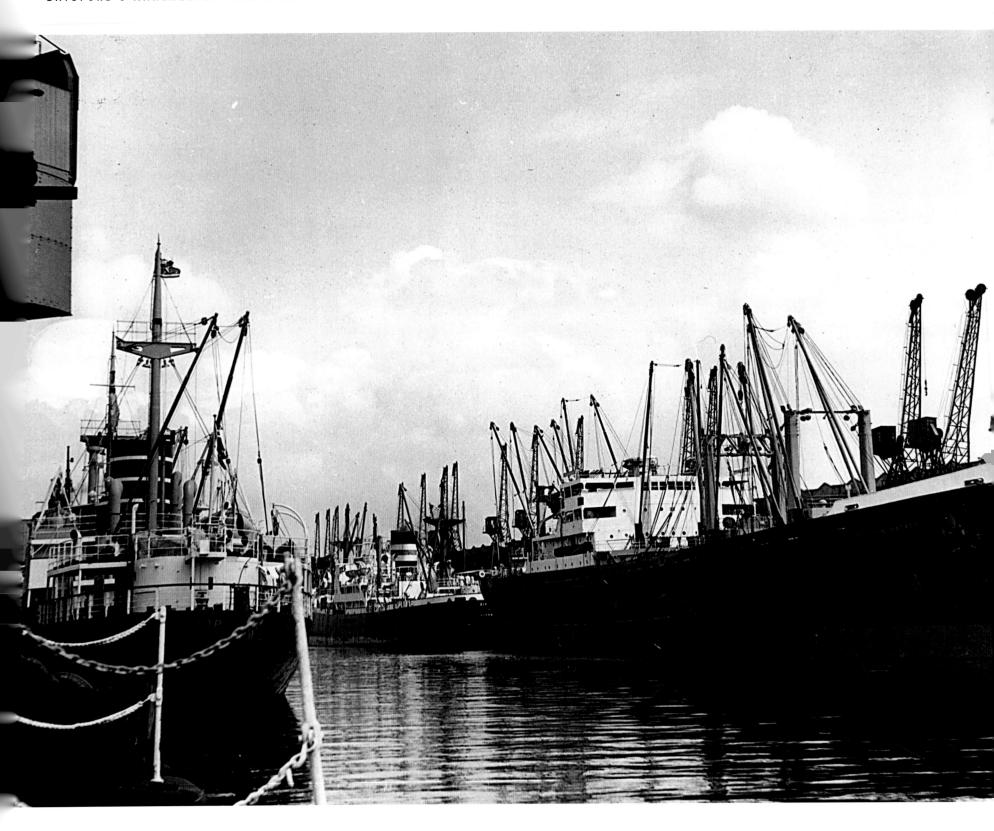

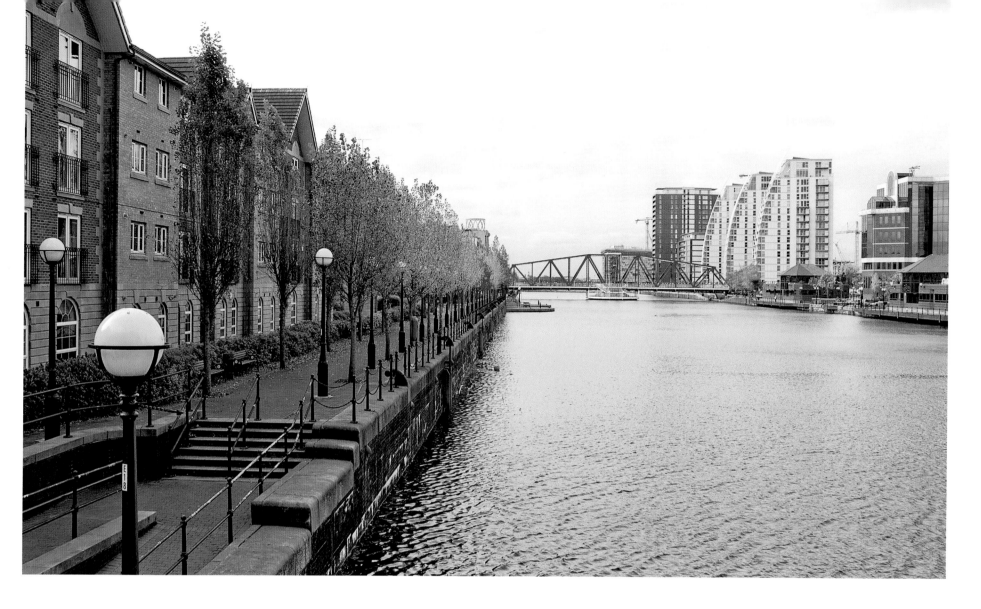

CANAL DOCK NINE

Giving a new home to the Detroit Bridge

Left: Dock Nine, photographed in 1953, shows a crowded dockside, a testimony to the post-World War II boom that made Manchester one of the four biggest ports, by tonnage, in the country. Many of the ships coming into Manchester were Manchester Liners vessels, as pictured here. The company had been created in 1898 and pioneered trade into the heart of the Great Lakes of North America in the 1950s. It was ironically one of the driving forces behind the use of containers in the 1960s that would spell doom for the docks as a commercial development. The company lost 15 merchant ships in the two world wars, with the S.S. *Manchester Commerce* being the first merchant ship of World War I to be sunk by a mine.

Above: After the last commercial ship sailed in 1982 several dock arms were closed off and liquid oxygen pumped in at rates of up to 15 tonnes a day. The clean-up has meant the return of perch, roach and other aquatic life, and the use of this dock for water sports. In the distance, on the left, the top of the Lowry arts centre complex peeps out. On the right-hand side can be seen the three white towers of the NV Buildings apartments. The brick and glass building far right is an office block called The Victoria, completed in 1993. The bridge across the dock is the Detroit Bridge and was moved here in 1990. It was a former rail swing bridge and can be seen over the main Ship Canal in the aerial picture on page 122, the second from bottom of the two bridges shown spanning the waterway.

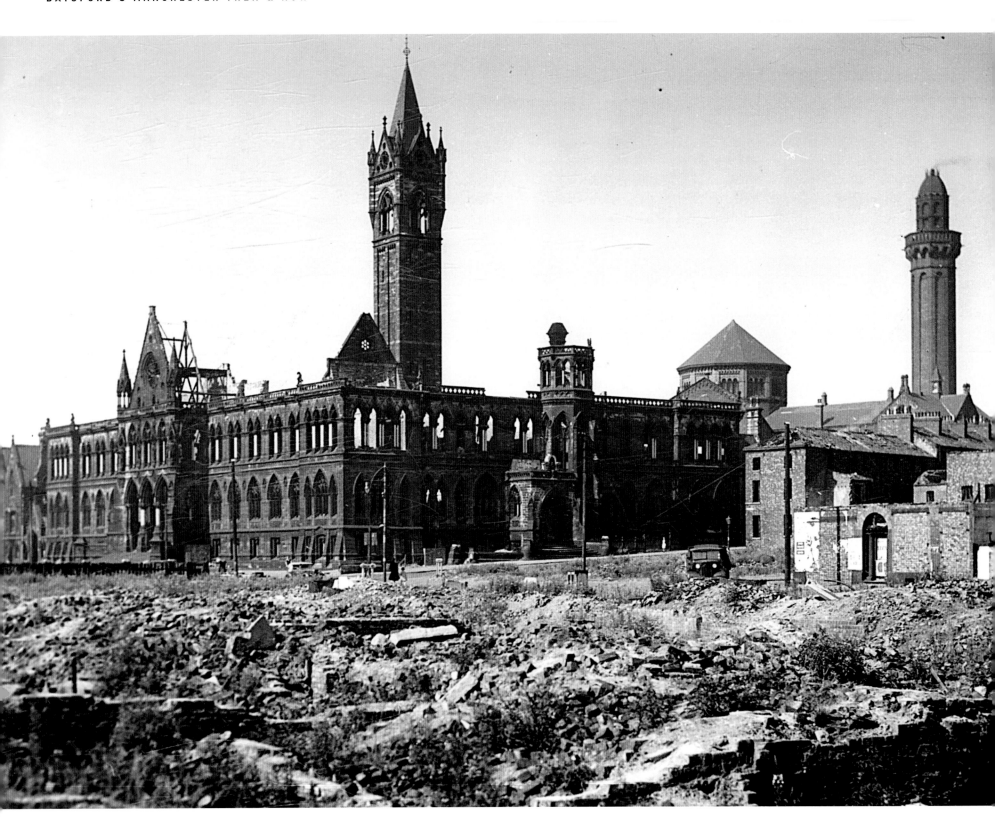

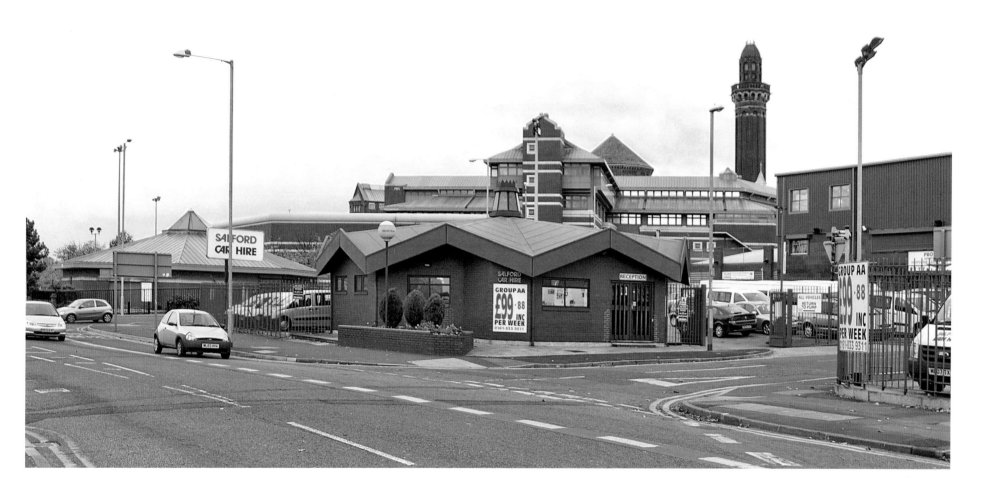

ASSIZE COURTS AND STRANGEWAYS

Manchester's greatest loss to the *Luftwaffe*

Left: Nineteenth-century periodical *The Builder* came up with the phrase 'Manchester Gothic'. Alfred Waterhouse, architect of Manchester Town Hall, was a leading exponent and designed both buildings in this 1945 picture. The Assize Courts in the foreground became Manchester's major casualty of World War II bombing and were demolished in the 1950s. Waterhouse had won the commission for the building at the age of 29 and it was completed in 1859. John Ruskin called it: 'A very beautiful and noble building and much beyond anything yet done in England.' Waterhouse also designed Strangeways Prison, immediately behind, which opened ten years later. This was based on the Panopticon principle of a central area with viewable wings radiating from it. The tall tower to the right in the prison is a very fancy chimney designed as an Italian *campanile*.

Above: Strangeways Prison is now officially known as HM Prison Manchester. After the loss of the Assize building the main courts of Manchester became scattered across the city centre. The chimney of Strangeways Prison is still a landmark. The prison witnessed exactly 100 executions, the last being on 13 August 1964 when murderer Gwynne Evans became the joint-final convict to be hanged in the UK (at the exact same time as his accomplice, Peter Allen, was hanged in Liverpool). In 1990 the Strangeways Prison riot became national news, lasted 25 days and caused the prison to be rebuilt at a cost of over £100 million. The jail is an unlikely tourist attraction too. In 1987 Manchester band The Smiths released an album called *Strangeways, Here We Come* and their devout followers still pose for photos outside the main gate.

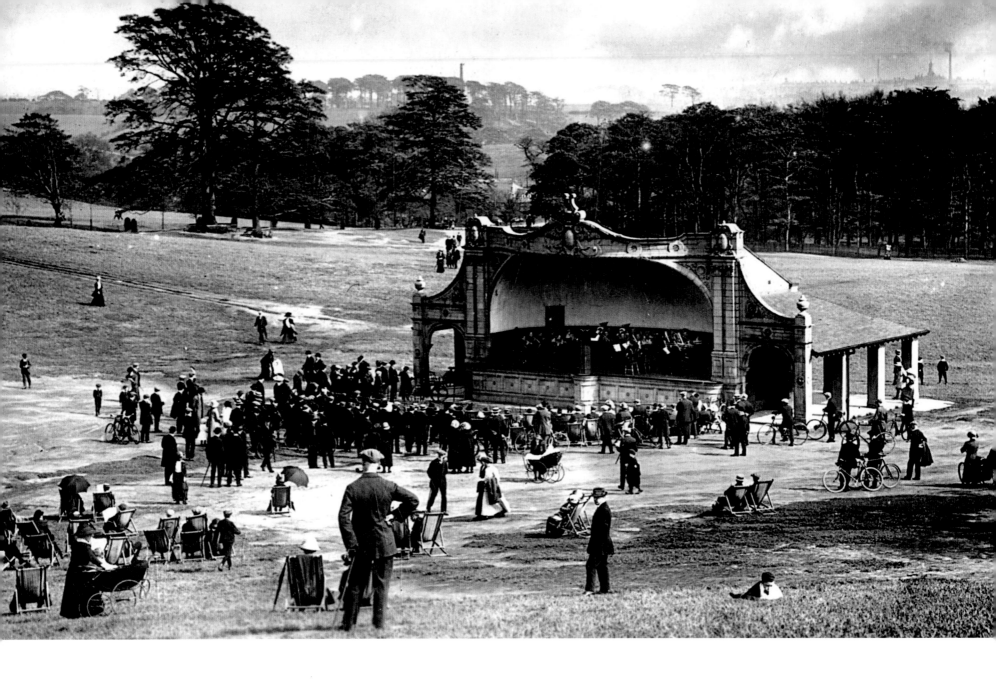

Heaton Park came into Manchester's ownership in 1902 when the 5th Earl of Wilton sold it to the city for £230,000. At over 600 acres it was one of the largest municipal parks in Europe. The park's vast bandstand is shown here in 1910. A year earlier, bicycle and gramophone retailer William Grimshaw, from the nearby suburb of Prestwich, brought a supersized gramophone to the bandstand. He'd heard the Italian tenor Enrico Caruso at the Free Trade Hall and wanted to share the experience using a recording of Caruso. The crowds were stupendous, up to 40,000 strong. His success led to other councils adopting the idea and Grimshaw, a dapper, middle-aged, bearded gent, became the first DJ, known as 'the Gramophone King'.

HEATON PARK

One of Europe's biggest municipal parks

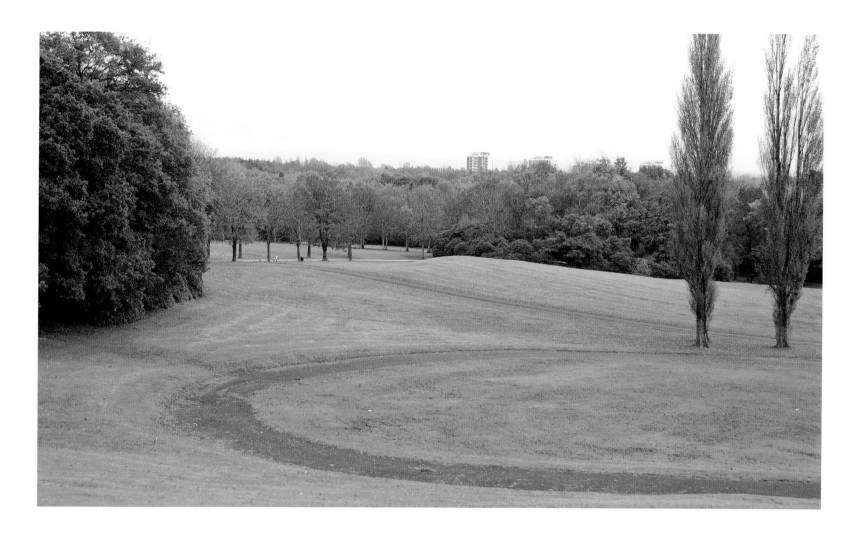

The original parkland of the Wilton family at Heaton had been landscaped in the late eighteenth century by a disciple of Capability Brown, William Eames. In the twenty-first century the expansive style of that period has been re-created at Heaton Park, resulting in a much more open space. The bandstand is long gone. Lottery funding has enabled a resurgence in activity and the park has again become a focus for the city with charitable runs, events and the recovery of several important buildings. Three key events between the two photographs should be noted: 133,000 RAF cadets were billeted in and around the park when it was used for aircrew training in World War II; in 1982 Pope John II celebrated mass for over 100,000 people in the park; and in 2002 the Commonwealth Games bowls competition was held here.

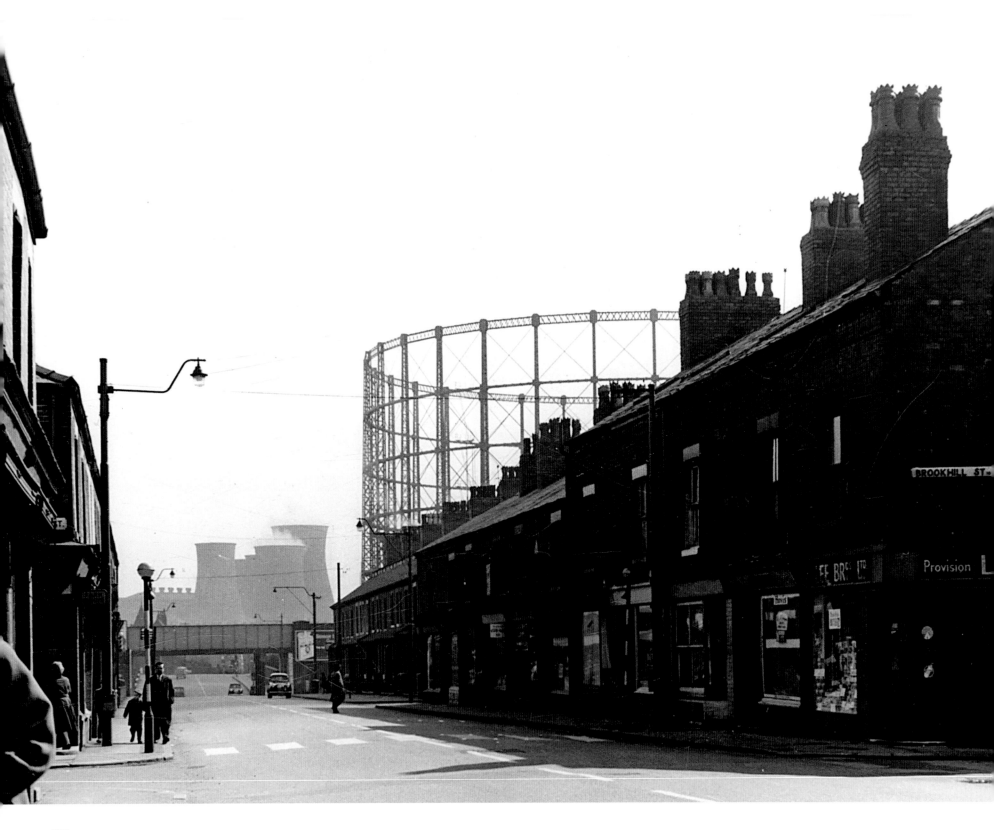

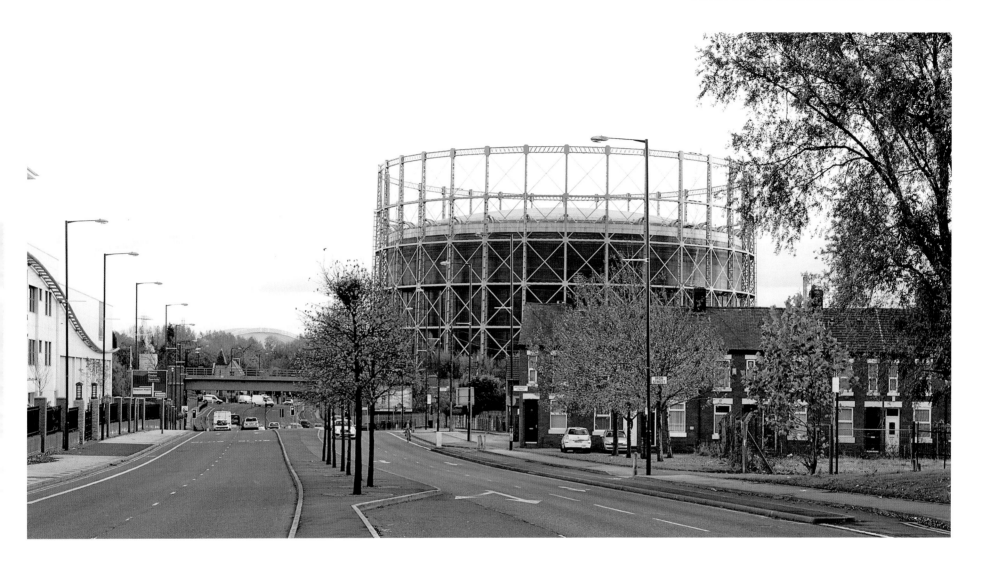

GASOMETER

From black gold to Olympic gold in one generation

Left: This 1962 photograph of East Manchester was taken on Hulme Hall Road, looking from Newton Heath and Miles Platting towards Bradford. At this time, the eastern suburbs had a population of around 162,000 and were defined by close terraces of houses. Employment levels, mostly in local manufacturing, were high, the streets were busy and here the sun is out. The gasometer is the oldest thing in the view, built in 1869 at the Bradford Gas Works. Over the railway bridge in the distance the cooling towers of the mighty (and filthy) Stuart Street Power Station can be seen. This arrived in the area in 1900, attracted by the proximity of Bradford Colliery (see page 136) with which it is connected by a tunnel with a conveyor belt taking coal directly to the boilers. The surrounding area supported light and heavy engineering, chemical works and much else.

Above: Today only the rail bridge and the gasometer survive from the 1962 view. The terraces were thinned in slum clearance schemes in the 1960s and 1970s and the East Manchester population has shrunk by 100,000 to around 62,000. The loss was caused by the disappearance of jobs as heavy manufacturing diminished. Where the power station stood the low dome of Manchester Velodrome can just be seen. This is where the eight gold medal winners of the Beijing Olympics trained. The cooling towers of the power station were demolished in 1978. The white building far left is Vermilion Thai Restaurant, built by the owners of Seamark, a Manchester success story. Seamark, created by the Iqbal brothers in 1976, is one of the largest UK importers of prawns and frozen fish.

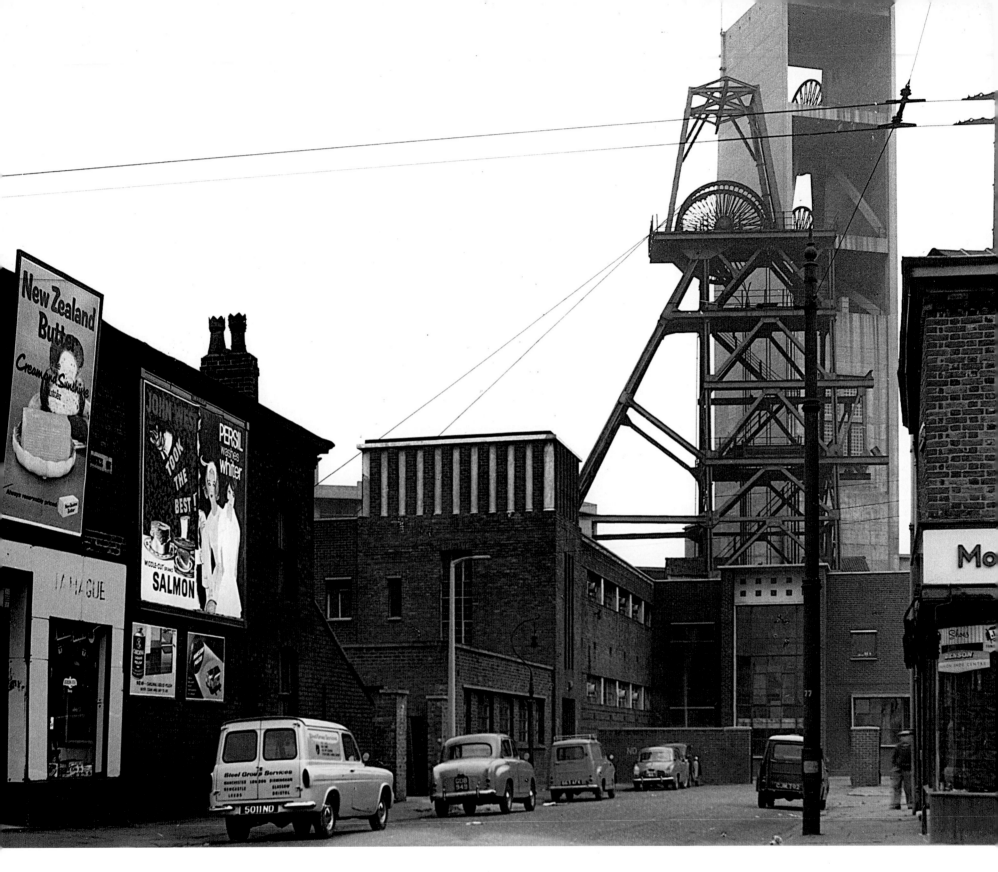

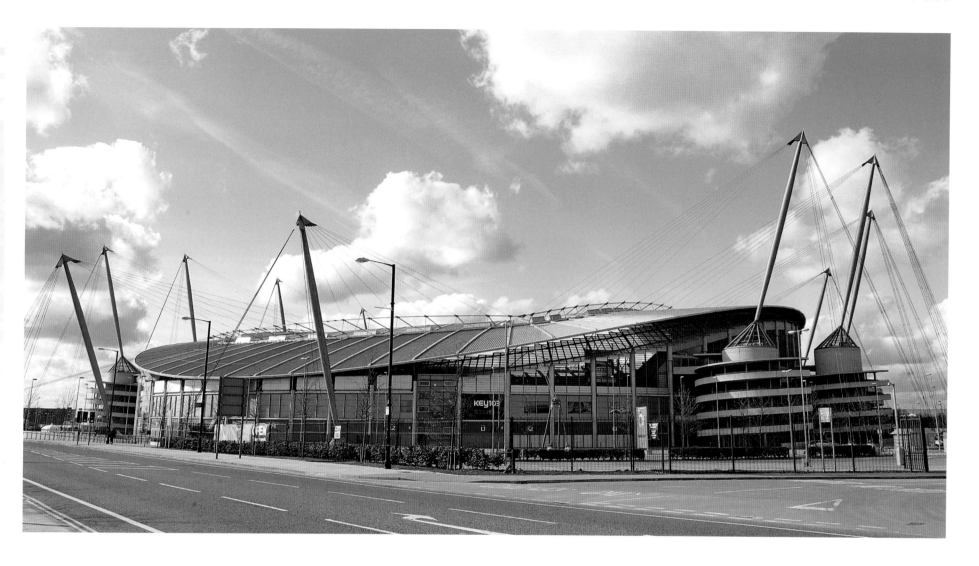

BRADFORD COLLIERY / CITY OF MANCHESTER STADIUM

Mining a rich seam at the City of Manchester Stadium

Left: A mile or so east from Piccadilly Station, Manchester had its own coal pit. This 1963 picture shows the two winding towers over the shafts, the newer concrete one from 1954. Known as Bradford Colliery from the name of its host suburb, the workings started in earnest in the 1840s, although coal had been taken from the area from at least the 1600s. In its last year, 1968, the pit produced 538,808 tonnes of saleable coal and was employing some 1,500 men. Fatalities were few in its long history despite the depth of the mine, almost 900 metres; more than five times the height of Beetham Tower, Manchester's tallest building. Although closed as uneconomic, it is worth noting that vast reserves of premium coal remain untouched under East Manchester should we ever need to return underground for energy.

Above: Manchester had twice bid for the Olympics and failed. Eventually the city secured the Commonwealth Games for 2002 and the picture shows the main venue, the City of Manchester Stadium. Sitting over Bradford Colliery, it was built to host the major track and field events as well as the opening and closing ceremonies. During the Games, a million people watched 74 nationalities and 4,000 athletes competing for 900 medals. After the Games, the capacity of the stadium was raised to 48,000 with the addition of another tier of seats and Manchester City Football Club vacated their Maine Road ground and moved in. This ensured the stadium didn't become a white elephant and gave the football club one of the most advanced grounds in the world, suitable for a club which aims to rival its neighbours in red across the city.

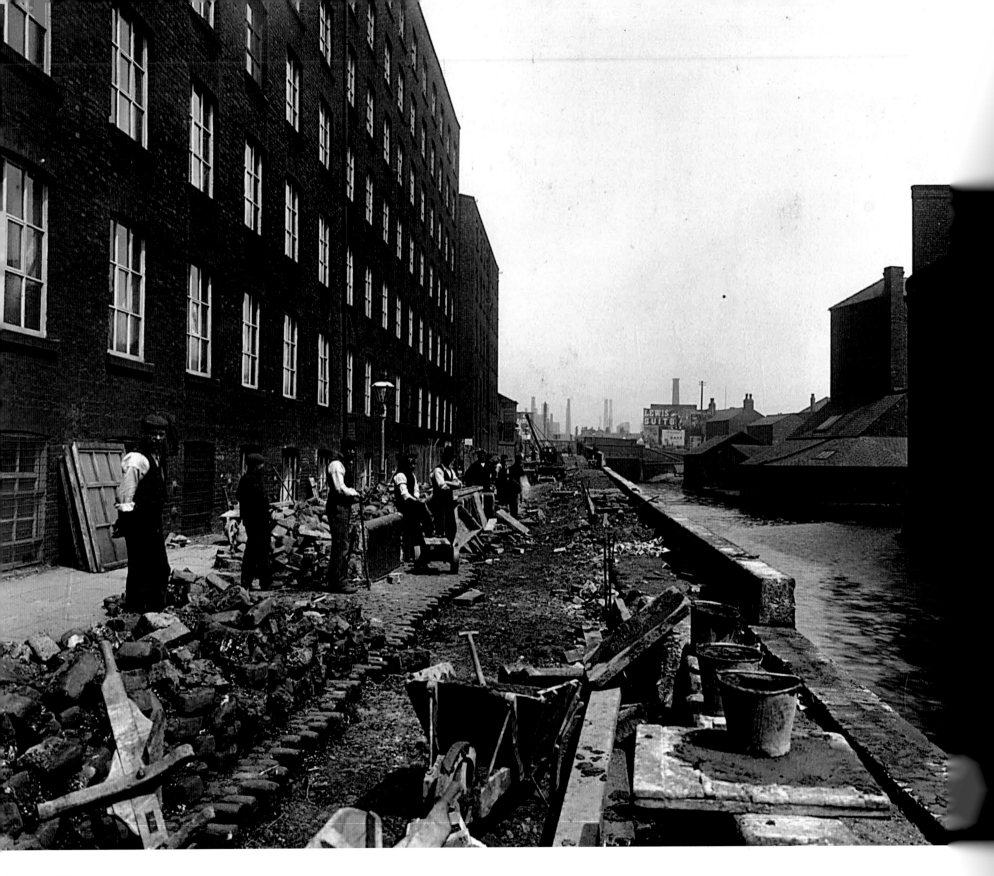

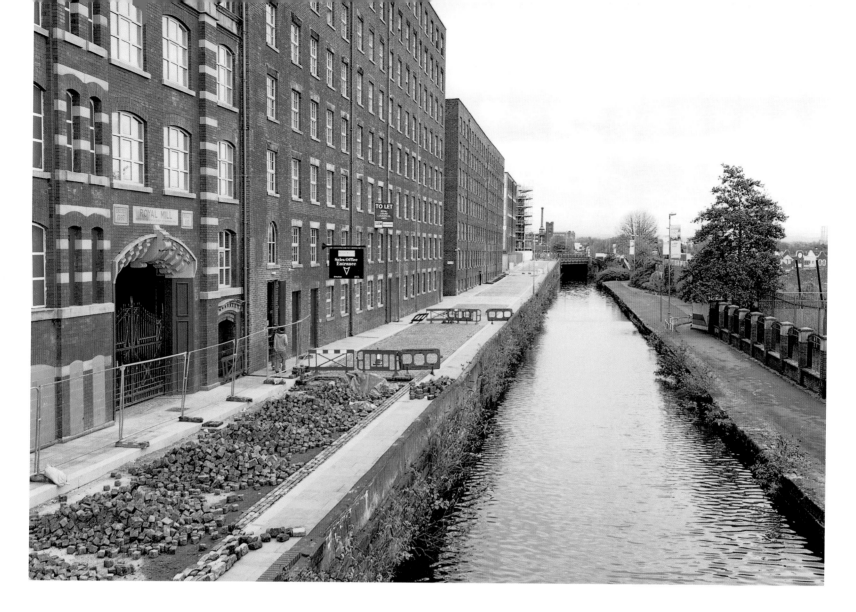

REDHILL STREET

The industrial powerhouse of Manchester's nineteenth-century prosperity

Left: This is a 1903 scene of road repairs along Union Street (now Redhill Street) in Ancoats with the Rochdale Canal to the right. The spinning mills on the immediate left date from 1798 and include those of Adam and George Murray. Totally functional, just a sheer cliff of undecorated brick with unadorned windows, these were perhaps the largest iron-framed buildings in the world when they were constructed. The next block is the Doubling Mill built in the early 1840s. Connected by tunnels and run strictly to the clock, these powerhouses amazed visitors from across the globe who often turned their backs against the unforgiving working conditions. Visitors noted that Manchester was the first city to have factories and chimneys taller than its palaces or churches.

Above: The Royal Mill was built in 1912 to replace its nineteenth-century predecessor and was the last in a series of mill buildings that represent the evolution of the industry along one stretch of canal. It is hoped that in the future these structures will become part of a UNESCO world heritage site. The mills closed in the second half of the twentieth century, the Lancashire cotton industry falling victim to its higher costs. The machinery inside the mills was dispersed across the world, the ring spinners in Murrays' Mills ending up in Hungary. Split into light industrial units or warehouses, the mills stood largely derelict until recently when they were converted into offices, apartments and even film sets.

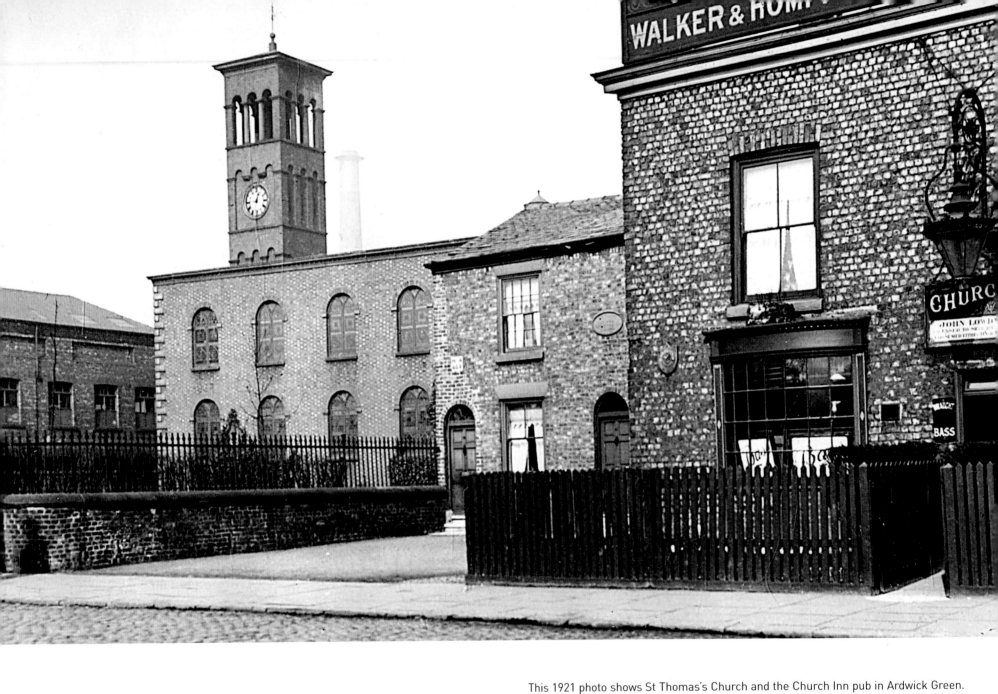

ARDWICK GREEN

Local resident Charles Rowley believed the devil was in the suburbs

This 1921 photo shows St Thomas's Church and the Church Inn pub in Ardwick Green. In 1899 Ardwick resident Charles Rowley had despaired of the way that the Manchester men of wealth and power were moving to live further and further from the city centre. Rowley felt that if 'God made the country and man made the town,' then 'the Devil made the suburbs'. Ironically, Ardwick Green lay a couple of miles from St Ann's Square in the city and had been the first purely residential suburb in the eighteenth century, but by Rowley's time it was surrounded by industry, railway lines and poor housing – note the chimney looming over the church in this picture. St Thomas's was built in 1741, enlarged in 1771 and again in 1831, with the tower being added in 1836. Modest in appearance, it served an immensely wealthy population of 'cottentots' and merchants.

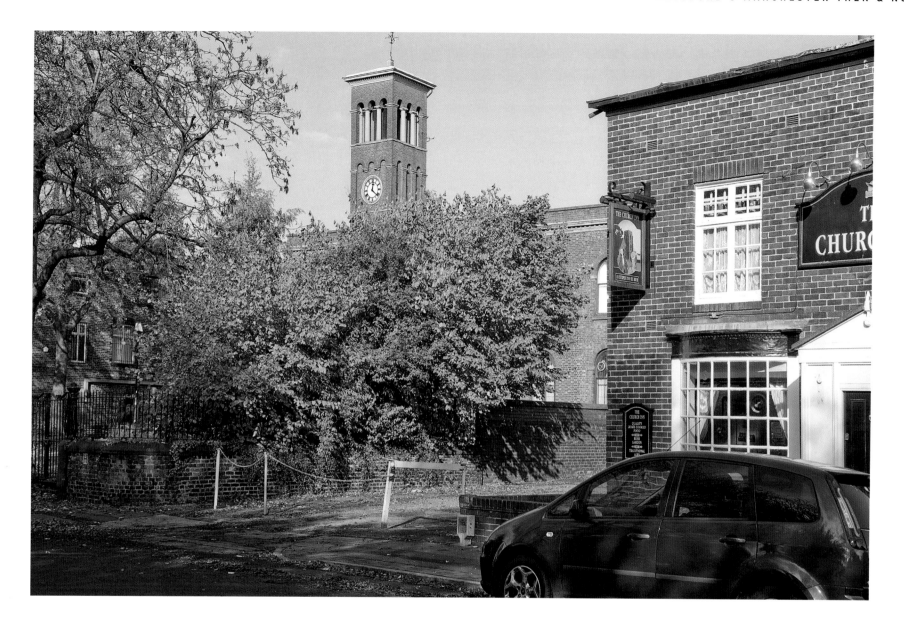

Today the industry with its tall chimneys has gone and so has the religious function of the church. St Thomas's is now a secular resources and conference centre. The future of the Church Inn is undecided. The building as a licensed premise dates from around the time Charles Rowley had been delivering his homily on city and suburbs. Up until that time the gentlefolk who lived around Ardwick Green – which remains as a small park behind the photographer's back – would have despaired of anything as low as a public house being imposed on their neighbourhood. The area is now a no-man's land of mixed offices, warehouses and some social housing between city centre and suburbia, in a zone beyond the definition of Charles Rowley.

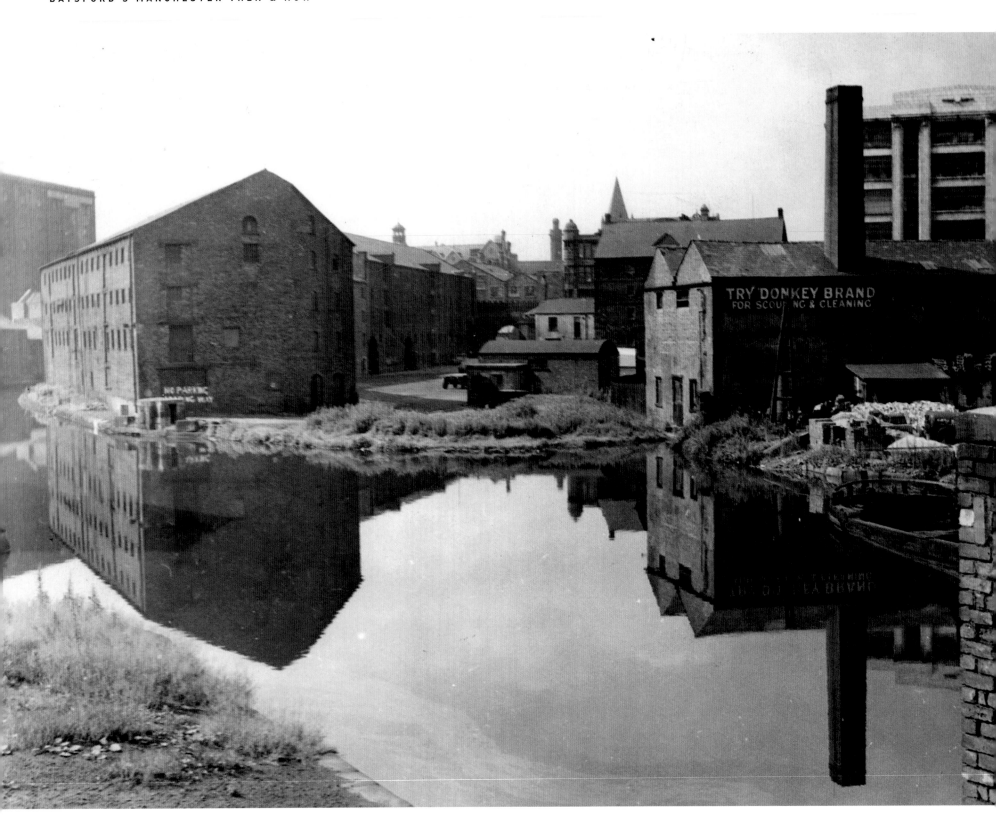

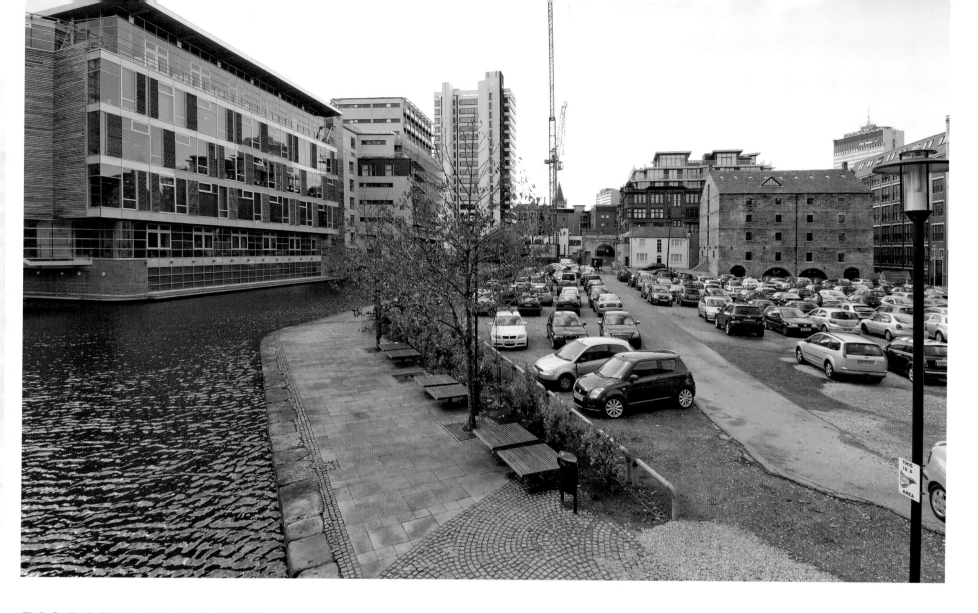

PICCADILLY BASIN

Marketing Manchester from one of its oldest stone buildings

Left: This is a 1956 picture of the Piccadilly Basin, the inland port where the Ashton and Rochdale canals connect. Only the Rochdale Canal, completed in 1804, is visible here; the slightly older Ashton Canal is out of shot to the left. The Rochdale Canal linked east and west coasts, straddling the Pennines from the Bridgewater Canal (which joins the Irish Sea) to the Calder and Aire navigations (which join the North Sea). The low building in the right middle distance is advertising the cleaning products supplied by the well-known Donkey Brand, which included Donkey Stones. These were produced in Ashton-under-Lyne a few miles east. Donkey stones were made of pulverised stone, cement, bleach powder and water and were used by every proud housewife to scrub their doorsteps to a polished lustre.

Above: The oldest building in the area and visible in both shots (although behind the Donkey Brand warehouse in the older picture) is the four-storey stone structure beyond the parked cars. This dates from 1806 and was constructed from millstone grit – unusual in the brick city of Manchester – and includes four shipping holes in the basement, where boats offloaded directly into the warehouse. A waterwheel was used to power pulleys for lifting goods: this still survives in the building. Known as Carver's Warehouse, the lower two floors are the headquarters for Marketing Manchester and Visit Manchester, the tourism agencies for the city region. On the right in the distance is the top of City Tower in Piccadilly (1965) with its radio mast; in the centre, middle distance, is the office tower No. 111 Piccadilly (1966).